BIEDERMEIER PAINTING

GERALDINE NORMAN

BIEDERMEIER PAINTING
1815~1848

Reality Observed in Genre, Portrait and Landscape

With 113 illustrations,
80 in colour

THAMES AND HUDSON

For Emmy and Rudolf von Miller

CONTENTS

✻

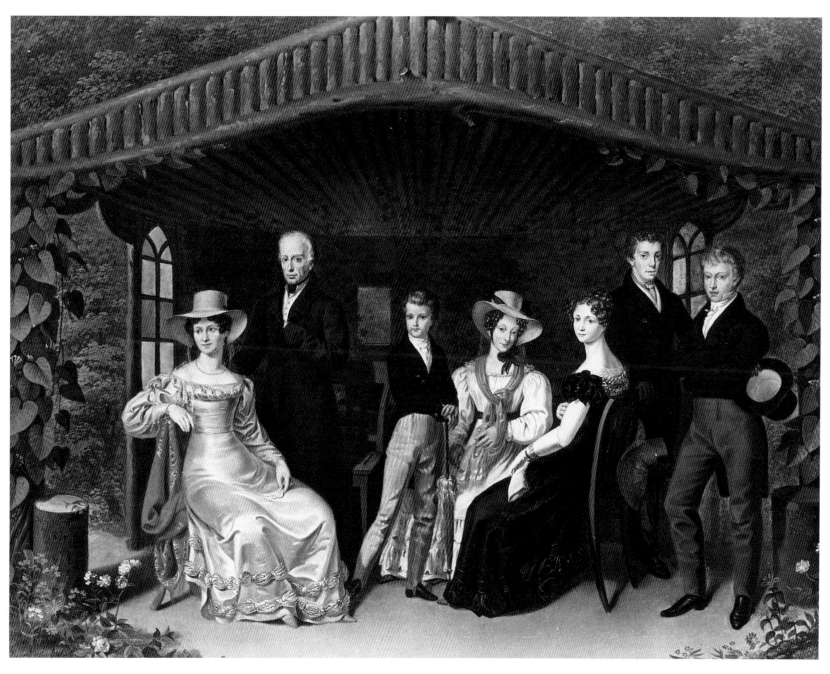

Leopold Fertbauer's painting *Kaiser Franz and his Family*, dating from 1826, could equally well depict any well-to-do family relaxing in their garden and is a charming and characteristic Biedermeier image. The emperor prided himself on the simplicity of his lifestyle.

INTRODUCTION

WIELAND GOTTLIEB BIEDERMAIER was the *nom de plume* adopted in the early 1850s by two young German poets, Ludwig Eichrodt and Adolf Kussmaul, who collaborated to create the Biedermaier *oeuvre*, with some assistance from their friends. The poems appeared from 1854 onwards in *Fliegende Blätter*, Munich's satirical magazine, and proved so popular that various volumes were also published.

Great effort had been put into choosing a name with the right ring. Biedermaier was to be a naive, ordinary, pious petit bourgeois. *Bieder* means upright or virtuous, while Maier is a German surname roughly as common as Smith or Jones. Together they can be translated as 'Upright-Smith' or 'Virtuous-Jones'.

In style and content Biedermaier's verses were inspired by a real poet whose life work Eichrodt and Kussmaul had discovered by chance. The work, a weighty publication of some five hundred pages, was entitled 'The Complete Poems of the Old Village Schoolmaster Samuel Friedrich Sauter, Who Was First in Flehingen, Then in Zaisenhausen and Lived in Flehingen Again as a Pensioner.' It included two illustrations and was published at the author's expense by Creutzbauer & Hasper, Karlsruhe, in 1845.

Eichrodt and Kussmaul were charmed not only by the title but also by the ludicrous simplicity of the schoolmaster's poems. His 'Lament for Widows and Widowers' gives some idea of their tone:

> Traurig ist es einsam sein,
> traurig so getrennt zu leben,
> einsam schlafen, nichts daneben,
> nichts von gleichem Fleisch und Bein . . .
> Traurig ist es einsam sein!

> (*It's sad to live alone,*
> *The gulf that parts us is too wide,*
> *Sad to sleep alone with no one at my side,*
> *I miss your flesh and bone . . .*
> *It's sad to live alone!*)

Biedermaier's poems were in the same vein. Indeed, some of Sauter's own poems were republished under the name Biedermaier.

Not until the last years of the nineteenth century, however, did the term Biedermeier begin to be used to describe the cultural epoch between the close of the Napoleonic Wars in 1815, and 1848 – the year of revolutions. This was the generation of Sauter's (or Biedermaier's) grandchildren which looked back nostalgically to a golden age before the industrialization of Germany or the creation of an urban proletariat,

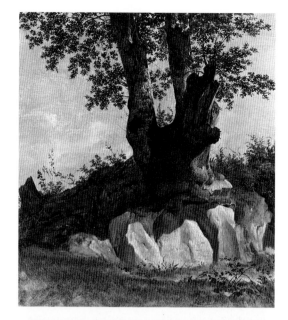

Half a tree trunk was a sufficient motif for a Realist exploration of textures and light. Heinrich Reinhold's painting (top) was made in the Roman campagna in 1822 and John Constable's (above) in an English meadow in 1821. The artists never met and the similarity of approach underlines the universality of the Realist spirit.

to an age of middle-class virtue, centred on the home and the family, and laughingly dubbed it 'Biedermeier'. The error of transcription that turned Biedermaier with an 'a' into Biedermeier with an 'e' is unrecorded.

At the same time, around 1900, art history was being rewritten so as to present the development of nineteenth-century art as a logical sequence leading through Realism to Impressionism. History painting, formerly considered the highest achievement of the century, came to be dismissed as an aberration.

The 1906 Centennial Exhibition in Berlin was a landmark in the reassessment of early-nineteenth-century German Realist painting, now often referred to as Biedermeier Realism. The little masters of landscape, portrait and genre were rediscovered and their reputations established. It is these artists that are now looked on as the major figures of the Biedermeier age.

The concept of Biedermeier art, as well as the Biedermeier age itself, was thus forged in the crucible of turn-of-the-century nostalgia. Bourgeois *Gemütlichkeit* was seen as the keynote of the Biedermeier period. The word *gemütlich* is commonly held to be untranslatable: it means cosy, snug, genial, friendly, pleasant . . . and more. *Gemüt*, from which it derives, can mean either soul or mind. The citizens of the Biedermeier period were pious and deeply interested in the cultivation of the mind. Romantic philosophers urged them to see God immanent in nature, thus giving a spiritual dimension to its faithful delineation.

Biedermeier landscape artists were constantly off on sketching trips. Studies made directly from nature were considered of the highest importance, though they were not normally sold *per se* but used as reference material for the composition of landscape paintings in the studio. Both sketches and finished pictures were exhibited at the 1906 Centennial Exhibition and their realism highly praised.

At the time of the exhibition, the landscape painters of the French Barbizon school were the height of fashion throughout Europe. There are obvious parallels between their work and that of the German Realists. Indeed, it was very probably the Barbizon aesthetic that directed the eyes and minds of the exhibition's organizers towards German Realism and led to its rediscovery.

In fact, the Biedermeier period coincided with the first flowering of Realist painting throughout Europe, from Constable in England, to the Barbizon painters in France, to Palizzi in Naples. Realism appears to have developed more or less independently in many centres. It was literally the spirit of the age.

Realism, the faithful and objective rendering of nature, is the essence of Biedermeier painting. It is found equally in landscape, portraiture, genre painting and still life and was generally seen as requiring painstaking attention to detail. Even landscapes are carefully finished with brushstrokes so fine as to be almost invisible. Artists who saw quick approximative brushwork as a more direct means of capturing atmospheric effects, in the manner of Constable or the Barbizon painters, were the exception rather than the rule in Germany, though Blechen and Rottmann may be counted among their number.

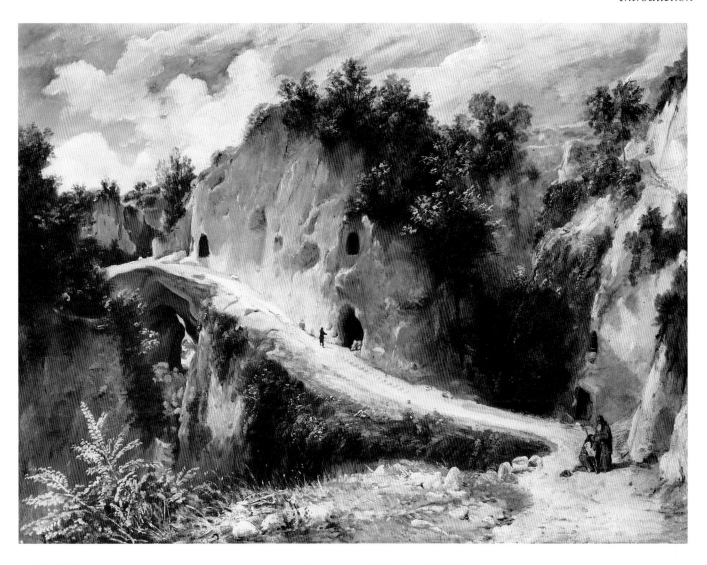

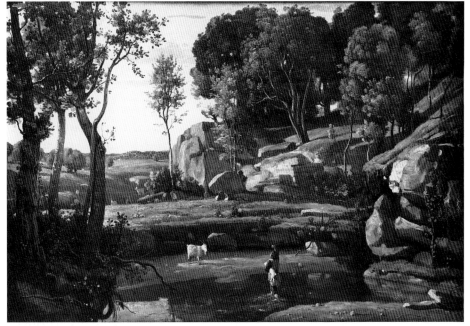

Both Corot and Karl Blechen were inspired by Italian landscape and southern sunlight to explore a new Realist approach to landscape painting. Blechen's *Southern Gorge with Caves* (above) and Corot's *Italian Landscape* (left) were painted around 1830 and 1840, respectively.

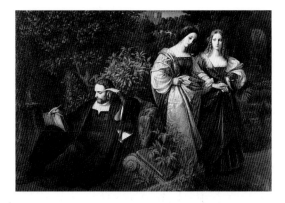

Carl Ferdinand Sohn's *Tasso and the Two Leonoras* of 1839 is characteristic of the highly regarded Düsseldorf school of history painting, simultaneously sentimental and theatrical.

Genre painting tends to be thought of as typically Biedermeier because the lives of the virtuous, ordinary petit bourgeois are directly represented. In fact, imaginary scenes of everyday life were rarely painted – only Vienna had a flourishing school of genre painters – but portrait groups treated in the manner of genre were universally popular and are very characteristic of the period. The subjects are often shown in real interiors, usually their own homes. The furnishings are lovingly delineated, reflecting the bourgeois joy of the sitters in their possessions, and often highlighting or reinforcing their characters.

Portrait groups are also set in landscapes, perhaps the family garden or a favourite locality, while the architectural views that were particularly favoured in Berlin are often embellished with the figures of family or friends.

In terms of art history, Realism was only one of many facets of the Romantic movement. German artists of the Biedermeier period, like their counterparts elsewhere in Europe, generally considered history painting to be the highest form of art. 'History' could encompass scenes from the Bible, classical myth, European history, Shakespeare, Dante, Ossian, Walter Scott and many other sources.

History paintings were generally executed on large canvases for royal or aristocratic clients or for churches. However, the new middle-class patrons of the arts wanted to purchase small-scale pictures that they could hang in their own homes. Their preference was for landscape, portrait and genre. Art unions (*Kunstvereine*) were established in most major towns in the early decades of the nineteenth century to channel this new patronage. Both artists and patrons would belong to their local union which would organize exhibitions, competitions, raffles of major paintings and the reproduction through engravings or lithographs of particularly popular works.

The art that was created to suit the taste of these new middle-class patrons is known as Biedermeier painting. But it was not reserved exclusively for the middle class. Members of ruling families – noblemen and princes – also commissioned Biedermeier pictures, which suited the lifestyle of pious simplicity (almost indistinguishable from that of the middle classes) that they chose to adopt at this time. Indeed, it was not always a matter of choice: many noblemen were living in reduced circumstances, having been dispossessed of their estates by Napoleon.

There is no exact definition of what constitutes a Biedermeier painting and what does not. The use of the term has evolved without any strict logic. It is an art that springs from a cosy but high-minded middle-class ethos. Realism – the faithful delineation of nature – is its chief characteristic, whether in portrait, genre scenes or landscape. Some of the pictures discussed in this book are more Romantic than Realist and might be excluded by a purist.

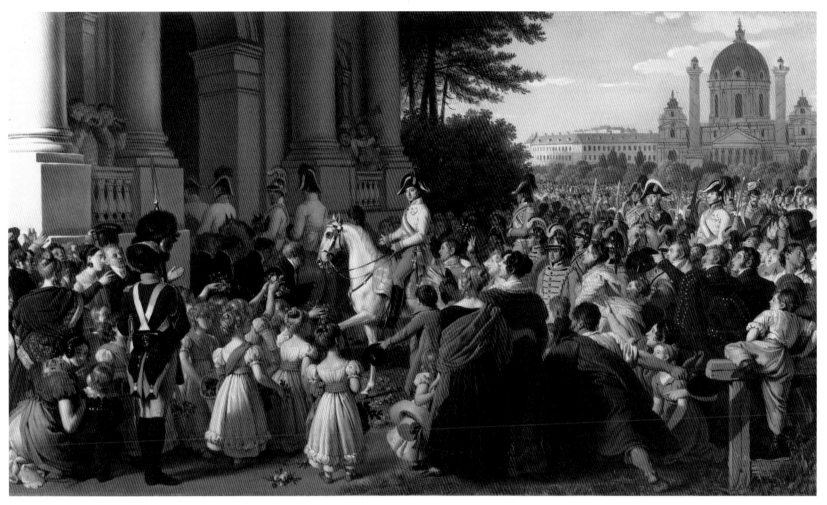

Historical Context

The geographic spread of the Biedermeier style is generally taken to include Austria, Germany and Denmark. The map of Europe in 1815 was quite different from today's, and a look at the political frontiers of the time helps to explain why these three countries were bound together by a common culture.

After the defeat of Napoleon, European rulers, notably those of Russia, Prussia, France, Austria and Britain, met at the Congress of Vienna to sort out who was to govern the territories conquered by Napoleon. The Congress lasted from September 1814 to June 1815, its deliberations slowed down by lavish entertainments.

One of the products of the Congress was the German Confederation, which linked together thirty-eight independent German states varying in size from the powerful kingdom of Prussia to the tiny city states of Hamburg and Lübeck. (Their number was increased to thirty-nine in 1818 by the creation of Hesse-Homburg.) The Austrian Emperor Franz I became the first president of the Confederation.

Johann Peter Krafft: *Entry of Kaiser Franz I into Vienna.* Kaiser Franz played host to the Congress of Vienna and became the first president of the German Confederation. Krafft turned major events from the emperor's life into a series of pictures which hover on the borderline between history painting and genre. The emperor is seen here entering Vienna on his return from the Treaty of Paris.

In the pre-Napoleonic days, the Habsburg ruler of Austria had borne the title of Holy Roman Emperor and the rulers of Germany, who then numbered more than three hundred, had nominally owed him allegiance – though this survival from antiquity had little practical significance. When Napoleon assumed the title of Emperor, Franz was forced to renounce his title and in 1804 he became merely Emperor of Austria.

With the restoration of traditional hegemonies in 1815, it was natural that Austria should resume the leadership of the Germanic states. The Confederation was a loosely structured league of nations which did not interfere with the individual sovereignty of its members. The ruling body or Diet met in Frankfurt and functioned more or less as a permanent congress of ambassadors. England, Holland and Denmark were represented at Frankfurt because they were the rulers of Hanover, Luxembourg and Holstein, respectively.

Membership of the Confederation formed a political link between Denmark and the German states. Because the countries were contiguous, it was a simple matter for German artists to study in Denmark. The Copenhagen Academy had been founded in 1738 to encourage young artists and to help establish a national school of painting. It had great attraction for young Germans because tuition was free. In the early years of the nineteenth century many German artists studied there and continued to exhibit in Copenhagen after they returned to Germany. The influence of Copenhagen was felt particularly strongly in Hamburg and Dresden.

In a politically fragmented Germany no single artistic centre took the lead. There were several of nearly equal importance and there was constant interraction between them.

It was natural that Vienna and Berlin, capitals of the two most powerful members of the Federation, should have had an active artistic life, while Bavaria, which had been Napoleon's ally and which became a kingdom in 1806, made a bid to establish Munich as the Germanic capital of the arts in the Biedermeier period, with some success.

Dresden, the capital of Saxony, was also a significant centre. The famous collection of pictures acquired by August III in the mid-eighteenth century had made the city popular among artists.

It was also the presence of a great picture collection that established Düsseldorf as an artistic centre. Formed around 1700 by Duke Johann Wilhelm of Berg, the collection attracted many artists to the city and in the late eighteenth century Düsseldorf had a flourishing academy.

The collection was removed to Munich in 1806 but Düsseldorf, which had been occupied by Napoleon, became the capital of Prussia's Rhineland province in 1815 and the Prussians reopened the academy. It was to be one of the most popular in nineteenth-century Germany.

Napoleon's conquests in Germany together with his subsequent expulsion and defeat ushered in the Biedermeier age. Napoleon conquered Prussia and Austria and deprived them of large parts of their territories. The left bank of the Rhine was annexed by France and, in 1806, sixteen German princes, including the rulers of Bavaria and Württemberg, joined Napoleon's Confederation of the Rhine.

Germany was thus divided into two camps: Napoleon's allies and his conquered opponents. Over the years both began to chafe at the dominance of a foreign power. The wars of liberation were supported by volunteers from all over Germany and in this pan-Germanic patriotism lay the seeds of its future nationhood. How to bring about the unification of Germany was to become a favourite topic in intellectual circles after 1815.

Throughout the country the sense of belonging to a common *Volk* or people was dominant; in art and literature it is reflected in an enthusiasm for all things medieval. The era when the German people were united under Charlemagne was looked back to with nostalgic pride.

Before Napoleon the power of most German rulers was absolute. Indeed, serfdom survived in some areas. Napoleon brought with him both the idea of a constitution embodying citizens' rights and the idea of elected assemblies. Some states hurried through constitutional reform in order to ward off internal unrest; others were not cajoled down the constitutional path until the 1848 revolutions. The introduction of constitutional government was a major preoccupation of the Biedermeier years.

At the same time, the French Revolution had given German princes and most of their subjects a deep mistrust of liberal or, worse, democratic, ideas. Their determination to prevent the spread of revolutionary thought in Germany gave rise to one of the Confederation's only political initiatives. The Karlsbad Decrees, voted by the federal Diet in 1819, established strict press censorship and commissions with powers to investigate the universities and dismiss undesirable professors and students. Metternich, the powerful Austrian chancellor, was the prime mover; Austria under his rule became virtually a police state.

The Napoleonic Wars left Germany economically decimated. Germany's fledgling industries, which had enjoyed the markets of France and the Netherlands during the Continental Blockade, were now swamped by cheap British goods. Trade in agricultural products was prevented by high tariff barriers.

Thus the Biedermeier period was marked by financial struggle as the little German states tried to rebuild their economies. Impoverishment was combined with the suppression of political activity. Robbed of external opportunities, the middle classes turned inwards and threw their best energies into home and family life.

Prosperity began to return in the 1830s. The first industries were established, the first railways were built and in 1834 a customs union pioneered by Prussia abolished internal tariffs over some three-quarters of Germany, creating a large home market. In the 1840s, however, industrialization began to put traditional craftsmen out of business while rural areas were devastated by the crop failure and potato blight of 1846 to 1847. The climate was ripe for revolution.

The 1848 uprisings in Austria, Prussia and the other German states took their cue from France. The overthrow of Louis Philippe on 24 February was followed in March by the uprisings in Germany. The

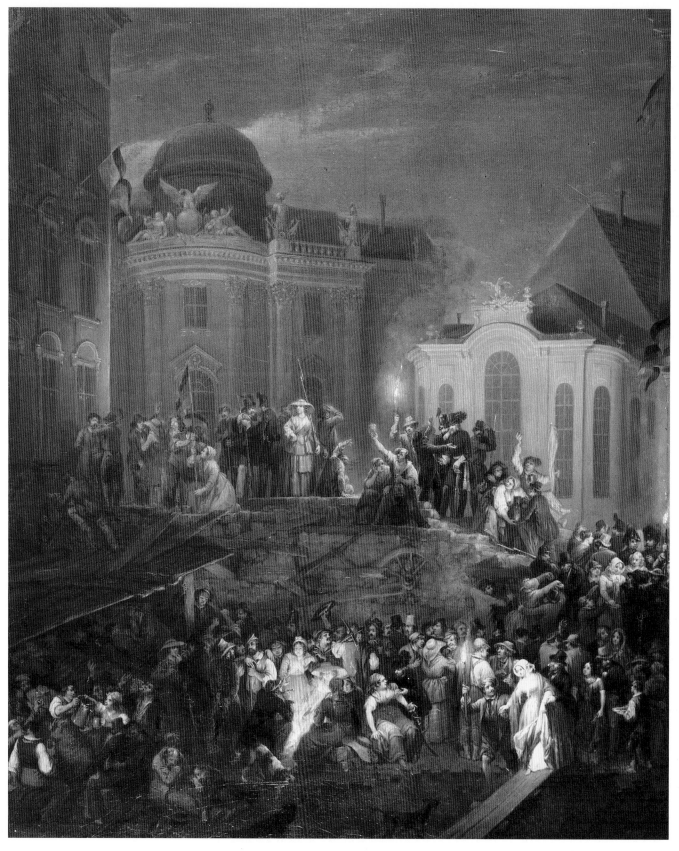

The 1848 uprisings in Austria brought revolution to the
very threshold of the palace. In Anton Ziegler's painting
*The Barricades on the Michaelerplatz in the Night of the
26th and 27th of May 1848*, the Baroque façade of the
palace rises behind the militant citizenry.

proletariat hardly had a hand in them; they were the work of university students and the politicized middle classes. Their primary aim was to wrest representative constitutions from their rulers. Remembering the horrors of the French Revolution, German rulers hurried to capitulate.

In March and April the granting and implementation of constitutional government took place in almost all the German states. The following weeks saw elections to a national assembly in Frankfurt which was charged with drawing up a constitution for a united Germany. Unused to the exercise of democracy, the assembly alienated its masters and collapsed without completing its task. The unification of Germany had to wait until 1871.

Biedermeier Culture

Most of the small towns of Germany had grown up for administrative rather than commercial reasons – Hamburg and the northern merchant towns being the exceptions. The tiny sovereign states of the pre-Napoleonic era each supported a court and local administration. Germany was exceptionally well supplied with universities which generated enough officials to keep the little states running.

All this was to change in the course of the nineteenth century but not until after the Biedermeier period. The middle classes who set the tone of the era were 'officials' rather than tradesmen, cultured professional people on terms of easy intercourse with an aristocracy that was also cultured and not, in the main, ostentatious.

Cultural life was centred in the home, and the women of the family were particularly important in determining its character. Their neat houses were basically Neo-classical in design, with plenty of windows looking onto tidy flower gardens. The rooms themselves usually had plain white walls, sometimes embellished with mouldings and a ceiling rosette.

Biedermeier furniture echoed the classical outlines of French Empire style but avoided all elaboration or ornament. Pale fruitwoods were preferred but maple and birch were sometimes used. There were little upholstered chairs with sabre legs, a *canapé* with a bolster rather than a sofa, a *secrétaire* with drawers and a writing surface that folded back and, of course, a spinet or piano for musical evenings. The women were also fond of small, unostentatious ornaments, clocks, porcelain or bronzes.

Simple traditional piety was combined with a passionate belief in learning, a desire to educate themselves shared by men and women alike. Improving books on religious, philosophical or historical subjects would be read aloud in the family salon in the evening. Poetry was also extremely popular and everyone wrote verses. Young women wrote romantic poems about nature, while their admirers courted them in rhyme and older men showed off their erudition or wit.

Novels were keenly read, particularly historical novels. The works of Sir Walter Scott were translated into German and achieved great popularity. The nostalgic enthusiasm for the Middle Ages was exemplified by the Grimm brothers, who collected their fairy tales in a

nationalistic as well as an anthropological spirit. By travelling around country districts recording stories that had been passed down orally for centuries, they sought to document German myth and legend.

Songs were also collected, and certain composers, most notably Schubert, set mythical stories, such as the Lorelei and the Erlkönig, to music – which, in turn, inspired Moritz von Schwind and others to paint them. Schwind and Ludwig Richter were among the leading illustrators who decorated books of fairy tales, poems and songs with their woodcuts. Illustrated books were much in demand, especially those that made improving texts more palatable to children. Great care was lavished on children's upbringing, both their education and their entertainment. The family groups which are such a special feature of Biedermeier painting bear witness to the affection in which children were held and show their relaxed, informal relations with their parents.

Friends invited into the home would share in the family's entertainment. Reading, music-making and amateur theatricals were common pastimes, as were *tableaux vivants*, which involved the participants dressing up in imitation of a picture. Chamber music was also popular, especially in Vienna.

Opportunities for entertainment outside the home, though few, were eagerly grasped. Most of the small courts supported theatres and they were keenly patronized. In Vienna the waltz had just evolved from the 'Ländler', or German dance, and dance halls sprang up all over the city to accommodate the passion for dancing common to all classes. Joseph Lanner and Johann Strauss the Elder provided the music.

A new, romantic appreciation of nature, encouraged by both poets and philosophers, increased the popularity of country walks and expeditions into the mountains. Among the student population walking became almost a vocation. Complete with backpacks, walking sticks

Moritz von Schwind: *The Erl-King*. Fairy pictures had a serious patriotic content in Germany where the Grimm brothers were busy collecting stories that had passed by word of mouth down generations of country dwellers. Schwind was the most distinguished artist to translate the stories into paint. In this picture he was inspired, like Goethe and Schubert, by the story of the Erlkönig.

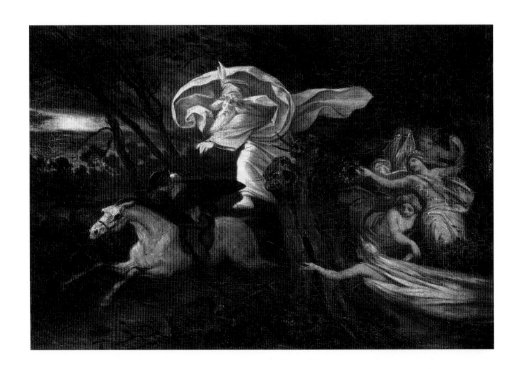

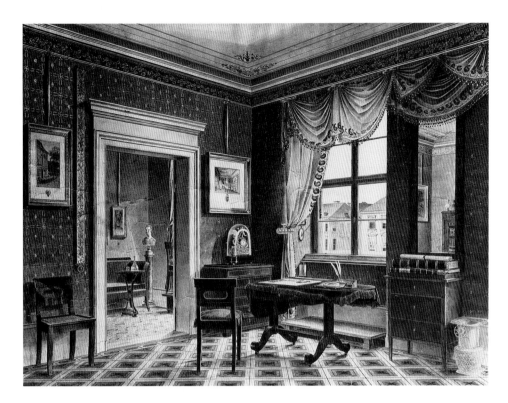

Leopold Zielke has made a careful watercolour of the interior of his workroom in his home in Berlin. The painting dates from 1825 and shows the simple but elegant style of interior decoration favoured in the Biedermeier period.

and musical instruments to accompany their songs, groups of students wandered happily, often for weeks at a time.

The Romantic movement flourished with particular vitality in Germany. Jean-Jacques Rousseau had taught the whole of Europe a reverence for nature: 'Everything is good as it comes from the hands of the Author of Nature; everything degenerates in the hands of man.'

Goethe, Herder and other German writers of the decades between 1770 and 1790 carried the new cult of nature to extremes, extolling intuition, impulse, and even anarchy. They were given the ironic nickname *Sturm und Drang* (Storm and Stress).

The turn of the century saw Germany's romantic energy channelled into religious revivals. Wackenroder, Tieck and Schlegel looked back to the painters of the Middle Ages for inspiration in the belief that all true art expresses God's design. They inspired a revival of orthodox Catholicism.

The protestant counterpart of this found expression in mysticism. According to Schelling's nature-philosophy, one creative spirit pervades both the physical world and human consciousness. This idea was of profound importance to landscape artists such as Caspar David Friedrich and Carl Gustav Carus who, in painting nature, felt they were literally painting the manifestations of God. It encouraged painstaking attention to visual reality.

The Biedermeier age followed in the wake of these intellectual movements and was much influenced by them. The great ideas were, however, reduced to manageable size. Mysticism provided the seed of Realism, while nationalists adopted the Middle Ages as a period symbolizing Germany's greatness. Much time was devoted to the rediscovery of folk songs, fairy tales and medieval legend.

Biedermeier in the Context of European Painting

In 1815 virtually every European artist would have agreed on the pre-eminence of history painting over other genres. To be 'great' a painting was expected to convey a great idea; history paintings might depict a renowned event, an uplifting story, a noble act or an allegory, but content was all-important. The dominant mode of history painting at the turn of the century was Neo-classicism and the most influential master was Jacques Louis David.

Born in 1748, David had supported the French Revolution and was named first painter to the Emperor in 1804. With the fall of Napoleon he escaped to Switzerland and finally settled in Brussels. The two most influential features of his teaching were classical idealism and a smooth, high finish. Idealism required the close study of nature and the selection from it of the most perfect of each of its parts.

The high finish which is characteristic of most Biedermeier painting has its roots in French classicism and the school of David. Christoffer Wilhelm Eckersberg, the most influential teacher of the Copenhagen school, studied with David in Paris, as did Johann Peter Krafft, the father of Viennese genre painting, while Karl Begas, Berlin's leading portraitist of the Biedermeier period, studied with David's pupil, the Baron Gros. It is a reflection of the continuing influence of classical idealism that most Biedermeier paintings prettify, or at least tidy up, their subjects.

The human figure, anatomically corrected to its most perfect proportions by reference to the sculpture of antiquity, was considered the noblest subject for a painter of the Neo-classical school. Christoffer Wilhelm Eckersberg's earnest attempt in *Two Shepherds* of 1813 (above) to emulate the classical style of David, whose painting *The Loves of Paris and Helen* (right) was shown in the Salon of 1789, underlines the influence of French classicism on Biedermeier painting.

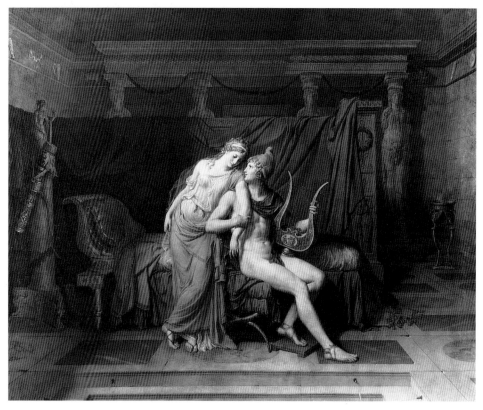

The influence of Valenciennes on landscape painting was carried throughout Europe by his writings. This view of *Tivoli* of 1819 marks him out as one of the most gifted exponents of the Realist landscape sketch which he advocated as a preparation for landscape paintings composed in the studio.

In his *Eléments de la perspective practique*, published in 1800, the French painter and theorist Valenciennes codified the proper approach for a historical landscapist. The artist should make constant sketches from nature to ensure the 'truth' of the paintings which would be composed in the studio from these sketches. The composition should emulate the landscape geometry of Claude and Poussin and should illustrate a classical theme.

This approach to landscape painting was taught throughout Europe and had an outstanding exponent in Joseph Anton Koch, the most influential German landscapist of the period. Some German artists substituted medieval romance for a classical theme.

In terms of painterly technique, two alternative traditions were inherited by the nineteenth century: the clean, smooth finish of Poussin and the classicists, and the strong approximative brushwork of Rubens. Delacroix and the French Romantics adopted the Rubens tradition and its influence can be traced from them through the Realist landscape

The influence of the loose, 'Rubens-esque' brushwork of the British portrait school was introduced to Vienna by Heinrich Füger, an ardent admirer of Gainsborough, in such works as his portrait of *Count Franz Josef Saurau* of 1797 (above). Then, in 1815, Sir Thomas Lawrence, whose dashing style shows to advantage in his portrait of the *Duc de Richelieu* (opposite), arrived in person to paint the delegates to the Congress of Vienna.

David Wilkie's painting *The Reading of the Will* (right) was bought by Ludwig I of Bavaria in 1826. It was enormously admired by German artists and had a direct influence on the Viennese school of Biedermeier genre painters. Josef Danhauser painted his own version of the same subject (see p. 33).

painters of the Barbizon school to the Impressionists. This facet of French painting appears to have had comparatively little contemporary impact in Germany.

The brushwork of Viennese painters of the Biedermeier period is, however, more visible, fluent and approximative than that of most painters in Germany and Denmark. Something of the Rubens tradition of 'colourism' had survived from the Baroque period and was reinforced, rather surprisingly, by the influence of the British school. Heinrich Füger, who was director of the Vienna Academy from 1795 to 1818, was a portraitist much influenced by Gainsborough and Reynolds. Then, in 1815, Sir Thomas Lawrence arrived in Vienna in person with a commission to paint the portraits of all the European leaders attending the Congress. Lawrence was at the height of his powers and made a great impression on his fellow artists – who were also, no doubt, dazzled by the extravagance of his commission.

Another source of British influence was the David Wilkie genre scene, *The Reading of the Will*, which was bought by Ludwig I of Bavaria in 1826. The choice of a contemporary scene and the sparkle of his approximative brushstrokes impressed many artists. Josef Danhauser, one of the leading Viennese genre painters, was inspired to paint a version of the same scene.

While French classicism and a survival of Baroque tradition, filtered through the British school, were the principal influences on the technique of Biedermeier painters, their subject matter was inherited from the Dutch. It was in the little city states of seventeenth-century Holland, which had achieved fabulous wealth through overseas trade, that the middle classes became patrons of the arts for the first time. The burghers wanted pictures to live with, rather than to live up to. The artists provided them with landscape and townscape, marine views, still lives, genre paintings and, of course, portraits.

The Dutch were enormously prolific and their work was admired and

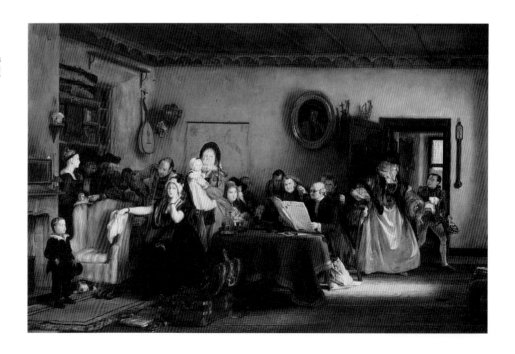

collected throughout Europe. By the eighteenth century they already had imitators in France, Germany and Britain. Few of these Dutch-inspired artists, however, achieved reputations of any resonance; they were little masters whose paintings sold for their decorative appeal. Generally modest in size, their works were suited to an ordinary home, rather than to a palace.

This is the tradition out of which Biedermeier painting grew. The Biedermeier artists knew that they were *Kleinmeister*, that is, engaged in the lesser genres of painting, though several did try their hands at history painting. It is no surprise that the predominantly middle-class patrons of the Biedermeier period should have had the same tastes as the middle-class burghers of seventeenth-century Holland. Both liked to see their everyday world cleverly and naturalistically delineated. Neither was averse to prettifying or a touch of sentiment. Most Biedermeier paintings, like their Dutch counterparts, were of modest size.

There was, however, one particular way in which the nineteenth-century painters differed from their predecessors: they attached unprecedented importance to objective realism.

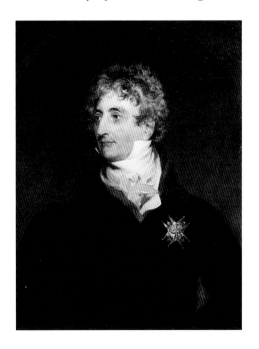

Biedermeier in the Context of German Painting

Biedermeier painting belongs to the age of Romanticism and must be considered one of the diverse products of that age. Romanticism was a reaction against the extreme rationalism of the Enlightenment in philosophy, literature and art. In painting it is taken to cover roughly the period from 1770 to 1850. Where the Enlightenment sought for truths of universal significance, the Romantics gloried in diversity and poetic subjectivity.

Realism, the particularized fidelity to observed nature, was one facet of Romanticism and the central ambition of the little masters of the Biedermeier age. They were, however, influenced by the strivings of contemporary painters whose aims were very different from their own. Some Realist painters dabbled in other fields while some significant Romantic artists painted Realist pictures as a sideline. Thus the Biedermeier masters need to be seen within the context of German Romantic painting as a whole.

The most influential group of German Romantic painters were the Nazarenes. Their aim was to achieve a renaissance of German art in the Christian spirit of the Middle Ages. The movement began as a student breakaway from the rigid classicism of the Vienna Academy. The group of young artists founded the Brotherhood of St Luke and in 1810 set out for Rome where they worked together in a monastic environment. It was in Rome that they earned the derogatory nickname 'Nazarenes'.

Franz Pforr and Friedrich Overbeck were the initial leaders of the group, modelling their styles on early German and Italian artists, then still dismissed as primitives. Pforr died in 1812 but Overbeck lived on in

Friedrich Overbeck, the leading painter of the Nazarene group, evoked the northerner's devotion to the South in this symbolic painting of *Italia and Germania* (1828), which consciously echoes the style of Italian Renaissance painting.

Rome until 1869, painting religious subjects which owed a heavy debt to early Raphael. Many artists joined the Nazarene circle in Rome for a period but left to work elsewhere. Overbeck, who never left Rome, remained its pivotal figure.

Throughout the nineteenth century a student visit to Rome was considered a crucial part of an artist's education. Many young German artists met the Nazarenes in Rome and carried their influence home. Peter Cornelius was the most outstanding example and a dominant figure in the Nazarene circle from 1811 to 1819. His personal dream was a rejuvenation of fresco painting. At his instigation, the Nazarene group executed two important fresco cycles in Rome: the Casa Bartholdy frescoes of 1815–17 and the Casino Massimo frescoes of 1817–27.

Koch, the landscape painter, was already in Rome when the Nazarenes arrived and collaborated with them on the Casino Massimo frescoes. His work was also an important influence on visiting Germans, with its combination of classical composition inspired by Claude and Poussin and careful realism in landscape detail. Koch was a strong advocate of sketching from nature; many young German landscapists had their first formative experience of Realist landscape painting in his company in Italy. The little village of Olevano outside Rome was a favourite resort and inspired masterly sketches in pencil, watercolour and oils from Friedrich Olivier, Franz Horny, Ludwig Richter and Heinrich Reinhold, among others.

The young Crown Prince Ludwig of Bavaria met the Nazarenes on his early visits to Rome and was inspired by Cornelius's vision of a new flowering of the fresco painter's art. In 1819 he summoned Cornelius to Munich to execute frescoes for the Glyptothek, a vast new building which was to house his collection of classical art. Cornelius was successively director of the Düsseldorf Academy (1821) and the Munich Academy (1824) and under his direction a generation of ambitious artists devoted themselves to the preparation of cartoons and the execution of frescoes. Notable among the fresco painters of Munich were Julius Schnorr von Carolsfeld and Moritz von Schwind, both of whom painted German legendary scenes in the new nationalist spirit of the times.

Under Cornelius the Düsseldorf Academy was largely devoted to the preparation of fresco cartoons to be executed in Munich. When he left in 1824 the academy's Prussian overlords appointed as director another Nazarene, Wilhelm von Schadow, who had been teaching in Berlin. Schadow turned the Düsseldorf Academy into one of the most influential art centres in Germany. Many foreign artists, especially Americans, chose to study there in preference to Paris.

The speciality of the Düsseldorf school was history painting of a story-telling, sentimental kind with strong links to the theatre. The main exponents were Ferdinand Hildebrandt, Carl Sohn and Karl Friedrich Lessing. As the school gradually became politicized in the years leading up to the 1848 revolutions, historical subjects were chosen which had obvious parallels to current political issues. Lessing's *Hussite Prayer* of 1836 depicted a historic rebellion against religious and political repression and became a *succès de scandale*.

The Düsseldorf Academy was very popular with young American artists. *The Sailor's Wedding*, painted by Richard Caton Woodville in 1852, is almost indistinguishable from a Biedermeier genre scene.

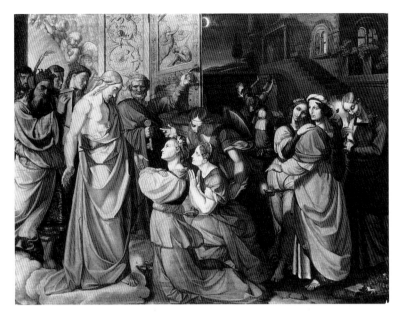

A strand of Romanticism quite distinct from the historical imaginings of the Nazarenes or Düsseldorf artists is exemplified by the work of Caspar David Friedrich in Dresden. Friedrich developed a visionary landscape style filled with religious symbolism. It is a dramatic world of ivy-clad Gothic ruins, blasted oak trees, lonely figures etched against moonlit skies and exotic natural phenomena such as glaciers and icebergs. Friedrich's brief moment of fame ran from around 1805 to 1815; poverty and a sense of persecution clouded his later years and his art was virtually forgotten until the Centennial Exhibition in 1906. But echoes of his style are found among the landscape painters who gathered in Salzburg around Ferdinand Olivier.

The Wise and Foolish Virgins (c.1815–19) by Peter Cornelius (above left) shows the influence of the late Renaissance stealing into German history painting. The accent on monumental composition reflects Cornelius's passionate interest in fresco painting.

Karl Friedrich Lessing concealed a contemporary political message in his 1836 painting *The Hussite Prayer* (above) – a vivid reminder of an historical rebellion against religious and political repression.

Caspar David Friedrich's *Man and Woman Gazing at the Moon* of 1824 (left) is a visionary image with a powerful spiritual content. Friedrich's work made an idiosyncratic and original contribution to German Romanticism.

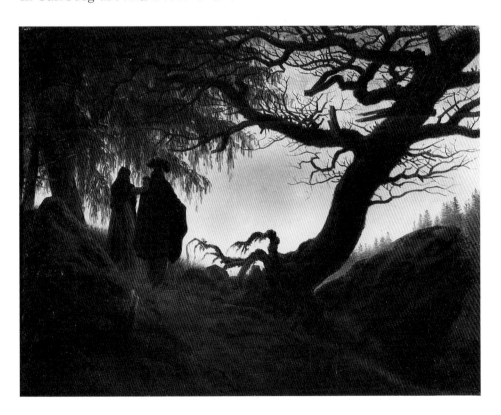

Biedermeier and Photography

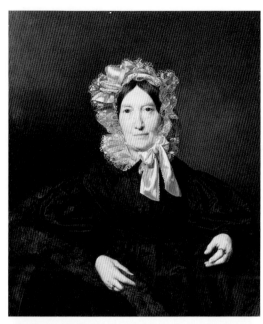

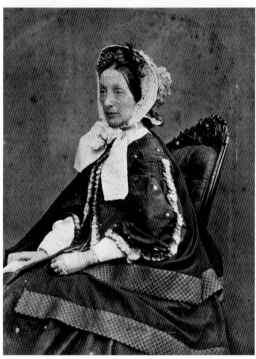

Ferdinand Georg Waldmüller's small portrait of a plain, aging lady, *Frau M. von Lerchenau*, in a beautiful bonnet (top) was painted in 1837. It is an historical record rather than a picture with a decorative purpose. A few decades later *The Hon Mrs Murcheson* (above) had a similar portrait made, this time by a photographer.

Photography was invented more or less simultaneously in France and England around 1830. Since the scientific phenomena which it harnesses had long been known and the *camera obscura* had been used by artists since the Renaissance, historians of photography often express surprise that it was not invented earlier. The explanation is probably cultural rather than scientific: the technique of producing photographic images evolved to satisfy a demand for images of this kind.

The Biedermeier age coincides with the invention of photography and close parallels can be drawn between the function of Biedermeier paintings and the function of photographic images. The problem of exact reproduction of detail was, of course, easily resolved by the camera. It is the parallels in subject matter that are more interesting.

Virtually every Biedermeier artist turned his hand to portrait painting because the demand was almost insatiable. These were not the grand ceremonial portraits characteristic of previous centuries but, in the main, a simple head, or head and shoulders, against a neutral background. They were likenesses of family and friends or of contemporary figures, commissioned out of affection for the sitter and valued in proportion to the realism with which he or she was depicted.

Portraits were generally of modest size to facilitate hanging and served the same purpose as family photographs. The central role that home and family played in the cultural life of the Biedermeier period helps explain the demand for them. A natural extension of the portrait – in painting, as in photography – is the family group. The purpose is again affectionate: to obtain a permanent record of a fleeting moment in family history.

Family groups are among the most charming and characteristic products of the Biedermeier period, sometimes carefully posed and sometimes capturing the informality of an ordinary scene in everyday life. Watercolours of unpeopled interiors had a vogue in the early years of the century and the notion that family furnishings and ornaments are in themselves historically interesting carries over to group portraits in family interiors.

A window opening on a landscape is also a common device, sometimes forming the background to a portrait and sometimes painted on its own account. A familiar landscape is, after all, as much a treasured memory as a face or room. For the same reason, the group portrait is sometimes posed outdoors, in a garden or landscape setting.

Yet another extension of the idea is the portrait in an occupational setting. The artist's studio, in particular, is a recurrent theme in Biedermeier painting, sometimes incorporating a self-portrait and sometimes other artists idling or at work.

Biedermeier paintings, like photographs, thus serve as tangible records of a specific place or time or, more generally, a style of life or landscape.

Specific records include, in addition to portraits, such memorable images as Krüger's *Parade on the Opernplatz* or Krafft's *Entry of Kaiser*

Franz I into Vienna after the Treaty of Paris, images, that is, of notable occasions. The town views of Eduard Gärtner or Domenico Quaglio, precise architectural records, fall into the same category.

Just as photographs can record an interesting scene in which the figures are unfamiliar, Biedermeier genre paintings record the flavour of contemporary life. Peasant and military scenes were particularly favoured. The former fed the town dweller's romantic yearning for rural life and the latter the peaceful citizen's perennial fascination with war.

As today, holidays at home or abroad led to a demand for realistically treated landscapes as souvenirs. The German artists resident in Rome, or studying there for a period, found a ready market among visitors for Italian views and idealized scenes of Italian peasant life.

Another instance of art as the precursor of photography is the landscape sketch. Valenciennes had recommended sketching from nature as a regular practice for landscape artists to provide the components from which studio pictures could be composed. He cautioned that not more than two hours at most should be spent on a sketch, because of the change in light.

The aim of these sketches was to catch instantaneously the look of a tract of landscape at a specific time of day. Artists throughout Europe followed Valenciennes' advice and have left us a wealth of rapidly executed vistas recording effects of light, a type of sketch which is found so abundantly at no other period. This striving to record rapidly changing effects of light was to be mechanically resolved by photography.

Photography is now so much a part of our lives that we take it for granted. It is curious to reflect that the citizens of the Biedermeier age were the first to demand from their artists an objective record of the world around them without ornamental, spiritual or didactic overtones. For later generations this demand has been met by photographers to the point of satiety but our familiarity with such images helps us to appreciate all the more readily the artistry of Biedermeier painters.

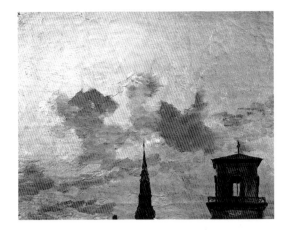

For Johan Christian Dahl (top), towers and spires against the sky were a stimulus to painterly experiment in his abiding search for Realism. A few decades later Charles Marville (above) resolved the problem of recording textures and atmosphere by using a camera.

VIENNA

VIENNA was the capital of an empire and the most important city of the Germanic world. Painting had flourished there in the eighteenth century and this had two important effects on the Biedermeier period.

In the first place, the schooling provided by the Vienna Academy was superior to that offered in any of the smaller German towns. Even in Berlin, Biedermeier painting can be stiff and naive, but the Austrian painters have a fluent mastery of their medium.

Secondly, Baroque composition, Baroque elegance, and sweeping Baroque brushwork – in the Rubens rather than the Poussin tradition – spilled over from the eighteenth into the nineteenth century. Ferdinand Georg Waldmüller's group portrait of the Eltz family (see p. 61) or Friedrich von Amerling's of the Arthabers (see p. 31) are ornamental rather than naturalistic compositions: the Eltz family are much too richly dressed for the country picnic they are supposed to be enjoying. Strong brushwork echoing the Baroque tradition can be seen in the work of Amerling as well as in that of the leading genre painters: Josef Danhauser, Peter Fendi and Carl Schindler.

Although the subject matter of these painters belongs to the Biedermeier period, the approach retains a Baroque panache. This is particularly evident in flower paintings, where the Baroque tradition survived almost unchanged into the Biedermeier period. The only variants introduced by the flower painters Joseph Nigg and Franz Petter are landscape backgrounds and, on occasion, the substitution of wild flowers for garden blossoms.

Flowers as a decorative element were almost a signature tune of Biedermeier culture, on bookplates, valentine cards, textiles, embroidery and porcelains, yet Vienna was the only centre where still lives of flowers were painted extensively in oils. The academy had a professor of flower painting and the tradition was additionally supported by the art school attached to the Vienna porcelain factory.

Vienna was also exceptional in nurturing a school of imaginative genre painting. Portrait groups treated in the manner of genre are a ubiquitous and typical feature of the Biedermeier period but imaginary scenes telling a story or pointing a moral are rare. They were to find popularity later in the century.

The Viennese genre school has Johann Peter Krafft as its founding father. His three monumental wall paintings for the Imperial Chancellery depicting scenes from the life of the Emperor Franz I contain brilliant genre studies of the emperor's subjects. Danhauser, Fendi, Schindler and Friedrich Treml went on to paint imaginary scenes of contemporary life whose affecting subject matter is suggested by titles such as *The Poor Officer's Widow* or *The Reading of the Will*.

All of these painters were equally at home painting real Viennese interiors in the manner of genre. Danhauser's *Liszt at the Grand Piano* shows a group of enraptured friends gathered round the composer while Fendi's *Evening Prayers* (see p. 34) depicts Archduchess Sophie and her children in a room pleasingly littered with recently abandoned toys. One of the little boys is the future emperor Franz Joseph, but the scene could have been painted in any middle-class home of the Biedermeier period. It serves to underline the way in which the middle-class ethos had spread to include the court and aristocracy.

Austrian landscape painting arrived at Realism via religious mysticism. Salzburg and the Salzkammergut was the area where artists gathered to sketch from nature. The first to work there were Ferdinand Olivier and his brother Friedrich. Ferdinand had studied in Dresden and he admired the religious symbolism of Caspar David Friedrich's art; in Vienna he had been encouraged by Koch to imbue his landscapes with a poetry that went beyond naturalism. But above all he was influenced by Friedrich Schlegel, the Romantic writer who interpreted the religious inspiration of medieval art for the painters of his day.

Ferdinand Olivier's Salzburg views are dense with carefully delineated detail; for him God's spirit was immanent in the smallest particle of creation. For the artists who followed him to Salzburg, attention to detail became part of a Realist endeavour to give a faithful and objective rendering of nature. They included Felix Steinfeld, Heinrich Reinhold, Friedrich Loos and Ferdinand Georg Waldmüller.

Waldmüller is the most universal genius of Austrian Biedermeier. Having begun his career as a miniature painter, he graduated to full-size portraits, took up landscape painting in the 1830s and moved on to genre scenes of peasant life in landscape settings at the close of his career. He was a passionate propagandist of Realism; his attempt to direct the academy's teaching towards Realist principles led to his temporary dismissal as a professor. He shared with his Viennese contemporaries an interpretation of Realism as painstaking attention to detail.

Waldmüller's greatest achievements lie in portraiture and landscape painting and, occasionally, in their combination. His contemporary Friedrich Gauermann painted peasant life in a landscape setting in a Realist, though anecdotal, vein. He was noted as an animal painter and enjoyed one of the highest artistic reputations of his time.

Jakob Alt
1789–1872

View from the Artist's Studio, 1836

THE ARTIST has pushed back his chair and left the table where he has been working on a watercolour of the view from the window. The glass of water, already pink with paint, awaits his return. By depicting not only the view itself but also the corner of the studio, the artist insists that the viewer share his own intimate perception of the scene.

The carefully painted landscape reveals the artist's pleasure in looking out at it. Alt was living on the outskirts of Vienna near Dornbach at the time. There is a long white house across the road and a dense little wood, beyond which, sparkling in sunlight, are the distant roofs of a village and the foothills of the Wienerwald. The sky is filled with luminous clouds.

Painting a view out of a window was a device used quite frequently by artists of the Biedermeier period. It suited the Realist spirit of the age to combine a faithful rendering of the view with an evocation of the vantage point from which the artist was seeing it. As a result, the open landscape is captured, enclosed and tamed within the bourgeois ethos of the room.

Jakob Alt was a Viennese landscape painter, watercolourist and lithographer. He studied at the Vienna Academy from 1811 but was largely self-taught as a landscapist. Stylistically he belongs to the first generation of Realists who sought to give a faithful record of nature through carefully realized detail and high finish. His son Rudolf (1812–1905) is considered the most distinguished Viennese watercolourist of the century and developed a loose, impressionistic style.

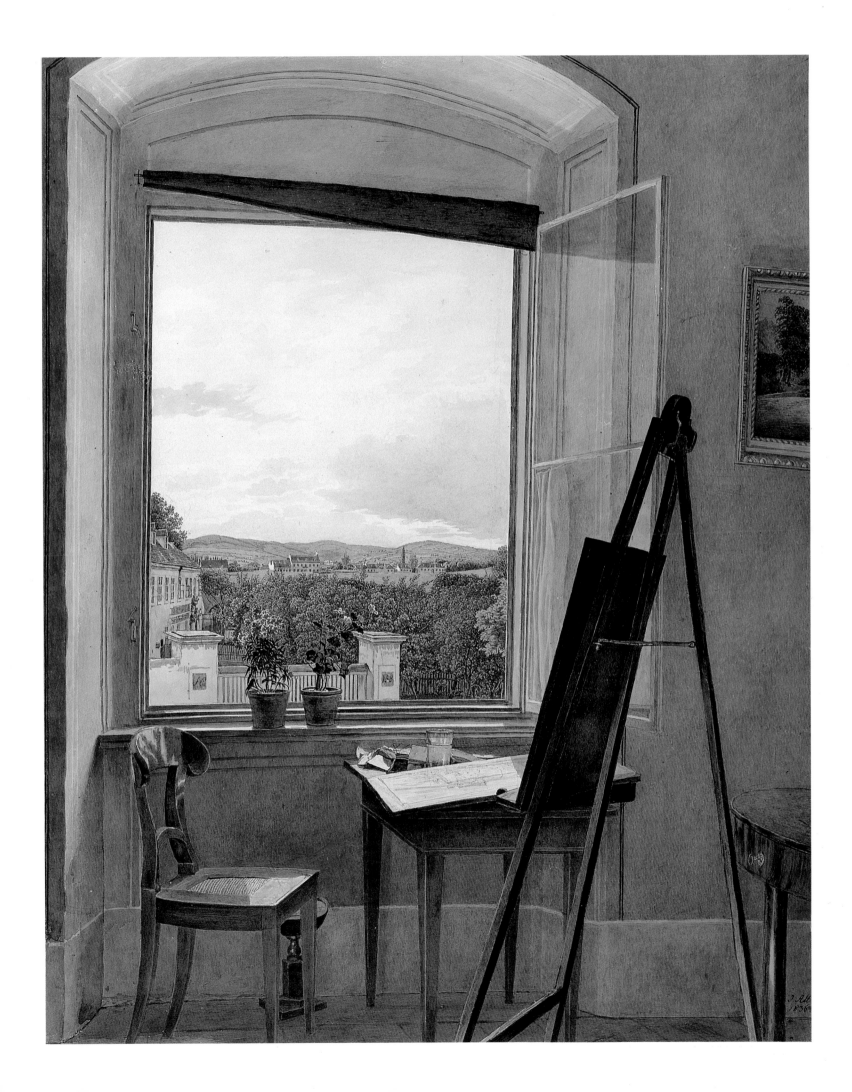

Friedrich von Amerling

1803–87

Rudolf von Arthaber with his Children, 1837

RUDOLF VON ARTHABER is pictured with his three children, gazing at a portrait of his dead wife which the youngest child has propped on his knee. Only the little girl, with her smart straw hat with yellow ribbons and her favourite doll, has let her attention wander from her mother's image. Despite the melancholy focus, the children give the picture a cheerful impact. This is enhanced by Amerling's loving attention to still-life details such as the colourful rug on the table, the arum lily, a discarded racquet on the floor and the open picture books abandoned in the corner of the sofa.

Arthaber was a wealthy textile manufacturer and exporter who was also a keen art collector. He owned nine works by Amerling, Austria's most acclaimed portraitist of the nineteenth century.

Amerling combined a rich use of colour, bravura brushwork, an eye for ornamental composition and a gift for catching a telling likeness. This famous family group was painted when he was thirty-three; he had achieved his first major success four years before with a specially commissioned portrait of Kaiser Franz seated on the throne in his imperial robes.

After studying at the Vienna Academy, Amerling sought out Sir Thomas Lawrence in London and was allowed to copy in his studio; in Paris he worked with Horace Vernet. The dashing brushwork of the former and the cool classical composition of the latter were pronounced influences on Amerling's art and can be traced in the Arthaber portrait.

That the portrait group could pass equally well as a genre painting in its own right is very characteristic of the Biedermeier period.

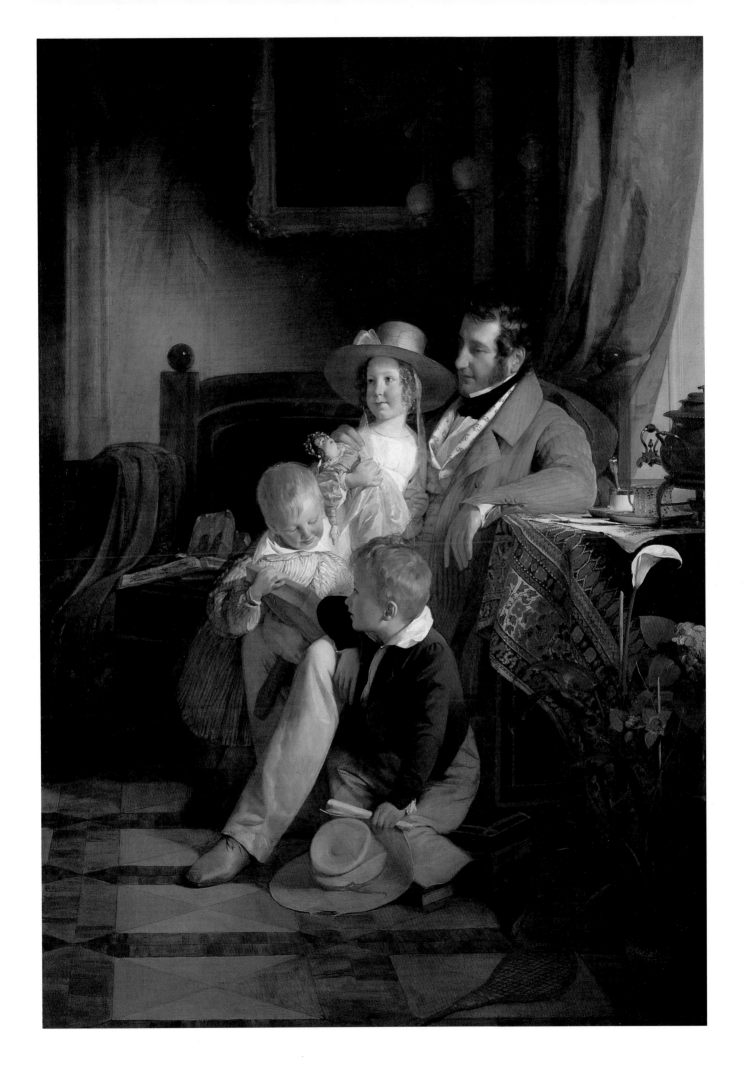

Josef Danhauser
1805–45
The Reading of the Will, 1839

THE PASSIONS aroused by the inheritance of a fortune – or the failure to inherit one – are played out in a theatrical manner in this canvas. On the right a red-eyed lady allows herself a trembling smile of delight while her relations to the left of the notary show anger and disappointment.

Danhauser was the founding father of Viennese genre painting, treating the way of life of the well-to-do in a moralizing vein, especially in a strong series of paintings executed in the late 1830s of which this is the most famous example. He went beyond mere sentiment to a sharp critique of the hardhearted ways and wasteful lifestyle of the rich.

This picture focuses on a treasure chest with a bright red lining, full of gold coins and bundles of notes. It provides the only flash of colour in a group rendered sombre by the participants' mourning wear. In the foreground are a broken globe, books, a telescope and an overturned inkwell, evidence of a disregard for scholarship on the part of the deceased's relations. Money is their only interest.

Danhauser was himself brought up in a rich middle-class milieu. His father ran a cabinet-making firm and played an important role in adapting and simplifying the French Empire style into what has become known as Biedermeier. After his father's death in 1830 the firm passed into Danhauser's hands and he contributed a Baroque element to new designs.

Danhauser studied at the Vienna Academy under Peter Krafft, whose genre-style renderings of contemporary events were a formative influence. A visit to Venice gave him a profound admiration for Titian and the Venetian colourists which led on to an admiration of Rubens and Van Dyck. He achieved a painterly verve which was foreign to the Viennese classicism of his day.

Danhauser also owed a debt to the colourists of the British school. This painting, in particular, was inspired by Wilkie's *The Reading of the Will* which Ludwig I of Bavaria had bought in 1826 and whose exhibition in Munich created enormous enthusiasm and stimulated a new generation of genre painters.

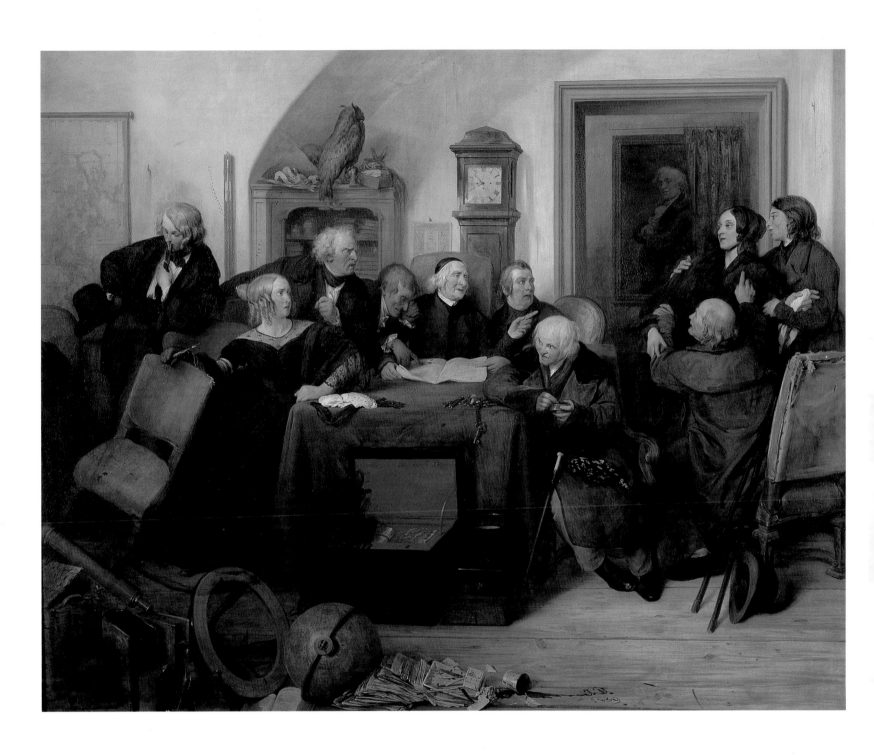

Peter Fendi
1796–1842
Evening Prayers, 1839

The Poor Officer's Widow, 1836

FENDI was one of Vienna's most popular painters, specializing in sentimental genre scenes of working-class life and depictions of comfortable middle-class families in their own surroundings.

He himself had every reason to identify with the struggles of the poor. His schoolteacher father died when Fendi was eighteen and for a while he was forced to give up his artistic studies to support his mother and family by working as a clerk. Commissions to draw the antiquities in various Viennese collections in his spare time brought his talent to the notice of the keeper of the Imperial Medal and Antiquity Collection. At twenty-two he was appointed official draughtsman to the collection, a post which introduced him to the highest circles of Viennese society.

It was in the 1830s that his watercolour interiors became popular. *Evening Prayers* is typical of his relaxed little scenes of family life, dwelling lovingly on furnishings as well as on the family itself. The litter of toys shows that the children have just been at play in this elegant but comfortable interior. Now their young mother has persuaded them to kneel down and say their prayers before going to bed. The painting contains many themes beloved of the Biedermeier bourgeoisie: mother love, childhood, piety and the intimacy of home life.

But this is no simple genre painting. It depicts the Habsburg Archduchess Sophie and her four children. Sophie was married to the emperor's youngest son Franz but, because of a number of deaths, the succession fell on the eldest of these blond boys, Franz Joseph. The second son, Maximilian, who kneels in front of the cross with his sister Maria Anna, was briefly created Emperor of Mexico; his execution by a firing squad is depicted in a famous painting by Manet.

Scenes of family life presented in the manner of genre paintings but containing a series of individual portraits were characteristic of the period and were particularly favoured in Vienna. Even the royal family desired its simple, virtuous home life to be recorded. It is an image of royalty that would have been unthinkable in any other period.

Fendi's accurate drawing is embellished with transparent colour washes; the combination of chocolate brown, dark blue, olive green and orange is characteristic of his watercolours.

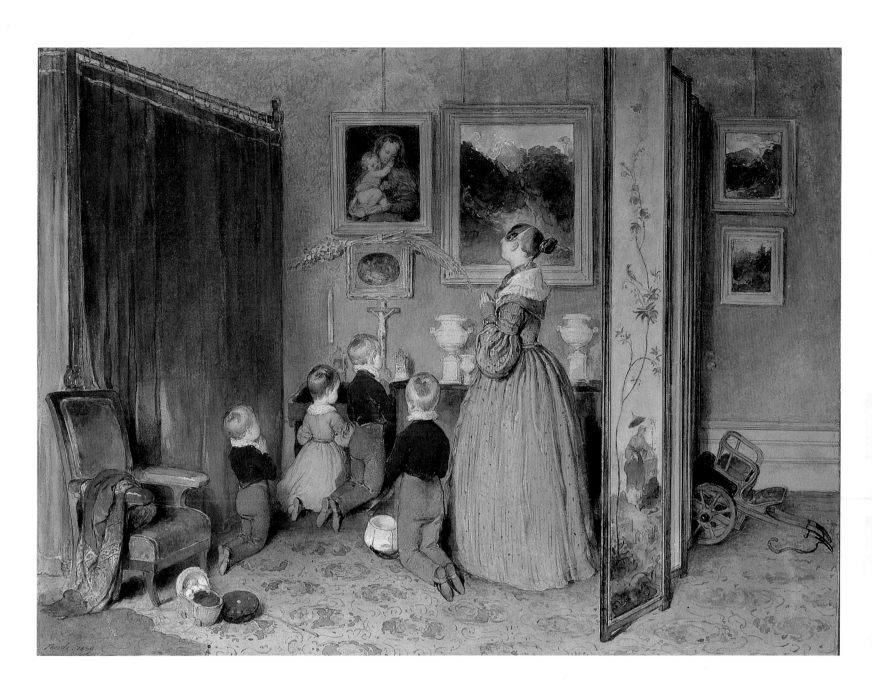

In *The Poor Officer's Widow*, the cashmere shawl which the little widow wears over her shoulders speaks of happier days and gives Fendi the opportunity to introduce a sparkle of colour into this sombre scene. The pots on the table by the window provide another opportunity, introducing a rich brown, a blue-green and a clear blue stripe on a white ground.

The widow in her garret with the two sleeping children has her husband's army greatcoat over her knees. On it she has spread a letter from him and an open case containing his portrait miniature. Miniature painting was a flourishing trade in Biedermeier Vienna, to which Fendi himself turned his hand.

Tearful sentiment was a characteristic of his genre scenes, never overstated but brought close to home by domestic details like the girl's shoes, the washing drying in the window and the overflowing workbox. The portrayal of the poor widow's struggle for survival shows a stirring of social conscience which looks forward to the 1848 revolution.

Children feature prominently in Biedermeier paintings and the sensitivity with which Fendi caught their gestures and character contributed to his popularity as both a genre painter and a portraitist. Child portraiture was already popular in the eighteenth century but treated in much the same manner as adult portraiture. Fendi and other artists of the Biedermeier era, in contrast, entered wholeheartedly into the reality of the child's world. The sleeping girl and the baby are treated here with direct realism.

The strength of Fendi's draughtsmanship carries over into his oil paintings, showing in the confidence of his contours and modelling as well as in the rendering of fine detail. The many years that he had spent in the employ of the Imperial family and other connoisseur-aristocrats, making careful drawings from their collections of antique vases and sculptures, gave him this exceptional mastery of line drawing.

He was admired as much by his fellow artists as by his aristocratic patrons. In his later years he was an influential teacher, taking great pains with his pupils. Both Carl Schindler and Friedrich Treml profited from his instruction.

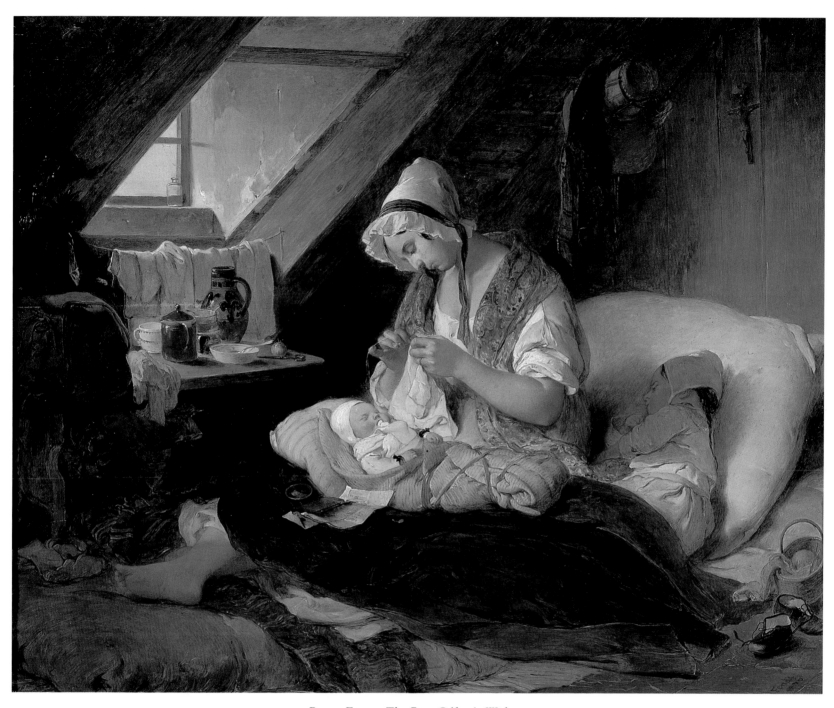

PETER FENDI. *The Poor Officer's Widow*

Friedrich Gauermann
1807–62

White Fallow Deer and Doe in a Mountain Landscape, 1833

Landscape near Miesenbach, c.1830

Meadow Flowers, c.1835

GAUERMANN'S fame in Austria as an animal painter was equivalent to that of Landseer in England, while his alpine landscapes and rustic genre paintings also achieved wide popular acclaim. He enjoyed the patronage of Metternich, the Imperial Chancellor, the imperial family and the aristocracy. There was a large market in prints after his paintings.

The prints could be found in every modest home in the mid-nineteenth century and were mainly of such poor quality that they turned the succeeding generation against his work. His reputation was not restored until the early twentieth century, when his brilliant sketches and nature studies were rediscovered.

Gauermann's father Jakob was a landscape painter and engraver of good reputation who divided his time between Vienna and a small estate in the mountains near Miesenbach. He impressed on his son at an early age the importance of studying from nature and making a record of what pleased him 'not only in his sketchbook but also in his soul'.

As a child Gauermann wandered the high mountains around their home at Miesenbach, sketching landscape, figures and animals. He went out with hunting parties, sketchbook in hand, and in later years kept his own menagerie to work from. He studied at the Vienna Academy from 1824 to 1827 and taught himself by copying Dutch seventeenth-century masters.

White Fallow Deer and Doe in a Mountain Landscape could be dubbed the Austrian equivalent of Landseer's *Monarch of the Glen*. The deer with his fine antlers guards his doe on their craggy perch in the high mountains. The painting conveys the animal's mastery of the wild terrain of precipices and dark forests. The clouds of an approaching storm and a shaft of sunlight glancing over the lonely figures heighten the grandeur of the scene.

Gauermann liked to paint his animals in the wild – deer on the mountain top or wild boars fighting in the forest. The animal paintings of Rubens, Snyders, Riedinger and others were much in vogue at the time and provided his inspiration. He belonged, however, to the Realist generation. The objective representation of reality, whether landscape or the animal kingdom, was his first preoccupation.

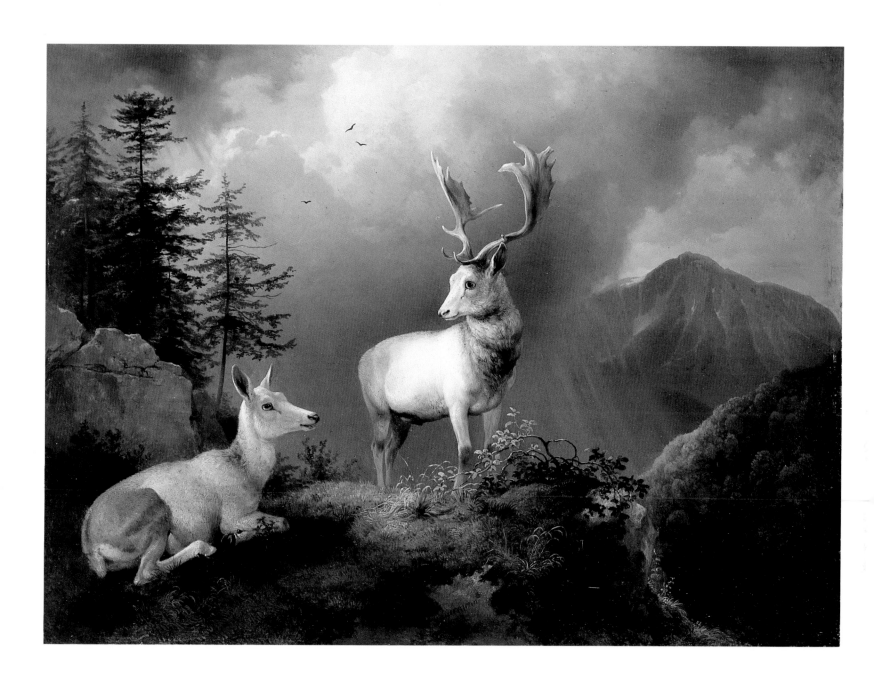

His accurate observation of nature and his delight in rendering its moods are demonstrated in his *Landscape near Miesenbach*. The high alpine pasture dotted with trees opens out of the forest while the eye is led on to tree clad peaks in the distance. Gauermann concentrates on rendering the variety of shades of green which constitute the intrinsic glory of this quiet vista. The virulent yellow green of the fertile pasture faithfully follows nature and eschews any artificial adjustment aimed at 'artistic' colour harmonies. The pine forests are dark with flecks of brown while the foliage of the deciduous trees is differentiated with tones of blue, grey and yellow. The dappling play of sunlight accentuates the variety of tones.

Gauermann was in his early twenties when he painted this picture, a brilliant young artist enjoying the first flush of popular success. Metternich had bought one of his first alpine landscapes, exhibited in Vienna in 1826.

Gauermann had a special affinity with this view, close to his father's small agricultural estate at Miesenbach which he eventually inherited and made his home. Although he found the responsibilities of a farmer a serious interruption to his artistic activities, his close working relationship with the countryside gave him an intimate understanding of the plant and animal kingdom which enhances the impact of his paintings.

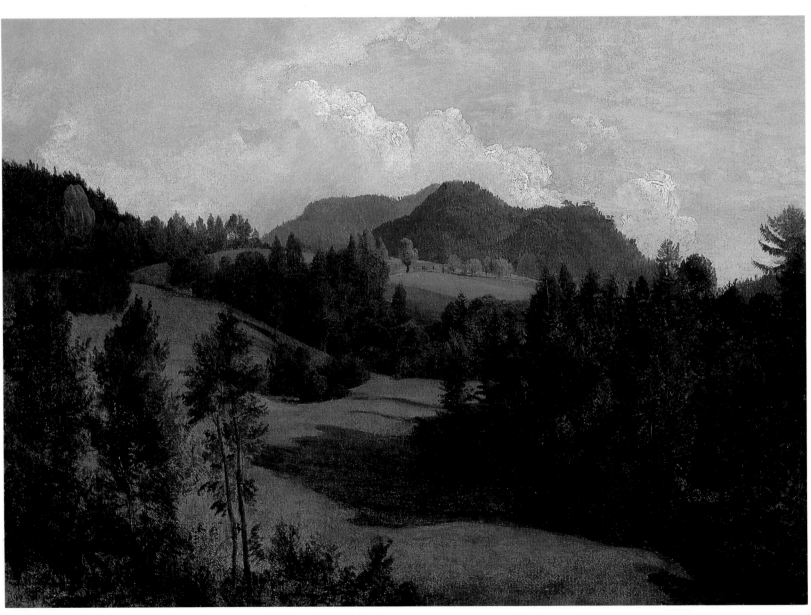

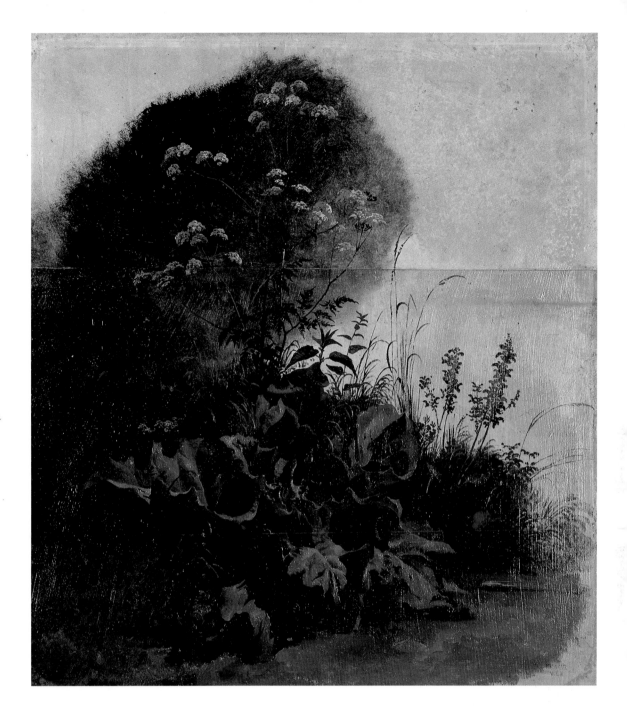

FRIEDRICH GAUERMANN.
Landscape near Miesenbach

FRIEDRICH GAUERMANN.
Meadow Flowers

When he turned his hand to an oil sketch of *Meadow Flowers* in the mid-1830s, he was clearly familiar with each plant. The sketch is unfinished but he has begun to put in a dark background to set off the clustered white flowers of a tall hemlock plant. In the foreground purple spikes of meadow sage and straggling summer grasses show brightly against the white, unpainted background.

Gauermann amassed an enormous volume of sketches, some, like this one, executed in oils, others made in pencil and wash on paper. They were the source material from which he composed his paintings and he refused permission for their reproduction in his lifetime. They remained wholly unknown to the public until they were auctioned by his family after his death. The series of sketches begins in his childhood and stretches over his entire life. The sheer quantity demonstrates how assiduously he studied from nature. Their remarkable quality led to a major reassessment of his reputation in the early years of the twentieth century.

Johann Peter Krafft
1780–1856
Kaiser Franz Giving a Public Audience, 1836–37

KAISER FRANZ gave an open audience on Wednesday mornings to members of the public who wished to see him. On this occasion a young widow and her children are the centre of attention. The Emperor holds her petition in one hand while he motions her to rise from her knees with the other, eagerly watched by a miscellany of citizens.

It is a highly finished preparatory sketch for one of three paintings commissioned by the widowed Empress after the death of Kaiser Franz in 1835. They were designed to show how close the paternalistic ruler was to his subjects. The other two depict *Kaiser Franz Escorting a Poor Man's Coffin* and *Kaiser Franz Ferrying a Man across the Laxenburg Lake.*

Krafft combined history painting with the depiction of notable contemporary events, particularly scenes from the Napoleonic campaigns and from the life of the imperial family. Romantic, patriotic and packed with charming genre-style detail, these pictures proved very popular. They were the chief inspiration of the Viennese genre painters of the succeeding generation.

He studied at the drawing school in Hanau and the Vienna Academy before leaving in 1801 for Paris, where he worked with David and was profoundly influenced by the heroic contemporary scenes depicted by David, Gérard and Gros.

He was much in demand as a portrait painter but scored his first major success in 1813 with *A Militiaman's Farewell*, a poignant life-size depiction of a soldier bidding goodbye to his family. Between 1826 and 1835 he executed three monumental wall paintings for the Imperial Chancellery showing scenes from the life of Kaiser Franz. He taught at the Vienna Academy from 1823 and was appointed director of the Imperial Picture Gallery in the Belvedere in 1828.

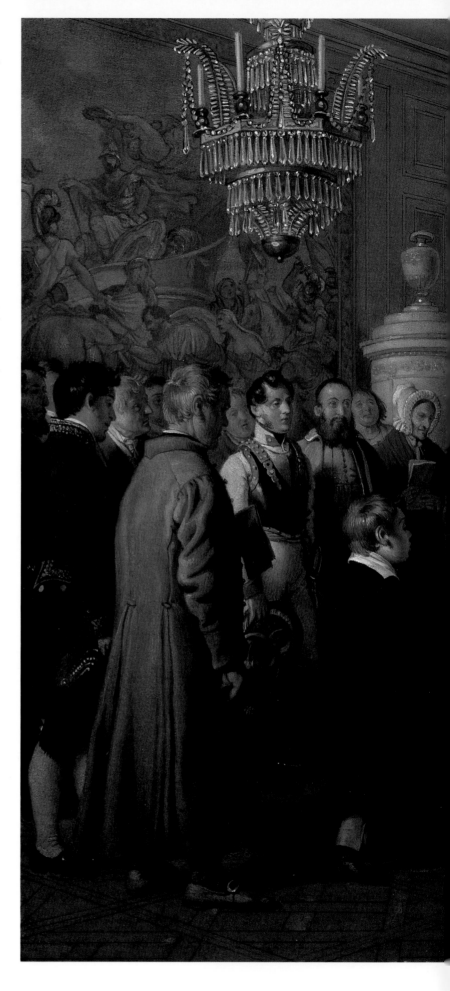

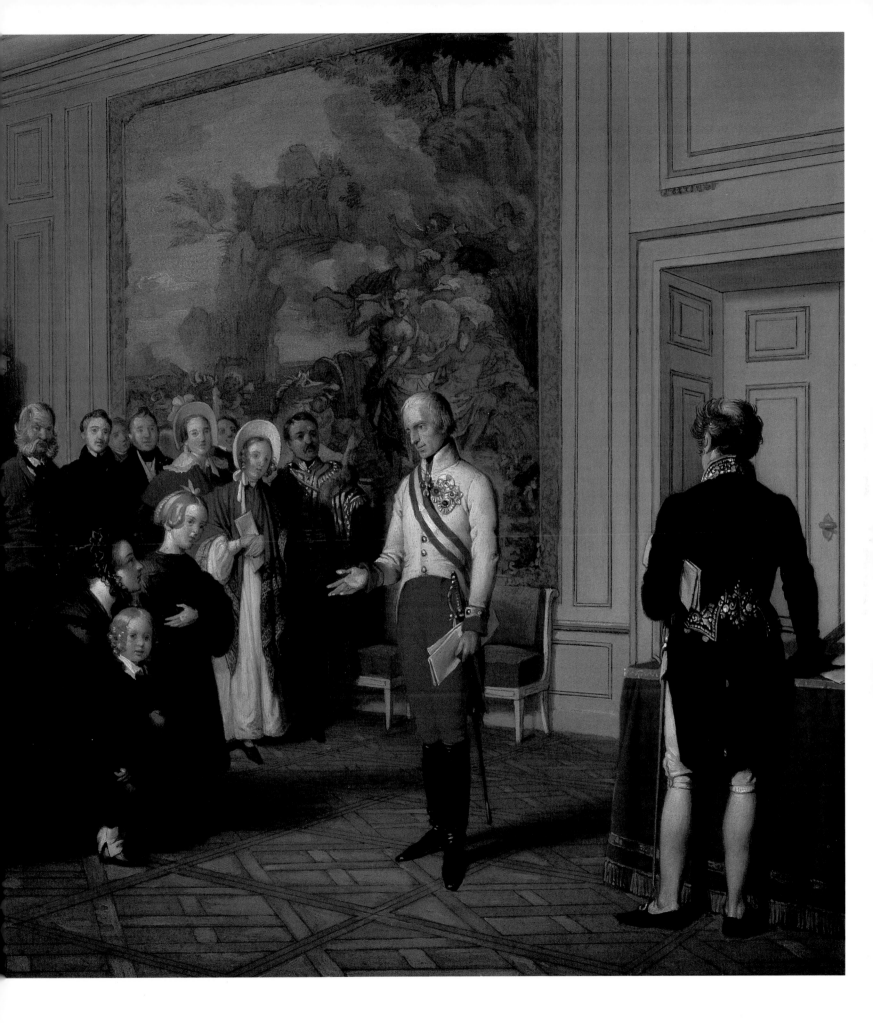

Johann Michael Neder
1807–82
Family Portrait, 1836

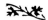

FRANZ JÄGER, a successful Viennese builder, is portrayed with his wife and two stepchildren. The intention is to depict an informal domestic interior: the stepdaughter is about to pour coffee and the little boy is shown to be more interested in the parrot that has been taken out of its cage to sit on his stepfather's hand than in posing for a painting. Yet the figures are as stiff as those of any latter-day family photograph.

Neder was a close friend of the Jägers; their artificial poses and glazed looks suggest that they sat for him, uncomfortably still, for a very long time.

The result, however, is a work of outstanding charm, stemming partly from the lively likenesses of the sitters, who can be recognized as real characters, and partly from the celebration of their smart possessions. It is a portrait not only of a family but also of a home. The parquet floor is lovingly and exactly rendered, as is the well polished mahogany table in the latest Biedermeier style, a simplified version of French Empire.

A statue of a cupid dominates the left of the painting while an ormolu figure sits in contemplation under a glass dome to the right. For the boy, the parrot is clearly a prized possession: its colouring echoes the mother's fashionable green gown and the yellow bows in her muslin cap.

The Viennese were proud of their homes and liked to have their interiors painted at this period. The elegance of the group is also characteristic of Vienna. Neder shows himself an able exponent of the Viennese style although, doubtful of his artistic ability, he also worked as a shoemaker.

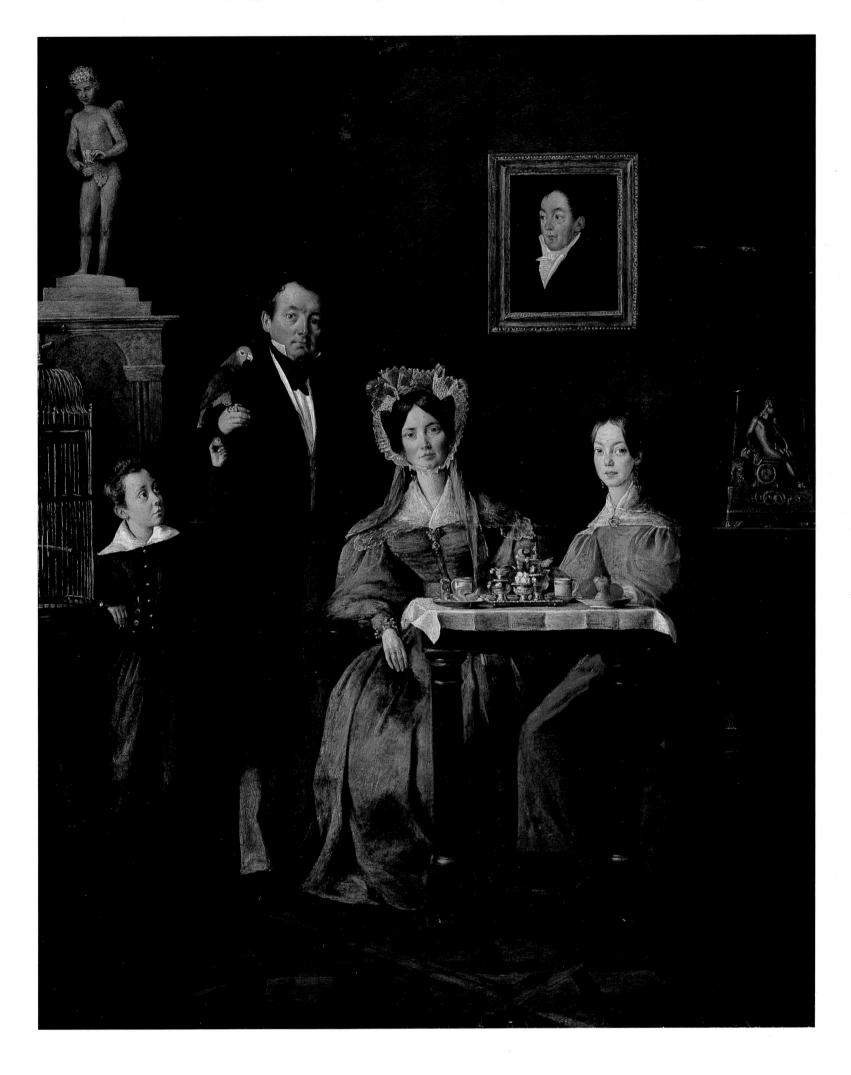

Joseph Nigg
1782–1863
Bowl of Flowers in a Landscape, 1845

A MAGNIFICENT ARRANGEMENT of flowers and fruit on a small stone pedestal has attracted the attention of a guinea pig and butterflies. The tree behind and the landscape setting demonstrate that this is a flight of fancy, purely decorative in its intention. The elegantly curling prickly leaves in the right hand of the picture are enhanced by a blue butterfly.

Flower painting had flourished in Vienna throughout the eighteenth century, emulating the work of Dutch seventeenth-century artists but adding a Baroque exuberance. The tradition continued into the nineteenth century with few stylistic changes.

Flower pictures in a landscape setting are, however, a characteristic feature of the Biedermeier period. Sometimes the flowers are growing naturally but in unnatural profusion and sometimes a bouquet is unnaturally exposed.

The Biedermeier middle classes were keen gardeners and took a new scientific interest in botany. They were sentimentally attached to the language of flowers. Flower paintings were popular. Special classes in flower painting were held at the Vienna Academy, which also had a professor specializing in the field. Johann Baptist Drechsler was professor when Nigg was a student.

Nigg later directed the flower painting school at the Vienna porcelain factory. He decorated porcelain himself and his flower paintings on picture-sized porcelain plaques were highly regarded. In the decorative, as opposed to botanic, field he was the leading Viennese flower painter of his day.

Ferdinand Olivier

1785–1841

Landscape in the Campagna with Monte Soracte,
c.1830

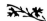

THREE ITALIAN PEASANTS rest on a bank. Framed by trees, the rolling hills of the *campagna* stretch into the distance crowned by the peak of Monte Soracte, a familiar landmark north of Rome.

The mood is peaceful with a poetic play of sun and shade and a wispy tree in the middle distance reminiscent of Perugino, the fifteenth-century master. This is not a Realist landscape painting but a romantic idealization of landscape, suggesting the parallels between pastoral Italy and the Garden of Eden before the Fall.

Ferdinand Olivier never visited Italy but he painted many views like this one using other artists' drawings. This painting was executed after a drawing by his brother Friedrich and has often mistakenly been ascribed to him.

The two brothers, both landscape painters, had strong links with the Romantics but helped to found the Realist school of landscape painting in Austria. Born in Dessau, Ferdinand began his artistic education there. He spent the years 1804 to 1806 in Dresden, where he met the mystic landscapist Caspar David Friedrich.

Ferdinand moved to Vienna in 1811 and learned from Koch that landscape should not be mere naturalistic copying but should contain 'meaning and poetic ideas'. He was a friend of the Nazarene artists before they left for Rome and he shared their religious inspiration.

In 1815, he and his brother Friedrich discovered the Salzburg landscape, producing very careful paintings and drawings which expressed their admiration of God's hand in every detail of nature. Ferdinand's dense ink drawings are particularly remarkable. Other artists joined them, sketching and painting in the countryside around Salzburg and emulating the Oliviers' attention to detail, though not their spiritual approach. Thus a Realist school of Austrian landscape painting was born.

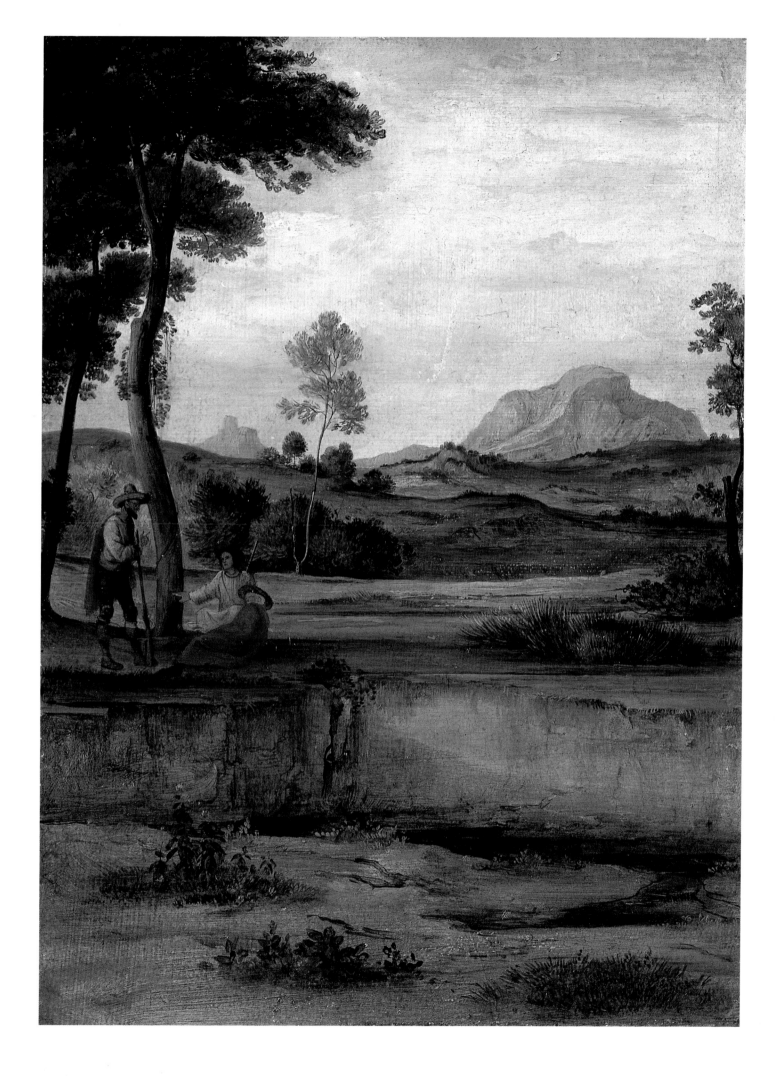

Franz Xaver Petter
1791–1866
Woodland Flowers, 1860

WITH A FINE DISREGARD for their proper season, Petter combines gentians, cyclamen, lilies, fox-gloves and columbine while a strawberry plant simultaneously bears flower and fruit in the foreground. The riot of carefully depicted flowers and foliage is in the best tradition of Austrian flower painting, but instead of placing his blossoms in a vase Petter shows them growing naturally beneath a pine tree in a mountain landscape.

An enthusiasm for walking tours in the mountains, combined with a scientific interest in botany, gave the Biedermeier generation a special interest in wild flowers. This is reflected in Petter's choice of woodland rather than garden flowers and in the landscape setting, while the blossoms' impossible profusion makes clear his purely decorative aim.

Petter made a career out of flower and still-life painting, a field of art that was taken seriously in Vienna. He studied with Johann Baptist Drechsler, the professor of flower painting at the Vienna Academy, and from 1814 was himself a teacher of flower drawing. In 1832 he began to teach at the special art school attached to the Vienna porcelain factory and in 1835 became its director.

His work was very popular with the aristocracy and his flower paintings can still be found in many Austrian castles.

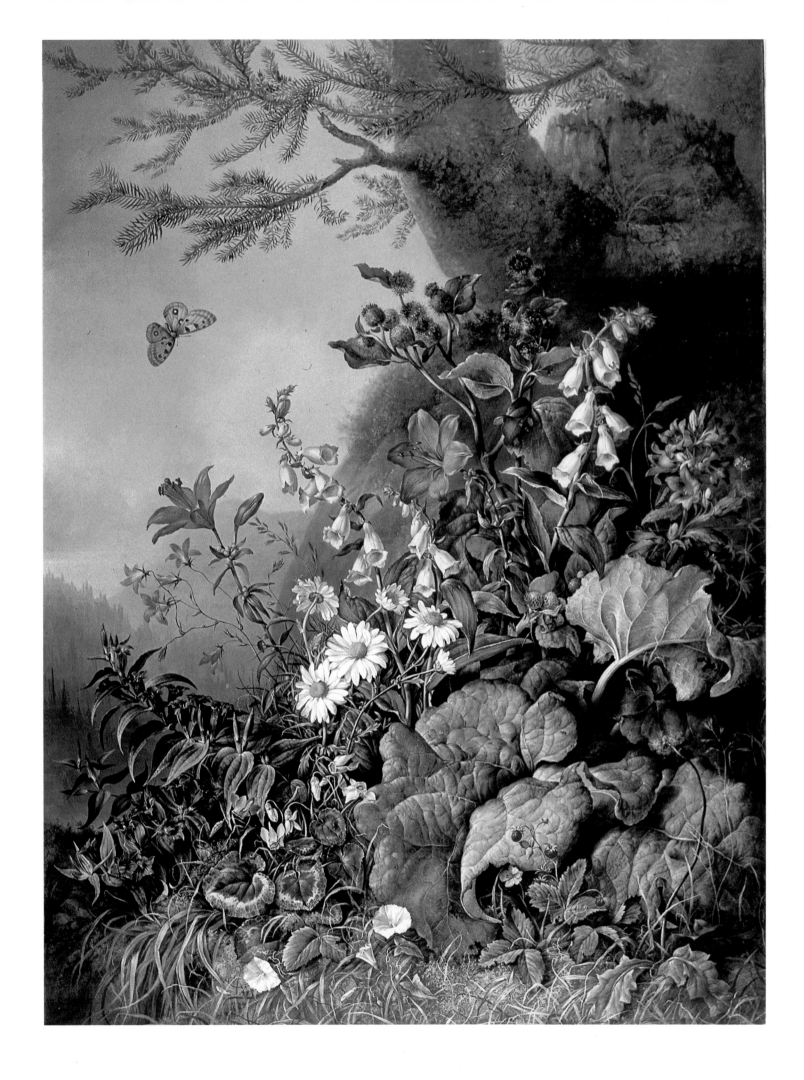

Carl Schindler

1821–42

The Sentry's Call to Arms, 1839

THE EXQUISITELY turned out soldiers in their primrose coloured jackets and blue trousers, each equipped with a curling moustache and a bayonet, come tumbling out of the guard house at the sentry's call. Through the arch to the right a team of grey horses drawing an invisible carriage can be glimpsed in the distance. Presumably the soldiers are hurrying to present arms as the Emperor or some person of major importance passes.

Schindler enjoys the strategic unimportance of this military manoeuvre and highlights its humour by placing in the foreground two ragged children who stand respectfully admiring the grandeur of the sentry.

The small painting in oils on paper has a freedom of brushwork unusual in the Biedermeier period when high finish was the rule. Schindler worked extensively in watercolour and his fast, impressionistic brushwork in that medium carries over into his oils to good effect.

Military subjects were his passion and earned him the nickname 'Soldatenschindler'. He was chiefly inspired by French lithographs, celebrations of Napoleon's campaigns from the hands of such artists as Charlet, Raffet and Eugène Lami, all of whom drew and painted with the approximative verve of the Romantic school, disdaining the high finish of the classicists.

The son of a drawing master, Schindler was only fourteen when he first attended the Vienna Academy. He gave it up after a few months and worked instead with Peter Fendi, a gifted genre painter. Schindler died at twenty-one, leaving a large number of fine watercolours, some lithographs and a small group of oil paintings. He was eighteen when he painted this picture.

Adalbert Stifter
1805–68
The Königsee and the Watzmann, 1837

THE WATZMANN is a famous mountain near Salzburg. Stifter's view of it concentrates on the play of reflections in the lake below, the green and brown of the mountainside, the bright blue sky and scudding white clouds. The rocky precipices and flashes of snow add to the grandeur of the scene, but Stifter takes just as much care with the rendering of stones under the clear water in the foreground. The shallow water shades from green to brown over the rocks.

Stifter achieved fame as a poet and novelist, rather than as an artist. He liked to depict nature, in words and paint, in its positive aspect, serene and harmonious. His philosophy was based on a 'gentle law' of nature which saw the manifestation of greatness in little things. The loving care that he has expended on foreground detail in this picture exemplifies this approach.

Apart from learning to draw at school, he was entirely self-taught as an artist. He studied law, mathematics, physics and astronomy at the University of Vienna and earned his living as a tutor while he started to write.

The years around 1840 were particularly productive for Stifter as both a poet and a landscape painter. The first volume of his *Studien* (Collected Poems) was published in 1844. He exhibited landscapes at the Vienna Academy in 1839, 1840 and 1842. His painting was, however, little known in his lifetime. During the period he lived in Vienna (1826–48) he made bright impressionistic sketches of landscape and townscape. After moving to Linz he produced landscapes of mood with titles such as *Movement* and *Rest*. His brightly coloured landscape sketches have been seen as forerunners of Impressionism.

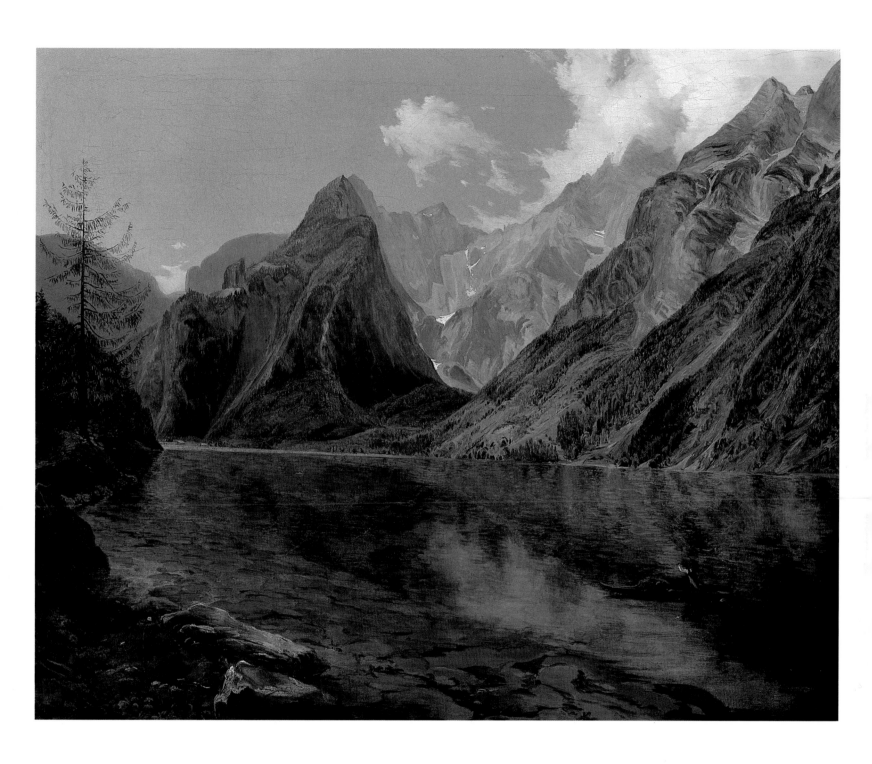

Johann Friedrich Treml

1816–52

Wounded Cuirassier in a Hay Loft, c.1840

THE CUIRASSIER with a magnificent curling military moustache has bound his wounded head with a blue handkerchief and taken refuge in a hay loft. He has been asleep and now looks out of the window in amazement at a furious battle raging outside.

Treml suggests the soldier's doubt as to whether the battle is reality or a dream. The ferocious onslaught is painted without much colour and more sketchily than the foreground; it may be intended as a dream. The cuirassier himself, his handsome uniform and the hay are painted with realistic detail and high finish.

It is a little picture in the best tradition of Viennese genre painting. Treml studied at the Vienna Academy and was among the group of painters who received private tuition from Peter Fendi, one of the most distinguished genre painters of the day. Treml was to marry Fendi's niece.

Austria was still an empire and a police state in which military activity was an ever present reality. Fendi himself painted many melancholy pictures showing the harsh results of war. His pupils Carl Schindler and Friedrich Treml were also devoted to military subjects but preferred to treat them with humour. Treml much enjoys the contrast between the elegance of the wounded soldier and his humble surroundings.

In oils and watercolours Treml depicts the constant presence of soldiers in ordinary village life. His work was popularized through reproductive lithographs. From 1849 he worked exclusively for the royal family.

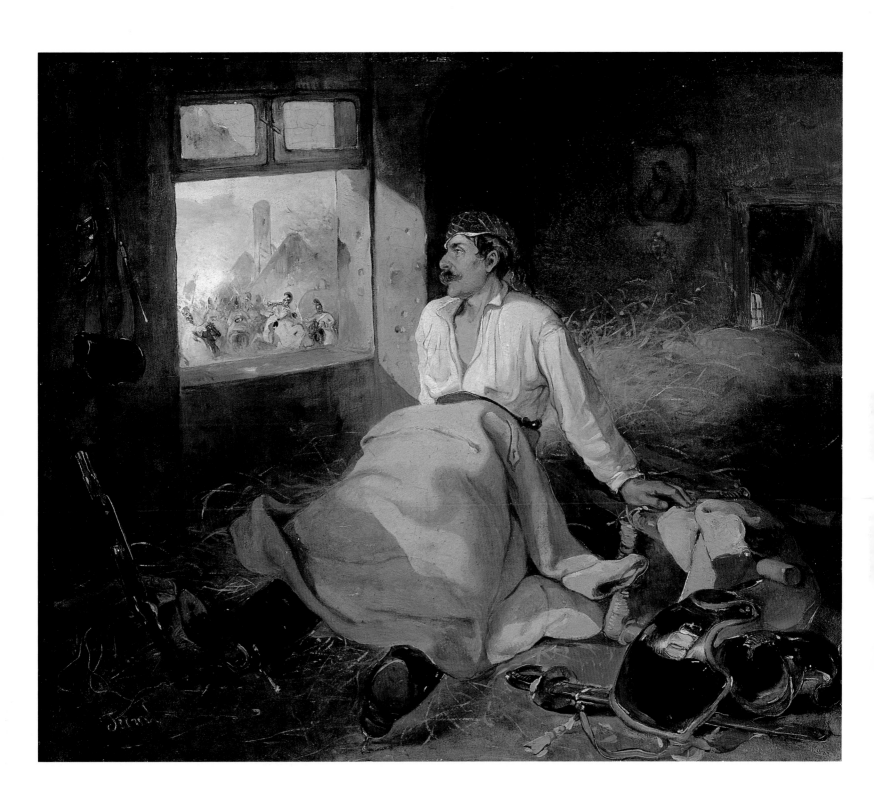

Ferdinand Georg Waldmüller
1793–1865

Portrait of the Viennese Actress Elise Hofer, 1827

The Family of the Viennese Notary, Dr Josef Eltz, at Ischl, 1835

The Liechtenstein Ruins near Mödling, 1848

❧

WALDMÜLLER was the greatest Austrian artist of the Biedermeier era. A passionate advocate of Realism, he turned his hand to portraits, portrait groups, landscapes and rustic genre.

He came of peasant stock, though his father was successively a butler and an innkeeper. He attended the Vienna Academy with frequent breaks necessitated by earning his living. He also taught himself by copying Old Masters.

At the start of his career he earned his keep by painting portrait miniatures and never lost his minute attention to detail. For his later, regular-scale portraits, he derived his style from the example of Füger and Lampi, two Viennese classicists. His portraits are often reminiscent of Ingres, though Waldmüller aims at an exact, objective rendering of his sitters – who are often plain – where Ingres tends to idealize.

Waldmüller was the most significant innovator among the Realist landscape painters of Austria. Contemporary critics pointed out that he did not 'compose' his views, he simply painted what he saw, sometimes a small section of the Prater park on the outskirts of Vienna, sometimes a domesticated mountain valley. His landscapes are friendly and generally bathed in bright sunlight. In his last years, he peopled them with happy peasants, achieving a rather sugary genre style.

In favour at court, he was appointed the first curator of the academy's picture gallery by Metternich in 1829 and given the title and rank of Professor. His efforts to reform the academy, replacing its classical teaching with a new Realist approach, led to many battles and to his temporary dismissal in 1857. He was reinstated in 1864. He also ran a private art school and was an influential teacher.

Waldmüller was already a successful and sought-after artist when he painted the *Portrait of the Viennese Actress Elise Hofer* in 1827.

The lovely young actress is fingering a rope of pearls as she turns to look out of the picture, leaving her profile reflected in the elegant silver toilet mirror. A red cashmere shawl, the latest fashion from the Orient, is draped over her chair while a trunk on the left of the picture overflows, leaving a rainbow coloured wrap spilling over the side.

The girl's white dress shows to advantage amid so much colour and so many elegant accessories. Waldmüller has achieved a masterly rendering of its textures, the shimmer of the satin waistband and the transparency of flounce upon flounce of lace.

Elise Hofer worked at the Theater an der Wien. The artist was familiar with the theatrical world, having married an operatic contralto in 1814. Over the next three years his wife's engagements had taken them to Baden, Brünn and Prague, and Waldmüller had divided his time between theatrical scene painting and portraits. In 1817 his wife began work at the court theatre in Vienna but they were already quarrelling and in 1822 were formally divorced.

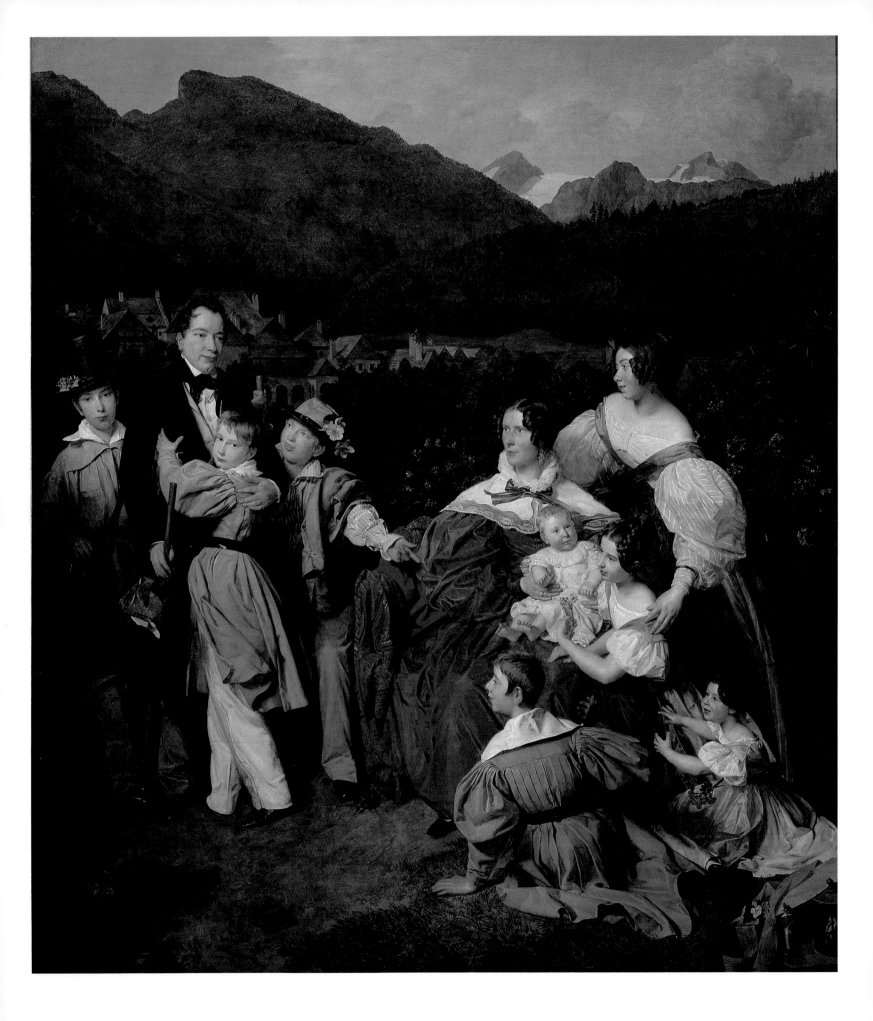

Opposite. FERDINAND GEORG WALDMÜLLER. *The Family of the Viennese Notary, Dr Joseph Eltz, at Ischl*

FERDINAND GEORG WALDMÜLLER. *The Liechtenstein Ruins near Mödling*

The Family of the Viennese Notary, Dr Josef Eltz, at Ischl was painted eight years later, and is one of the most famous images of the Biedermeier period in Vienna. The father has just walked to join his family and is being greeted enthusiastically by his sons, thus providing a rationale for dividing the figures into two separate groupings. The elegant arrangement of the figures and their gestures carry echoes of the Old Master paintings that Waldmüller copied in his youth. However, it is a portrait of an ordinary bourgeois family and the figures are realistically rendered.

The landscape is no longer a decorative background, but real space within which the figures are set – a view of the mountains around Bad Ischl, a fashionable watering place to the east of Salzburg.

As in his landscape paintings, Waldmüller has chosen to bathe the scene in cheerful sunlight. The landscape behind is dappled with shade and painted in soft greens and blues.

The Liechtenstein Ruins near Mödling shows Waldmüller at the height of his powers as a landscape painter. The plain is in shadow while a shaft of sunlight has broken through the clouds to light up the sweep of the dirt road that leads uphill towards the ruins. Its texture – broken stones and earth and tufts of grass – is painted with such mastery that the foreground holds the attention before the eye moves up to enjoy the twisted oak trees and ruins etched against the sky.

Waldmüller's early preference for small, enclosed views has given way to a spacious vista with a distant horizon. His frequent sketching tours in Italy helped him to master a sense of space and on his return to Austria he painted wider, open views.

In this work he combines a grandly balanced composition with careful detail. The peasant seated in shadow is here only an incidental detail but her inclusion prefigures Waldmüller's peasant scenes of the following decade.

BERLIN

BERLIN evolved from the principal city of a dukedom to the capital of an empire in less than two centuries. In 1815 it had reached the midpoint of its evolution; as capital of the kingdom of Prussia, it was the second most important power in the German Federation. It had a formal court life, a strong military tradition, a major university which attracted some of the best minds of the Romantic generation and a social life which brought together scholars, artists, writers, noblemen, soldiers and administrators in the salons of such famous hostesses as Bettina von Arnim and Rahel von Ense.

Biedermeier Berlin was thus a cultured city but without a long tradition. Many artists and scholars were imports from other parts of Germany; some artists, such as Franz Krüger, were virtually self-taught. Wilhelm von Schadow, a Nazarene and also a distinguished portraitist, is credited as fathering the 'Berlin School' while he was a professor at the academy between 1819 and 1826; in 1826 he left for Düsseldorf to run the Düsseldorf Academy. Schadow was particularly important in introducing good technical instruction; his own work, whether history or portrait, has clear, clean outlines, inspired by early Italian painting, and careful finish.

The other dominant artistic spirit of Biedermeier Berlin was Karl Friedrich Schinkel, the artist and architect. During the Napoleonic Wars, when building commissions were in short supply, he took to painting; his romantic architectural views, mostly of medieval buildings with theatrical effects of light, influenced many artists of the Biedermeier generation. More importantly, from 1819 onwards, his

buildings transformed Berlin. They are mostly in Neo-classical style with colonnades, handsome pediments, and curved flights of steps, and they include the Altes Museum in the Lustgarten, the Royal Theatre, the King's Guard House in the Unter den Linden, the School of Architecture (Bauakademie) and many private houses and palaces.

It was from the roof of Schinkel's newly completed Friedrichwerder Church that Eduard Gärtner painted his famous panorama of Berlin in 1834, incorporating among the figures on the rooftop himself, his wife and their children. This is an outstanding example of the architectural views, peopled with Biedermeier citizens, that are the most original achievement of the Berlin school.

The furious pace of Schinkel's rebuilding programme must have made Berlin's citizens highly conscious of the city's architecture. It certainly helped to stimulate the view painters.

Gärtner's panorama of Berlin was painted for King Friedrich Wilhelm III of Prussia; a replica of it was made for his daughter, the future Tsarina Alexandra Fedorovna, wife of Tsar Nicholas I of Russia; Franz Krüger's *Parade on the Opernplatz* of 1829 was painted for the Tsar. This famous painting combines architecture, genre and portrait. The spectators in the foreground include careful portraits of leading society figures.

The painting of portrait groups in the manner of genre is characteristic of Biedermeier art throughout the Germanic world and Krüger's parade pictures are among the most striking examples. Gärtner, Hummel and other artists also turned their hands to portrait groups in carefully delineated interiors.

The most distinguished portraitist of the Berlin school was Karl Begas, who came from Hainsberg, near Aachen. He owed his schooling to Baron Gros in Paris and helped to carry the stylistic influence of French classicism to Berlin. Krüger and many others also painted portraits.

Landscape was not a major interest in Berlin. Its finest exponent was Karl Blechen, who developed a strong, approximative brushwork which parallels the work of his French contemporaries in Barbizon. Blechen began his career as a theatrical scene painter, with help and encouragement from Schinkel. He developed his loose brushwork in the course of sketching expeditions in Italy. His influence on Adolf von Menzel was particularly significant for German painting in the second half of the nineteenth century.

Karl Begas the Elder
1794–1854
Portrait of Frau Wilhelmine Begas, 1828

THE ARTIST has used his wife, a noted Berlin beauty, as the subject in this romantically idealized, story-telling portrait. It is a type of painting much favoured by the sentimental burghers of the Biedermeier era. Amerling in Vienna, Stieler in Munich, and Begas and Magnus in Berlin are counted among its most successful exponents.

Frau Begas is shown in mourning, with an amethyst cross suspended from a golden cord around her shoulders. Her right hand rests on a prayer book and her blue eyes are raised towards heaven. The ray of light catching her forehead appears to be a response from above and leaves her lips trembling on the edge of a smile.

So theatrical a pose requires a backdrop: she is provided with a winding river landscape, a rose bush with red flowers and a window frame to prove that we are looking from the inside out.

The sheer technical virtuosity with which Begas renders his wife's soft, rounded arms under sleeves of black net embroidered with flowers reflects his schooling in the Paris studio of Baron Gros. His clear outlines and high finish owe a direct debt to the French classicists, as does his sensuous idealization of the female form.

Begas was much in demand as a portraitist but his principal triumphs were in the more highly considered field of history painting. His religious works won him the patronage of Friedrich Wilhelm III of Prussia during the Treaty of Paris negotiations of 1815; the king supported his further study in Paris and a three-year visit to Italy from 1821 to 1824, the date when Begas settled definitively in Berlin.

With more technical skill than profundity, Begas followed a succession of fashionable styles, imitating the archaic Romanticism of the Nazarenes in Rome, then the pseudo-medieval 'troubadour' style of the Düsseldorf school, and finishing up in the 1840s with a popular specialization in Realist genre.

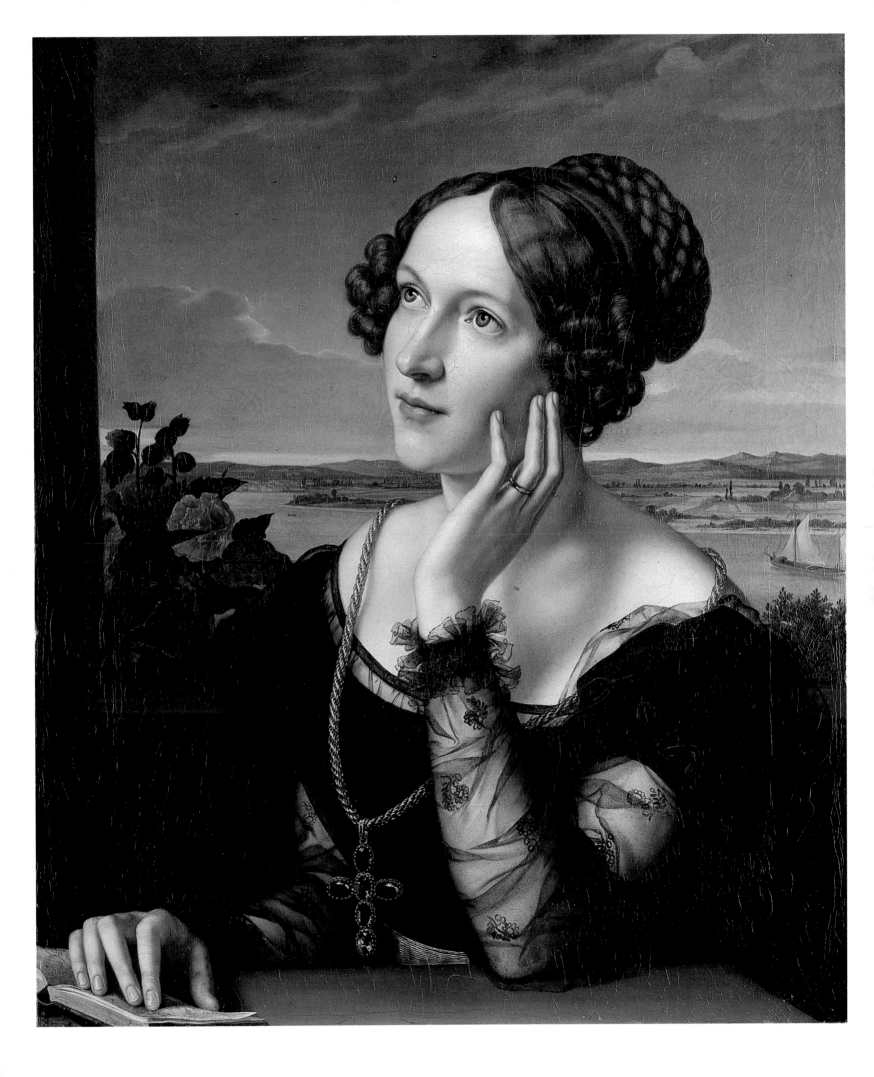

Karl Blechen
1798–1840
The Interior of the Former Palm House on the Peacock Island, 1832

THE EXPLOSION of tropical foliage combined with the sinuous Islamic arches of the building on the right of the picture hint at the magic of the East. The scene is, in fact, the interior of the palm house built by the King of Prussia on the Pfaueninsel in Berlin. In the foreground the grills for under-floor heating can be seen. Blechen himself was so carried away by the Oriental air of the scene that he positioned some lightly clad harem ladies under the central palm.

Botanical study and the collection of plant specimens from distant lands were very much part of the scientific spirit of the age. The famous explorer and botanist Alexander von Humboldt lived in Berlin and it was on his advice that Friedrich Wilhelm III purchased the Foulchiron collection of palms in Paris in 1830. The king had a new palm house built to designs by Karl Schinkel and in 1832 he commissioned Blechen to paint two views of the interior to give to his daughter the Tsarina of Russia. This is one of them.

Paintings of the interiors of rooms and their furnishings were popular in the Biedermeier period, especially in Berlin. Gärtner had painted several of the future Tsarina's favourite German palace interiors a few years before. This is a more exotic version of the same genre.

Blechen was one of the founders of naturalistic landscape painting in Germany. He studied in Berlin and was at first much influenced by the theatrical Romanticism of Schinkel. A visit to Italy in 1828–29 helped him to develop a loose, impressionistic brushwork and encouraged his interest in painting directly from nature.

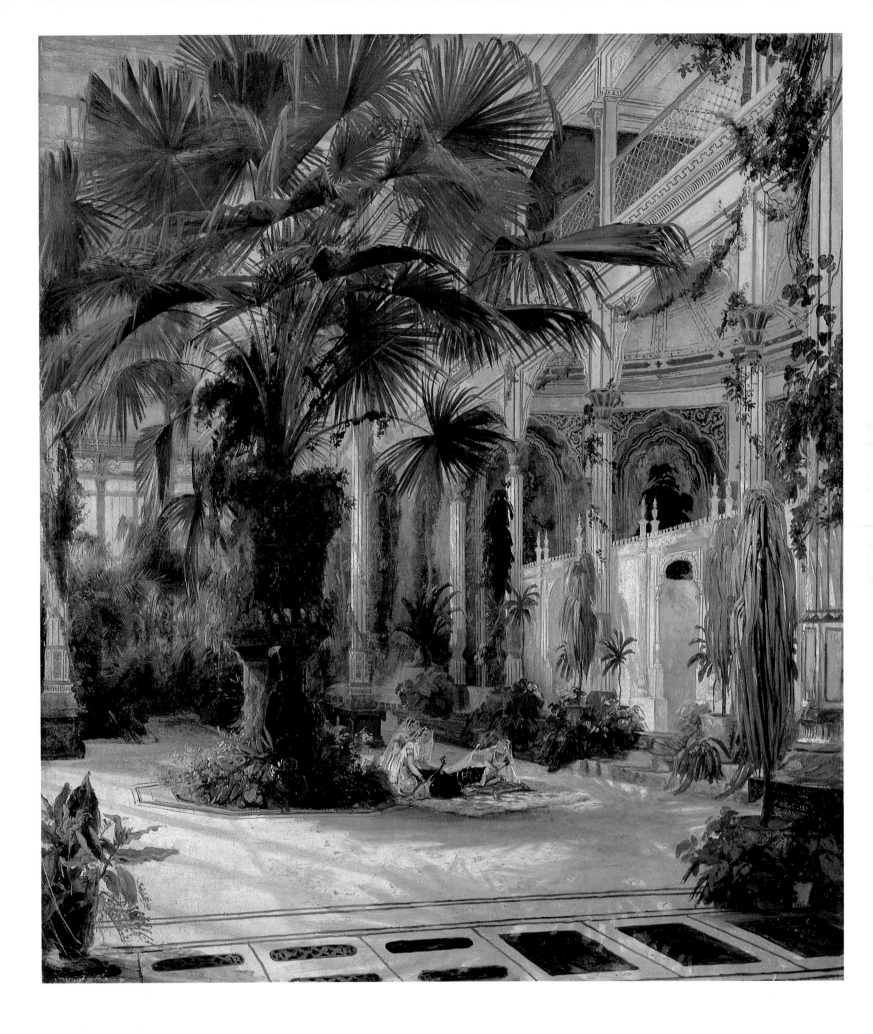

Johann Philipp Eduard Gärtner

1801–77

Panorama of Moscow, central panel, 1839

Panorama from the Roof of the Friedrichwerder Church,
the Three Views Looking South, 1834

The Living Room of the Locksmith, Hauschild, 1843

GÄRTNER was the most distinguished architectural painter of the Berlin school. The son of a humble chairmaker, he served seven years as an apprentice decorator at the Berlin porcelain factory before his talent earned him a place among the scene painters at the court theatre.

Encouraged by Carl Gropius, the theatre's artistic director, Gärtner exhibited an interior at the Berlin Academy in 1821. This won him a commission from Princess Louise to paint some of her favourite rooms in the Berliner Schloss and in 1824, at the age of only twenty-three, he received his first commission from King Friedrich Wilhelm III. The king remained a keen patron and it was for him that Gärtner painted the Berlin panorama (overleaf) in 1834.

Another of Friedrich Wilhelm's daughters, the Princess Charlotte, married Tsar Nicholas I of Russia. She was impressed by the Berlin panorama and commissioned Gärtner to paint her a replica. In 1837, having received no payment, the artist decided to travel to Russia and deliver the panorama

Once there, he immediately busied himself sketching the architecture of St Petersburg and Moscow. He found his first patrons among the German colony which had followed the Princess to Russia and was soon receiving commissions for both portraits and architectural views from the Russian aristocracy.

His *Panorama of Moscow* is the most famous of his Russian pictures. The Imperial Square at the centre of the Kremlin, dominated by the bell tower of Ivan Welikij which stands almost 100 metres high, crowned with its golden cupola, was chosen by Gärtner for the central panel of the triptych.

The ancient buildings, so clean and white, with their glittering cupolas, dwarf the citizens of Moscow who go about their business in the square below. The soberly clad figures serve, however, to anchor the exotic architecture of the Kremlin in humdrum Biedermeier reality.

Gärtner made many *plein air* oil sketches in preparation for this painting, as he did for other architectural commissions. He visited Russia several times between 1837 and 1839 and continued to paint Russian views in Berlin, using the pencil drawings and oil sketches he had brought back.

Panoramas, or pictures in the round, originated in England in the late eighteenth century but rapidly became popular in Germany. Many were portable and travelled the country like shows. A panorama of Berlin had been exhibited in 1800 with great success.

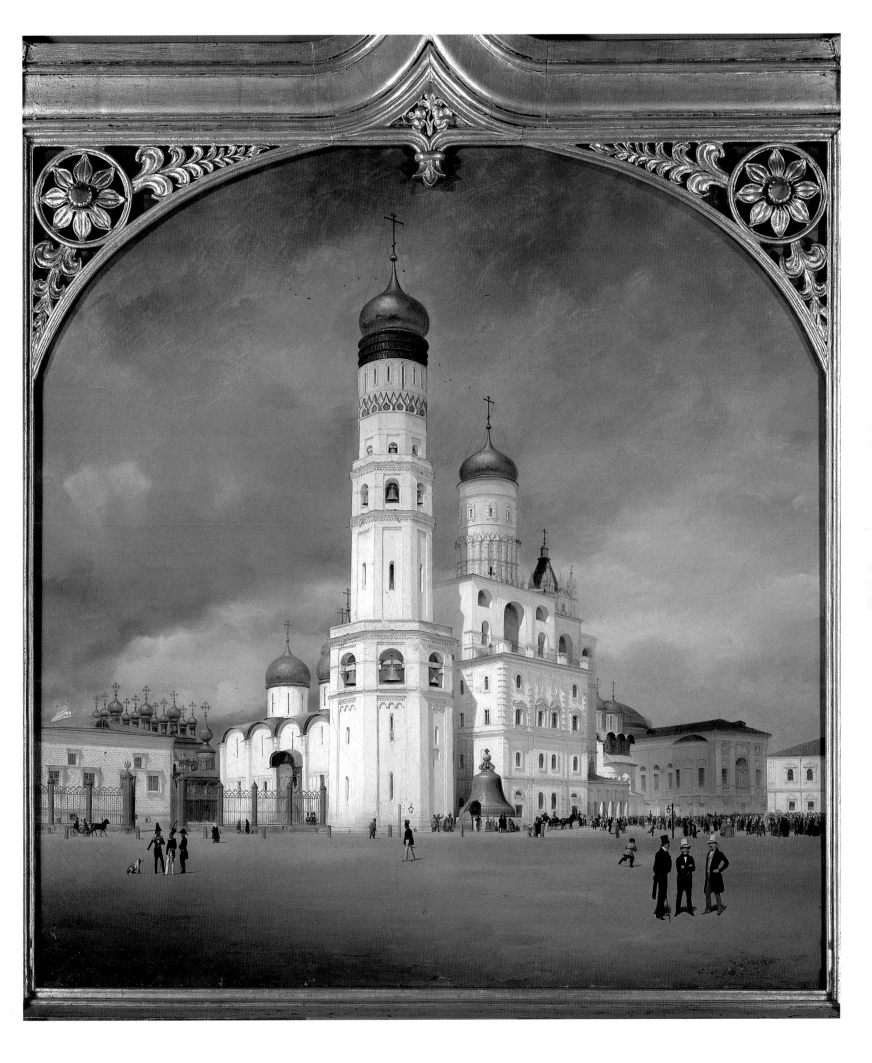

Eduard Gärtner. *Panorama from the Roof of the Friedrichwerder Church, the Three Views Looking South*

Gärtner took more than two years on his *Panorama from the Roof of the Friedrichwerder Church*. He built himself a small hut on the roof for shelter and is believed to have used a *camera obscura* to achieve such accurate perspective.

The rooftops, tree-lined streets, churches and palaces of Biedermeier Berlin are recorded with the utmost fidelity. The three views looking north are entirely separate from the three looking south. In both cases the set of three panels are joined together; the side panels need to be bent forward to match the perspective of the centre correctly. Gärtner has painted himself in top hat and tails in the left-hand panel of the three views looking south over the town.

On the left of the picture, still draped in scaffolding, is Schinkel's new building for the Bauakademie. It was not quite finished. Behind it a wing of the Berliner Schloss creeps into the picture and two spires, of the Nicolaikirche and the Parochialkirche, are etched against the sky.

On the right there is more evidence of Schinkel's transformation of Berlin. The pediment of his new Neo-classical theatre rises above the roofs in the distance, between the domed towers of the German cathedral and the French cathedral. While the foreground is a dense roofscape, the town has given way to countryside along the skyline, demonstrating how small Berlin was at the time. On the left of the right-hand panel

the monument erected on the Kreuzberg to commemorate the recent war of liberation can be discerned on the horizon.

His friend Eduard Meyerheim made a sketch of him on the roof which Gärtner then transposed. On the green portfolio which leans against the balustrade behind him is inscribed: 'Panorama von Berlin. Aufgenommen im Jahre 1834 von E. Gaertner'. In front of him his wife is holding one of their younger children by the hand while a second has climbed up the roof and peers over the top.

It is pleasingly characteristic of the Biedermeier period that a major work, commissioned by the king himself, should be turned into a family affair.

As a family man, Gärtner entered with relish
into the family pride of his friend when he painted
The Living Room of the Locksmith, Hauschild.
Hauschild's three little daughters in pink dresses
with black aprons have gathered to help Papa
make his meal, while his wife stands in the
doorway holding the baby. The grandmother
looks up from her book and is reflected in the wall
mirror.

The furnishings are painted with loving
attention, the patterned wallpaper, carpet, pic-
tures, heavy wooden furniture and vases of
flowers. They give the picture almost a still-life
quality.

After Gärtner's return from Russia he painted
Hauschild in his workshop. He stands in his
shirtsleeves in the foreground of the picture,
surrounded by tools and keys, leaning on his
workbench, while he talks to a friend. Assistants
are glimpsed at work through an arched doorway.
To paint a portrait in a working environment was
most unusual at this date. It is presumably
explained by the two men's close friendship.

Gärtner went on to paint the family interior
four years later as a pendant to the workshop
scene (which is now lost).

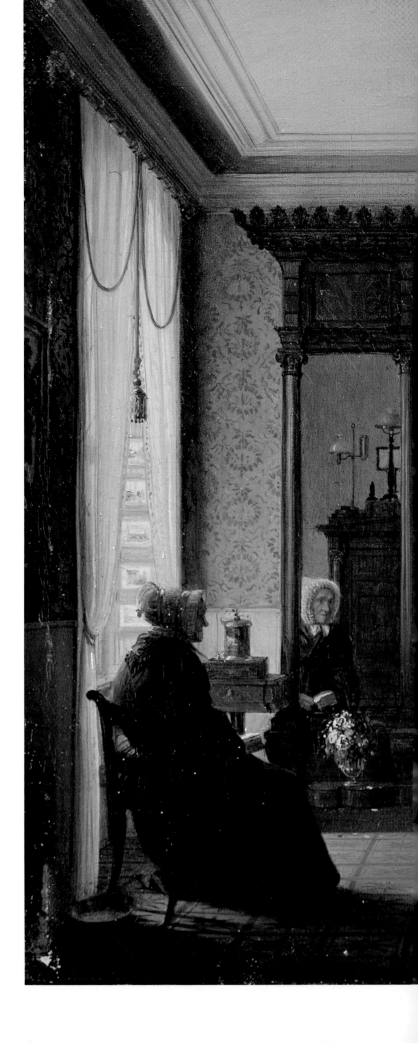

EDUARD GÄRTNER. *The Living
Room of the Locksmith, Hauschild*

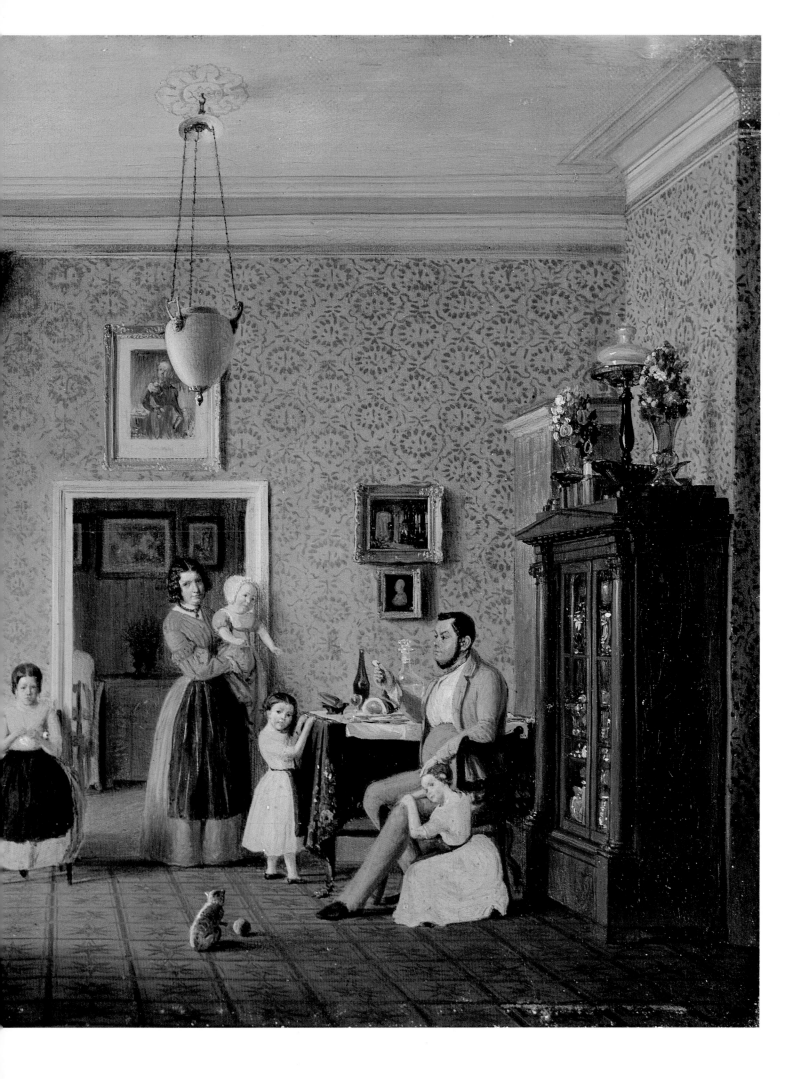

Johann Erdmann Hummel
1769–1852
The Granite Bowl in the Berlin Lustgarten, c. 1831

THE MASSIVE GRANITE BOWL erected in the Lustgarten has attracted a miscellany of sightseers. Some inverted, some foreshortened, they are reflected in the high polish of its surface. The Berliner Schloss is seen in the background.

The mathematical geometry of perspective was an obsession with Hummel. A professor at the Berlin Academy, he wrote several textbooks on the subject and earned himself the nickname 'Perspektivhummel'. In this painting he has posed himself the most intricate perspective problem and resolved it in a masterly fashion.

Architectural views were much favoured in Berlin at the time. Gärtner was the other major exponent of the genre. In both his and Hummel's work the streets are peopled with neatly dressed contemporary figures. Painted with charm and simple naturalism, they evoke the spirit of a well-ordered and unhurried age. The erection of the granite bowl inspired four paintings by Hummel. They are among his most famous works.

Born in Kassel, Hummel began to attend drawing classes at the academy at the age of eleven, went on to study architecture but transferred his allegiance to painting in 1786. He quickly attracted the patronage of the ruling house of Hesse and a grant from the Landgraf Wilhelm IX enabled him to spend seven formative years in Italy.

In 1800 he moved to Berlin and worked at the Prussian court. Nine years later, he was appointed professor of architecture, perspective and optics at the Berlin Academy.

Franz Krüger
1797–1857

Parade on the Opernplatz,
Berlin, in the Year 1822,
1829

THE IMPOSING SEVERITY of the architectural setting
and the disciplined lines of the troops on parade
contrast with the informality of the crowd which
fills the right-hand foreground of the painting.
Here elegantly dressed ladies mix with top-hatted
gentlemen, a coachman has dropped off to sleep, a
rearing horse frightens a lady with a parasol and a
group of dogs have wandered onto the parade
ground. Exquisitely turned out officers with
curling moustaches mingle with the crowd.

The artist, nicknamed 'Horses Krüger', atten-
ded the Berlin Academy from 1812 to 1814, and
then taught himself by sketching in the imperial
stables. Beautifully observed horse pictures –
racing, hunting and equestrian portraits – were an
important feature of his work. The example of
Carle Vernet, a French specialist in the same field,
was a point of departure for this picture. Krüger
made a careful study of Vernet's *Consecration of
the Prussian Regiment's Flag on the Champ de Mars
in Paris.*

The large painting was commissioned by
Archduke Nicholas of Russia, the future Tsar
Nicholas I, who had been given command of the
Brandenburg cuirassiers by his father-in-law, the
Prussian king. It includes careful portrait studies
of many major figures of the time and took Krüger
five years, from 1824 to 1829, to complete.

Krüger was one of the most highly regarded
Berlin artists of his day and a popular portraitist.
His precise draughtsmanship and high finish are
characteristic of the Berlin school. The Prussians
favoured a military precision in their paintings
and this can be found in the architectural views,
portraits and portrait interiors which were
particularly popular in the capital city.

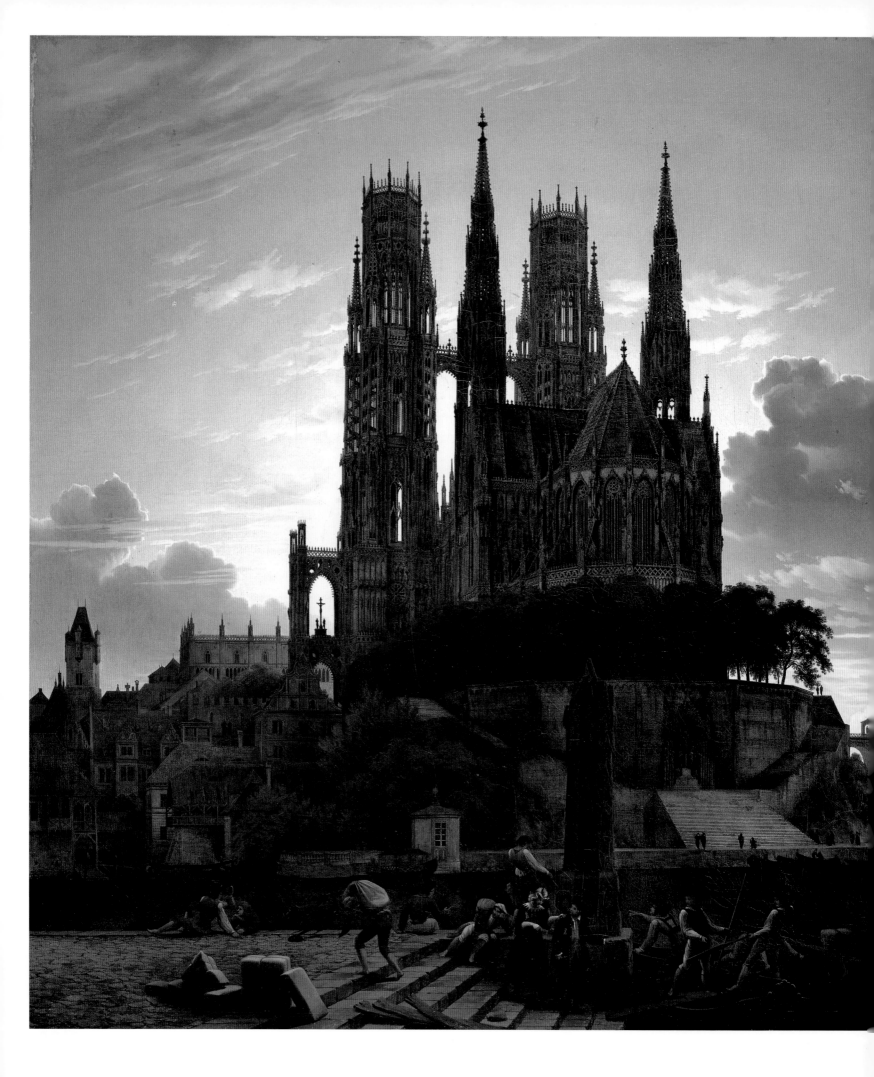

Karl Friedrich Schinkel
1781–1841
Cathedral above a Town, after 1813

THE SUN is going down behind a Gothic cathedral whose towers and spires are etched against the evening sky like black lace. The building dominates a spit of land which is connected by a high, arched bridge to an old town densely crowded on a sunlit promontory. In the foreground a boat has put into some steps and is being unloaded, the figures dwarfed by the mighty architecture.

Schinkel was Berlin's most distinguished architect of the early nineteenth century. He studied architecture with Friedrich Gilly from 1797 and was one of the first architectural students at the Berlin Academy when it opened in 1799. In 1803–05 he visited Italy, returning via Paris, but from 1806, when Napoleon defeated the Prussians, he could find no work as an architect and turned to painting, first to panoramas and dioramas for the entertainment of the public and then, around 1810, to easel painting. Once the war was over he began to receive major building commissions and consequently painted only occasionally. Between 1816 and 1832 he designed the scenery for forty-two productions at the Royal Theatre.

This painting, with its theatrical presentation of an architectural fantasy, is characteristic of Schinkel's work. He found many followers among the late Romantic painters of Germany. The war with France filled Schinkel and others with patriotic fervour. They looked on the Middle Ages, the days when Charlemagne ruled most of Europe, as Germany's golden age. The Gothic cathedral is a conscious symbol of the grandeur of the German spirit.

Julius Schoppe
1795–1868
View of Salzburg, 1817

ACROSS A SUNNY PLAIN sprinkled with neat buildings and trees, Salzburg is shown in the distance clustered on a rocky hilltop with blue mountains behind. The view is pleasingly framed by branches of trees in the foreground while the four young men who have gathered on a bench to enjoy it establish that this was a well known 'picturesque' vantage point.

It is an Austrian view but Schoppe came from Berlin and his approach is characteristic of the Berlin school. His taste is not for wild mountain scenery but for nature cultivated by man. The bench and the ornamental railing in the foreground indicate that this corner of a park has been arranged for man's enjoyment. A smooth meadow ends in a village, partially hidden in trees. Beyond stretches the well cultivated plain.

The tidy clarity with which figures, bench, buildings and vegetation are realized has that hint of naiveté which is often found in the work of Berlin view painters of the Biedermeier era and which constitutes an important part of their charm.

Another characteristic of the era is to paint a portrait group in the manner of genre. This group shows Schoppe himself, the artists C. W. Gropius and K. F. Zimmermann, and Alois Weissenbach, a doctor and poet who knew the region well and had brought the painters there.

Schoppe studied at the Berlin Academy from 1810. In 1816 he visited Vienna and the following year, when this picture was painted, he wandered on from Austria to Italy. He and Gropius published an album of lithographed views of Austria, Switzerland and Italy as a result of their journey. Schoppe became a professor at the Berlin Academy in 1836 and was highly regarded as a portraitist.

COPENHAGEN

In 1846 Christen Købke was denied membership of the Copenhagen Academy after he had submitted a view of Capri in a bid to qualify for this honour. He died, embittered, two years later. Today the flowering of Danish painting in the early nineteenth century is referred to interchangeably as 'The Golden Age' or 'The Age of Købke'.

The painters of the 'Golden Age' in Denmark were rediscovered, as the German Biedermeier painters were, around the turn of the century. The pioneering art historian Emil Hannover published a monograph on Købke in 1893, on Eckersberg in 1898 and on Constantin Hansen in 1903.

Where Købke was its genius, Eckersberg was the dominating influence on the age in his role as professor of painting at the Copenhagen Academy. The academy was housed in the old Charlottenborg Palace which also provided apartments for leading artists and craftsmen. Eckersberg was given an apartment when he became a professor in 1818 and he remained there for thirty-five years. He taught the drawing and life classes at the academy and his pupils learned to paint by working in his studio. They also accompanied him on sketching trips around the ramparts, harbour and lakes of Copenhagen.

Eckersberg's student years had been spent in David's studio in Paris and then in Rome. From David he had learned classical composition, idealization and smooth, highly finished modelling. The high finish and attention to detail were imitated by Eckersberg's pupils, though.Købke was to achieve a looser, more emotive, brushwork.

True to the spirit of the age, Eckersberg painted many religious and historical subjects but these pictures have now been forgotten. His portraits, Roman views and the little pictures of ships and harbours

which he painted for his own pleasure throughout his life are now considered his major achievements. All are characterized by simple, objective Realism which is also the hallmark of the Danish 'Golden Age'.

Købke applied the same Realist approach to the landscape around Copenhagen and to portraits, though he was prepared to cheat a little by heightening effects of light – with excellent results. Constantin Hansen applied it to portraits, Lundbye to landscape, Rørbye to genre and architectural views, and Bendz to the middle-class conversation piece.

Their pictures are of consistently small dimensions. It is astonishing with such famous works as Købke's portrait of Frederik Sødring to find so much lively detail crammed into so small a space.

As in neighbouring Germany, the middle classes were the principal clients for the work of these 'little masters'. Indeed, Denmark's economic and social life was very similar to that of Germany.

The country's attempt to remain neutral during the Napoleonic Wars had come to an end with the British fleet's devastating attack on Copenhagen in 1807. Thereafter Denmark became Napoleon's ally and suffered in consequence of his defeat. Norway, which had traditionally owed allegiance to the Danish crown, had to be ceded to Sweden as part of the peace settlement.

As Duke of Holstein, the Danish King was a member of the German Confederation but he resolutely declared Schleswig to be an integral part of Denmark. The Schleswig-Holsteiners' desire for independence became a growing political problem and led to war in 1848 when the Prussian army came to the aid of the insurgents.

In 1815 Denmark's economy, like that of most German states, was in ruins and recovery was slow. The Biedermeier years also saw press censorship and political repression in Denmark very parallel to that imposed by Metternich on the German Confederation.

The traditional antipathy between Danes and Germans, exemplified by the Schleswig-Holstein issue, did not extend to the field of art, where links were close and fruitful. Johan Christian Dahl was born in Norway in 1788, when it was still part of the Danish hegemony, and entered the Copenhagen Academy in 1811. One of the greatest masters of naturalistic landscape painting in northern Europe, he had a significant influence on the Danish school though he left for Dresden in 1818. Both Dahl and Caspar David Friedrich, who had studied in Copenhagen at the turn of the century, continued to exhibit there.

Several Danish artists of the 1840s experimented with a mystical interpretation of the moods of nature in the manner of Friedrich. In turn, Copenhagen provided the main inspiration for naturalistic painters in Hamburg and elsewhere in northern Germany.

Wilhelm Bendz
1804–32
Interior in the Amaliegade, c.1830

BENDZ has painted his two brothers in their student lodgings. It is at the same time a portrait of the room and a portrait study of the two boys. The room provides an insight into the context of their daily lives and reflects their interests: the soldier's cap, the skull, the coffee pot, the books. . . . The coat hung carelessly by the door and the paper littering the floor speak of an untidy student life, while the looped and fringed curtains and the plain but elegant furniture show its occupants as comfortably well-to-do.

To extend the impact of a portrait by the intimate portrayal of the subject's home life was a favourite Biedermeier device and characteristic of an age which shunned heroics, prizing instead domestic virtue, friendship and family life. This is one of the most successful examples of the genre.

Bendz is credited with introducing the middle-class conversation piece into Danish art. He studied with Eckersberg at the Copenhagen Academy and his work reflects in full measure the qualities with which that influential teacher imbued the younger Danish school: an attention to the architectural structure of a painting derived from the great masters of French classicism, an emphasis on fine modelling and finish, and a devotion to intimate realism.

Eckersberg's realism found its happiest outlet in landscape and marine subjects and it fell to Bendz to treat scenes of everyday life with the same direct intimacy. There are many parallels between his work and that of German contemporaries, particularly the tightly drawn figure paintings of Berliners such as Hummel. The German influence must have been filtered through fellow students at the Copenhagen Academy for Bendz did not leave Denmark until 1831. He made a brief but productive stay in Munich, travelling via Hamburg, Berlin and Dresden. The following year he went south to Italy but died in Vicenza.

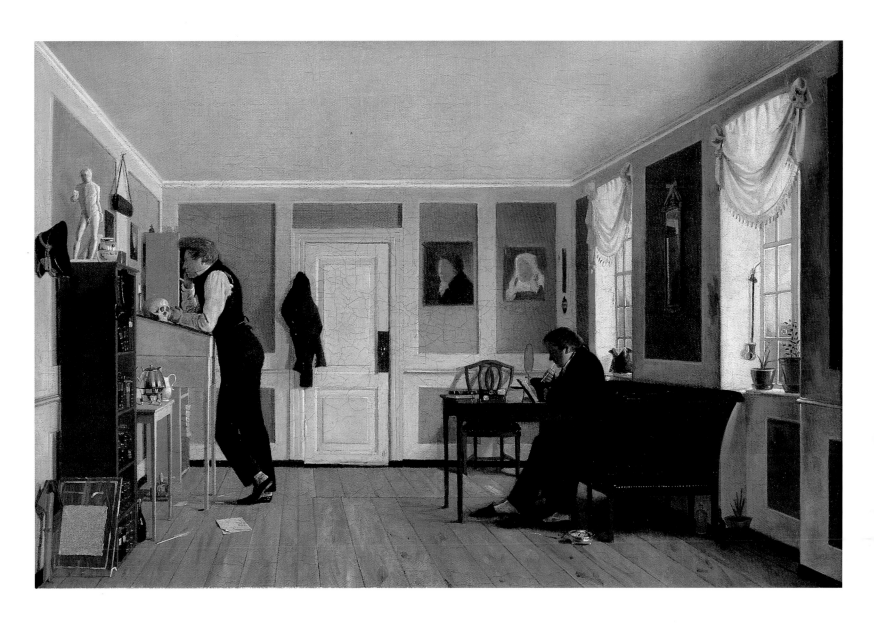

Christoffer Wilhelm Eckersberg
1783–1853

*A View through Three of the North-Western Arches of
the Third Storey of the Colosseum, 1813–16*

*A View towards the Wharf at Nyholm with its Crane
and Some Men-of-War, 1826*

*Bella and Hanna, the Eldest Daughters of M. L.
Nathanson, 1820*

ECKERSBERG was the most influential Danish artist of the Biedermeier period. He developed a simple, objective realism which he applied equally to architectural views, portraits and marine paintings. His smoothly finished pictures pay careful attention to detail.

As a professor at the Copenhagen Academy from 1818, he taught many of the most distinguished Danish artists of the nineteenth century. They emulated both his Realism and his painstaking approach.

He was criticized in his lifetime for leaning too heavily on the example of the French school. After studying at the Copenhagen Academy from 1803 to 1810, he spent three years in Paris, including a year as David's pupil. He mastered the hard-edged finish of the French school, learned classical composition and began a lifelong fascination with perspective. The last was one of the pivots of his teaching and he wrote two textbooks on it.

From Paris he moved on to Rome where he stayed until 1816, sharing a house with Bertel Thorvaldsen, the Danish Neo-classical sculptor, and getting to know Ingres who was at the French Academy in the Villa Medici.

On his return to Denmark he received a major commission for historical paintings from the royal family and was much in demand as a portrait painter. His later years were very much taken up with teaching but he found time to paint from nature with his pupils around Copenhagen and to pursue his interest in marine painting.

A View through Three of the North-Western Arches of the Third Storey of the Colosseum is a small picture (32 × 49.5 cm) and Eckersberg's most famous work. The foreground is painted quite broadly, though he delights in rendering the texture of the weathered stone and brick. The distant buildings seen through the three arches, however, are depicted with such minute precision that it has been suggested that the artist was working in the open air armed with a telescope.

This work belongs to a remarkable series of small Roman views which Eckersberg termed sketches but which are generally as highly finished as this example. The strictly classical division of the picture by the three arches and the shallow foreground echo David's ideas on composition. In the vistas through the arches, however, he has allowed his interest in perspective full rein.

In this and other Roman views Eckersberg concentrates on the faithful rendering of what he sees, avoiding romantic exaggeration. This prosaic eye trained on picturesque scenes gives his work its individual quality which is enhanced by the deliberate choice of an intimate scale.

overleaf

A *View towards the Wharf at Nyholm with its Crane and Some Men-of-War* belongs to a series of little pictures that Eckersberg painted for his own pleasure of vistas around Copenhagen and its harbour. The small size (19.6 × 32.4 cm) and lack of formal composition made them unsuitable for exhibition by Biedermeier standards but the detail and high finish show that Eckersberg took as much care with them as with saleable works.

The big, rusting anchor shares the foreground with bright green grass and a stony path. The skill with which the artist has rendered the textures gives the picture its special appeal, rather parallel to that of a photographic close-up. Behind, the calm sea, grey boats and little red roofs on the further shore are caught in soft Danish light. Eckersberg had a particular mastery of this pearly northern light and the way in which its dispersion in the damp atmosphere gives a hazy imprecision to sharp edges.

The subject that Eckersberg has chosen is little more than a pile of rubble. There are no figures to give it 'importance'. Yet out of an unconsidered corner of the harbour he has created a memorable record of reality and imbued it with a pervasive sense of peace.

CHRISTOFFER WILHELM ECKERSBERG. *A View towards the Wharf at Nyholm with Its Crane and Some Men-of-War*

Opposite. CHRISTOFFER WILHELM ECKERSBERG. *Bella and Hanna, the Eldest Daughters of M. L. Nathanson*

Bella and Hanna, the Eldest Daughters of M. L. Nathanson was painted on Eckersberg's return from Rome. The girls wear dresses of apricot and green which he draws into a muted colour harmony with the rest of the picture. They cannot in life have been so perfectly cut, have fitted so perfectly or fallen so elegantly. Plump, sloping shoulders were very much admired at the time, as were softly rounded arms, and it is unlikely that the girls were, in fact, so fashionably shaped.

The adapting and improving, the marvellous rendering of textures and the high finish are characteristic of French classicism – only the plain faces of the girls are Danish. The portrait is reminiscent of Ingres and clearly displays the influence of classicism on Eckersberg's work.

The shallow composition also echoes classical precepts. The scenes carved in relief on Roman sarcophagi were considered ideal models for painterly composition by David and his school, compositions which, for technical reasons, were limited to a single foreground plane. The combination of one girl's full face with the other in profile is a device typical of relief carving.

Mendel Levin Nathanson was a wealthy merchant who had commissioned history paintings from Eckersberg before he left for Paris and Rome and who commissioned two major portraits from him on his return: a family group and this portrait of his daughters.

Constantin Hansen
1804–80
Sportsman Showing a Little Girl his Bag, 1832

THE STOCKY LITTLE GIRL in her pink dress and shawl clutches a bunch of cherries as she stares seriously at the bird her brother holds up for her. Hansen is not interested in the romantic prettiness of childhood but in its touching reality. The strength of this beautifully composed painting lies in the care he has taken to render the precise texture and colour of every detail: the floor-boards, the young man's coat, the sofa, and the cat unravelling a ball of wool.

Hansen was one of Eckersberg's most prominent pupils at the Copenhagen Academy and this picture dates from his student years (1829–33). Its homely subject and careful execution are characteristic of the Realist approach fostered by Eckersberg which became the hallmark of the Danish school.

The merging of portraiture and genre is also characteristic of the school. The painting depicts the young artist Jørgen Roed with his sister. Roed became a close friend of Constantin's, having studied with his portraitist father, Hans Hansen, and entered the Copenhagen Academy under Eckersberg at the age of fourteen.

Constantin spent nine years studying to become an architect and came to painting rather late in life. His portraits, including a speciality in child portraiture, were the chief achievements of his student years. His earlier training was put to good use in architectural views which began to feature prominently in his work during a long visit to Italy (1835–44).

On his return he tried his hand at large-scale history painting with a mythological fresco cycle for the vestibule of Copenhagen University – an ambitious, and less than successful, endeavour to rise above the cosy realism which characterized the best Danish painting of the day. (See also p. 170 for Hansen's *A Group of Danish Artists in Rome*.)

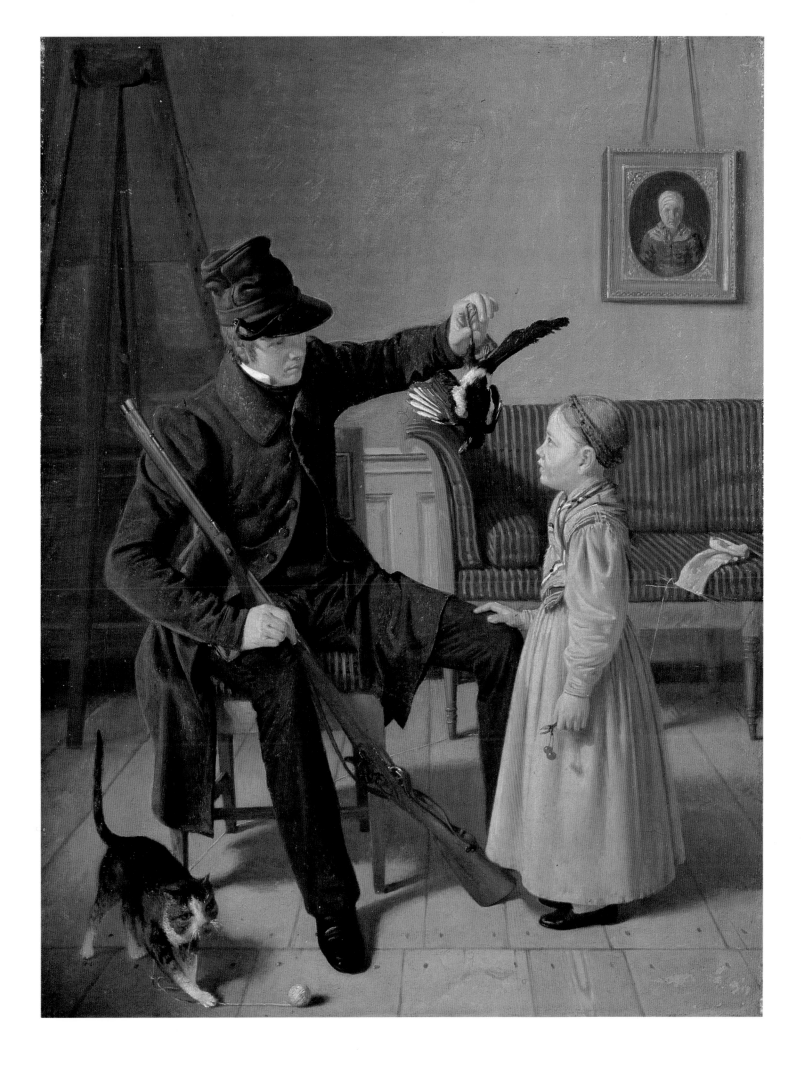

Christian Albrecht Jensen
1792–1870
Brigitte Søbøtker Hohlenberg, née Malling, 1826

THIS VIVACIOUS YOUNG BRIDE of twenty-six was destined to be left a widow only seven years later. She has put on her best bonnet for the portrait, its blue ribbon toning prettily with her simple blue dress. Jensen has enjoyed giving substance to the folds and tucks of muslin and has used the bonnet's wide brim to frame her face.

It is a little picture (23.5 × 19 cm), a format prized by the artist's middle-class patrons in Copenhagen who wanted a straightforward likeness of the loved one in the same way that their descendants want family photographs. Jensen supplied an enormous number of such portraits in the 1820s but seldom attempted the type of set piece portraiture favoured by Eckersberg and other Danish contemporaries.

Jensen studied at the Copenhagen Academy from 1810 to 1816 with C. A. Lorentzen, a minor portrait painter. His style was thus formed before

Eckersberg took up his professorship in 1818 and introduced the high finish he had learned from the French classicists. Jensen's freer brushwork looks old-fashioned by comparison; the lively charm of this painting still has a whiff of the eighteenth century about it.

The sitter's background is characteristic of the circle for which Jensen worked. The daughter of a noted Danish historian, Ove Malling, she married Johannes Søbøtker Hohlenberg, the governor of a small Danish trading colony in India.

Jensen was one of the most distinguished portraitists of the Danish Golden Age but never won the recognition he deserved. He travelled in search of commissions, working both in England and in Russia. After his sympathy for the cause of Schleswig-Holstein during the 1848 Danish-German war alienated his patrons, he gave up painting to become a museum curator.

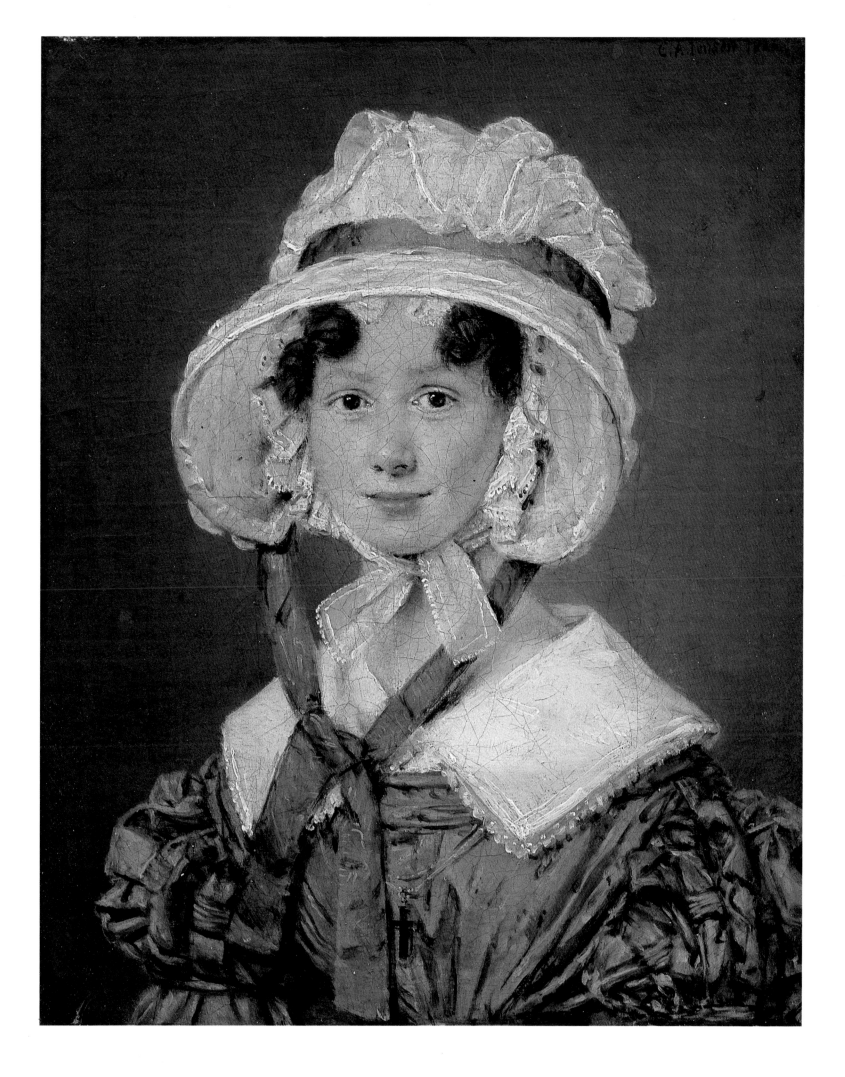

Christen Købke
1810–48

Portrait of Frederik Søbring, 1832

A View of One of the Lakes in Copenhagen, 1838

A View of a Street in Copenhagen, Morning Light,
1836

IN HIS OWN LIFETIME Købke achieved only a modest reputation but from the late nineteenth century onwards he has been seen as the greatest Danish artist of his time. The Biedermeier era in Denmark is known interchangeably as 'The Golden Age' or 'The Age of Købke'.

The son of a baker, Købke entered the Copenhagen Academy at the age of eleven in 1821. His first teacher was the minor portrait painter C. A. Lorentzen. In 1828 he became a pupil of Eckersberg and continued to work in his studio for two years after leaving the academy in 1832.

He absorbed Eckersberg's dedication to Realism, frequently sketching with him around Copenhagen and its outskirts. Købke always made large quantities of sketches from nature when preparing his major paintings. His brushwork is freer than that of his teacher, allowing a more naturalistic rendering of atmospheric effects, without straying too far from the high finish advocated by Eckersberg.

Although he had some success with his work in the 1830s, Købke was never elected to the academy.

The informality of the sitter's pose in *Portrait of Frederik Søbring* is a significant advance down the road to Realism when compared to the French formality of Eckersberg's portrait compositions.

Leaning back in his chair, Søbring has turned away from his easel, glimpsed in the mirror behind him, to look directly at the artist who is painting his portrait. From the twinkle in his eye one can conjecture that the two have just exchanged some humorous comment. His relaxed attitude conveys that he is taking a moment's rest from the concentration of painting.

Søbring, the landscape painter, shared a studio with Købke. The companionable disorder of the background is painted with crystalline clarity and used to convey the sitter's pre-occupations. Engraved views are pinned to the wall for inspiration and the artist's canvas sketching stool is propped in the right-hand corner.

The picture is nevertheless carefully composed and the clutter orchestrated to decorative effect. In this, as in other paintings of the period, Købke has paid careful attention to colour harmonies. The bright red box on the table is used as a contrast which highlights the subtler tones of the rest of the painting.

Købke's portraits are almost all of small format and usually depict his family and friends, though he received occasional commissions. He sought a likeness rather than trying to flatter the sitter.

A *View of One of the Lakes in Copenhagen* is among the most famous images of the 'Golden Age' of Danish painting. Two women on a small wooden pier watch a rowing boat out on the lake. Their stillness and the evening light imbue the painting with a romantic melancholy. One senses a parting, though it is not stated.

Most of Købke's pictures were painted close to his own home. This view is taken from the western end of the lake of Sortemdamsssøen on the outskirts of Copenhagen. Købke's home at Blegdammen was just behind the tree-covered spit of land projecting into the lake at the centre of the picture.

His preparatory sketch was painted in full sunlight and the melancholy evening mood has been achieved without moving the source of light from the south. In defiance of nature, Købke added a greenish tint to the sky and reddish-purple to its reflection in the water below. He also included the flag pole and the Danish flag tossing in a light breeze.

CHRISTEN KØBKE. *A View of One of the Lakes in Copenhagen*

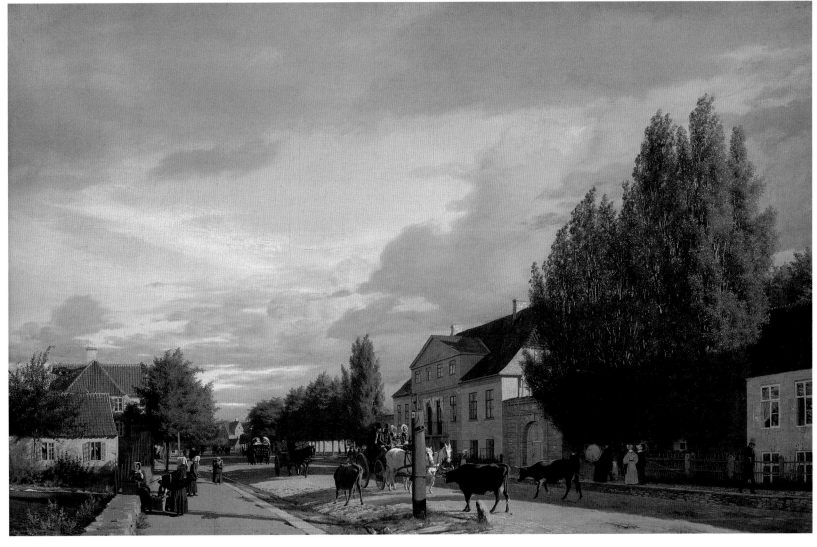

CHRISTEN KØBKE. *A View of a Street in Copenhagen, Morning Light*

Flying the national flag became popular in the 1830s because of a resurgence of patriotic feeling. The monarchy, however, disapproved and in 1834 private individuals were banned from flying the flag. Købke's painting indicates that the ban was not respected. The painting was nevertheless purchased by the Royal Collection in 1839, the year after its execution.

A View of a Street in Copenhagen, Morning Light was painted only a few hundred yards away, at the other end of the lake. It is early morning on the road through the hamlet of Østerbro. Fishwives with billowing green skirts have paused to rest as they carry the catch in to market. Cows are ambling in the opposite direction to spend their day on the common. A peasant family in their best clothes are on their way into town in a cart drawn by two white horses with a load of hay in the back.

Købke has bathed the scene in the grey luminous light characteristic of his country, while pale morning sunlight picks out a variety of features, notably the brilliantly drawn cow skidding with fear in front of the oncoming cart.

The artist's grandfather had a bakery at the end of the road which was burned down during the British bombardment of Copenhagen in 1807. His father worked as a baker in the citadel and the building features prominently in Købke's early work. In 1833 his father moved the bakery out to Blegdammen, a short walk to the left of the road in this picture.

Johan Thomas Lundbye
1818–48
A Landscape with the Manor of Vognserup, 1847

A LONG LOW BARN is tucked into the shelter of a group of trees while between them is glimpsed the rooftop and chimneys of Vognserup manor, from which the picture takes its title. Lundbye's interest does not lie in the topography but in the play of light and shade on a typical flat, Danish meadow. He has caught the softness of the northern sunlight. Leaving the centre of the picture in shade, the sun picks out a group of cows and sheep grazing on the left.

The little painting has the freedom of a sketch which allows the artist to catch the subtlety of atmospheric effects. The understated transcription of the poetry he finds in a very ordinary corner of nature closely parallels Constable's oil sketches. Both convey a direct perception of light and mood.

Lundbye studied at the Copenhagen Academy from 1832 but never under Eckersberg, the most influential teacher of the period. He thus avoids the high finish which gives a glassy, almost surreal, look to Eckersberg's own works and those of his faithful pupils. Lundbye catches the poetry of nature where the Eckersberg school looked for an objective transcription.

From Købke, the artist who exerted the greatest influence on him, Lundbye learned a sense of colour and a romantic manipulation of the effects of sunlight. His other important mentor was the art historian N. L. Høyen, who recorded the struggles behind his achievement: 'The difficulties grew, and he felt restricted where he wanted to be free, taut where he wanted to be loose, hard where he wanted to be airy and light.'

Wilhelm Marstrand
1810–73
The Waagepetersen Family, 1836

A HAPPY FAMILY of children are at play around a highly polished Biedermeier table with the little boy at the front turning to show off the naughty picture he has drawn. The mother has broken off from her knitting to greet the family nurse who has come in carrying the youngest child in her arms. Through the open doorway on the right we catch a glimpse of a bedroom.

The informality of the scene contrasts with the classically composed portrait groups of Eckersberg, Marstrand's friend and teacher, and demonstrates how Realism was gaining ground in Copenhagen. Nevertheless, the picture is carefully composed. Attention has been paid to colour harmonies, with the nurse's pink gingham apron setting off the children's blue dresses while pink ribbons embellish the mother's white gown. The careful finish is a survival from the classical generation.

Marstrand made his name as a genre painter and portraitist. Many of his pictures illustrate scenes from literature and the theatre. Even this group portrait has a story-telling element. His literary approach gave him a wide popularity in his day and even at the turn of the century the art critic Karl Madsen could still describe him as 'the greatest genius in Danish painting'. In the twentieth century story-telling has been less admired and Marstrand's reputation has suffered accordingly.

Marstrand enrolled in the academy in 1825. He began to work with Eckersberg the following year and was to become his favourite student. Genre painting attracted him from the first and his pretty, idealized scenes often have a humorous element. He spent several years in Italy painting street scenes which owe a debt to Pinelli. He became a professor at the Copenhagen Academy in 1848 and in his later years turned his hand to history painting.

Martinus Rørbye
1803–48
The Prison of Copenhagen, 1831

THE FACADE of the new prison is seen through an arch, bathed in sunlight. The prison stood next to the combined town hall and courthouse so the street in front of it is busy with activity. Both the architecture and the bustling figures are painted with the simple, objective realism characteristic of the Copenhagen school under the influence of Eckersberg.

When it was exhibited at the annual salon in the Charlottenborg Palace in 1832, this was seen not as a Realist painting but as an allegory of crime and punishment. The slippery path leads from the sunlit dandy in the foreground turning to watch a pretty woman and her children, to the pregnant girl who stands begging at the left of the arch, leaning against the stonework for support, to a man on the right soliciting a moneylender while a policeman pulls at his cloak and points to the debtors' prison. Punishment is embodied both in the robed figure who walks into the courtyard followed by a servant carrying his briefcase and in the head and shoulders of a prisoner just glimpsed behind a barred window.

The frowning man with a lamp who is walking out of the picture towards the spectator was described as 'the old misanthropist' who is 'dissatisfied with all that goes on about him'. The black cat crouched on the ledge of the arch portends catastrophe.

Rørbye entered the Copenhagen Academy in 1820 and received private tuition from Eckersberg from 1825. He travelled much more than his Danish contemporaries, spending time in Paris and exploring the Near East. Genre and architecture were his two principal interests; most of his paintings combine figures and buildings. This picture was bought by the Danish Royal Collection in 1832, the year it was first exhibited.

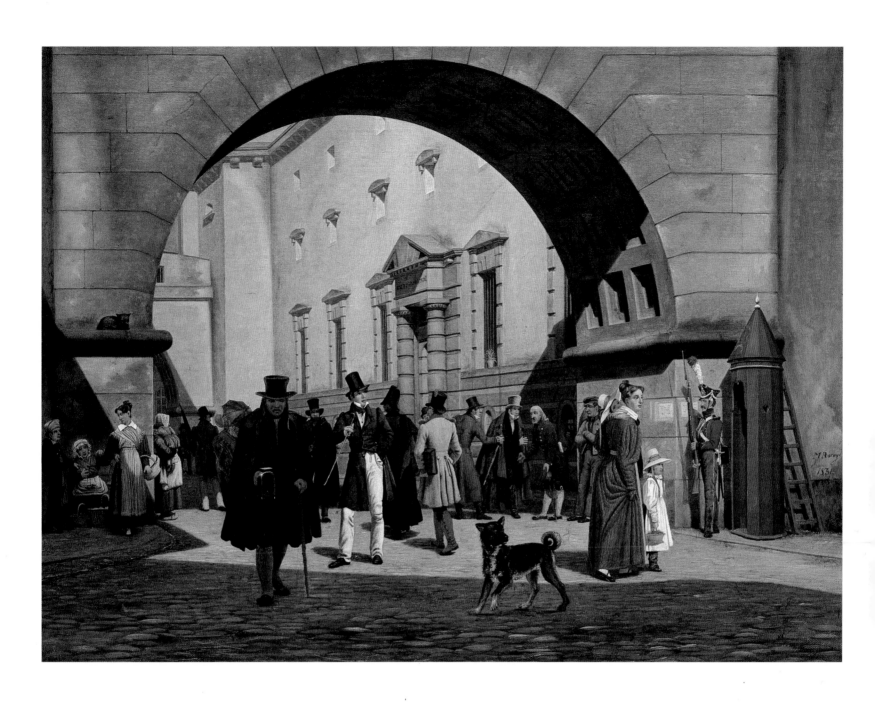

MUNICH

LUDWIG I BECAME KING of Bavaria in 1825 at the age of thirty-nine. As crown prince he had already been a keen art collector and patron; as king he determined to turn Munich into the greatest art centre in northern Europe. He embarked on a massive building programme, mainly in classical style. In the field of painting, he dreamed of a rejuvenation of German art through fresco painting – a dream initiated and encouraged by the Nazarene, Peter Cornelius – and he commissioned a series of fresco cycles for public buildings, palaces and castles.

Cornelius was appointed director of the Munich Academy in 1824 and the official art of Munich was thereafter concentrated on history painting and frescoes. The little masters of the Biedermeier period survived despite the art-loving king and his academy, not because of them. Fortunately their work had been promoted by Ludwig's predecessors and the taste for landscape, architectural views and genre was already well established in Munich.

The old Wittelsbach line had died out in 1777 and Karl Theodor, the Elector Palatine, had moved from Mannheim to Munich to become ruler of Bavaria as well as of the Palatinate and the duchies of Jülich and Berg. His patronage, particularly of landscape and architectural painters, attracted many artists to Munich. Wilhelm von Kobell, Munich's most individual landscape painter of the Biedermeier period, was called from Mannheim in 1792 by Karl Theodor to become his court painter. The Quaglio family also became established in Munich under his patronage.

In 1799 Karl Theodor was succeeded by Max Joseph and the latter was created King of Bavaria by Napoleon in 1806. He continued to encourage the arts, founding the Munich Academy in 1807. Having inherited the Dukedom of Berg, he removed the superb ducal collection of paintings from Düsseldorf to Munich in 1806. This proved an invaluable aid to the little masters of the day who taught themselves by copying Dutch seventeenth-century paintings.

The Munich naturalistic landscape school developed from the example of the Dutch seventeenth century. Artists such as Johann von Dillis and Ferdinand Kobell and his son Wilhelm all taught themselves by copying the work of the Dutch masters, notably the Ruisdaels, Wouwermans and Cuyp. Through constant sketching trips and studies from nature, however, they gradually evolved away from the Dutch tradition towards a new Realistic style.

Naturalistic landscape painting was Munich's particular forte, but the city also had gifted specialists in other fields. The Quaglio family had travelled north from Italy as theatrical scene painters but Domenico Quaglio the Younger became a distinguished painter of architectural views, something of a Biedermeier Canaletto.

Albrecht Adam, in contrast, arrived in Munich in the train of Eugène de Beauharnais, Napoleon's stepson and Max Joseph's son-in-law. Adam was a military painter who had accompanied Beauharnais on his campaigns; he settled down in Munich as a horse painter and his sons followed the same trade.

Carl Spitzweg was the most distinguished of Munich's Biedermeier genre painters. Having started life as a pharmacist, he taught himself painting in the 1830s by copying Dutch masters and painted humorous little scenes of petit-bourgeois life.

The Munich Kunstverein, or art club, was founded in 1824 by Domenico Quaglio, Joseph Karl Stieler, the portraitist, and Peter Hess, among others. The Kunstverein was the main support of the little masters of the Biedermeier period, organizing exhibitions and selling pictures to the new middle-class patrons. Peter Cornelius closed down the landscape classes at the academy and dismissed Wilhelm von Kobell, the professor of landscape painting, in 1826. An alternative to the academy was thus much needed.

Ludwig I lent the Kunstverein his official patronage. He did not share Cornelius's rejection of landscape painting as a genre and in Carl Rottmann he found the exponent of classical landscape most suited to his taste. He commissioned from Rottmann a series of landscape frescoes of Italy to ornament the Hofgarten arcades and a second series of Greece for the Neue Pinakothek. With sweeping brushstrokes Rottmann evoked the poetry of landscape; in this he has an affinity with Turner. His views were, nevertheless, naturalistically painted. He was the most respected landscapist in Germany in his day and his influence was considerable.

Albrecht Adam
1786–1862
The Artist and his Sons in their Munich Studio, 1835

IN A STUDIO especially constructed for horses, Adam is painting the white arab which was given to the Crown Prince of Bavaria by the Sultan of Turkey in 1833. He is surrounded by his artist sons: Franz behind him, Eugen at the second easel and Benno, the eldest, sitting sketching on the other side of the room. They recorded the event in two other pictures: Franz painted his father at work and Benno painted the two dogs that appear in this picture.

The group portrait of artists at work or play in their studios was a favourite subject in the Biedermeier period, with a treatment somewhere on the frontier between genre and portrait. The white horse and its two colourful Turkish attendants make Adam's version of the subject particularly exotic.

Albrecht Adam was a horse painter much favoured by princes, and especially patronized by Eugène de Beauharnais, Napoleon's stepson. Appointed court painter by Beauharnais in 1809, when the latter was viceroy of Italy, Adam accompanied him on the Russian campaign and painted many famous battles. After the fall of Napoleon, Beauharnais, who had married a Bavarian princess, retired to Munich and so did Adam. He turned from painting cavalry charges to depicting sporting scenes or farm horses at work.

In contrast to the Romantic battle painters of the French school, Adam was always a Realist and very much in his element among the talented group of Munich landscape and genre painters whose Realism won a popular following among the city's Biedermeier bourgeoisie. He was a founder member of the Munich Kunstverein, the exhibition society founded in 1824 by artists who found themselves out of favour with the academy.

Johann Georg von Dillis
1759–1841
View of the Tegernsee Looking towards the Quirinus Chapel, 1825

THE TREATMENT of the trees on the left of this picture, the choice of a sandy bank as a foreground feature, and the group of peasants seated at the edge of the path clearly come from the tradition of the seventeenth-century Dutch landscapists. Dillis taught himself by copying their work.

The view over the lake to the blue mountains in the distance is less composed. Dillis has sketched it from nature and translated his personal experience of it into paint. The two sides of the picture neatly illustrate Dillis's place in the evolution of Munich landscape painting from a tradition leaning heavily on the Dutch example to painting from nature in the open air. He is considered the founding father of Munich's nineteenth-century landscape school.

In the days before photography, noble travellers took artists with them to record their journeys and Dillis was much in demand to accompany German and English travellers. Gradually, however, the patronage of the Bavarian royal house came to exclude all other activities. He was given charge of the Hofgarten Gallery in 1790, appointed professor of landscape painting when the Munich Academy was founded in 1808, travelled to Italy several times with Crown Prince Ludwig and was given overall charge of all Munich's galleries in 1822.

This picture was a gift from Dillis to King Maximilian I for his name-day, 12 October 1825. In the distance can be seen the double towers of the old Benedictine cloister which the king had bought in 1817 and converted into a summer palace. It was a view close to the king's heart.

Dillis was one of the first artists to paint from nature in the Bavarian countryside and he successfully encouraged many friends and pupils to do the same. Most of his, nowadays highly regarded, open-air paintings have a sketch finish. The high finish of this painting reminds us that the artist himself would have considered such sketches only as preparatory studies.

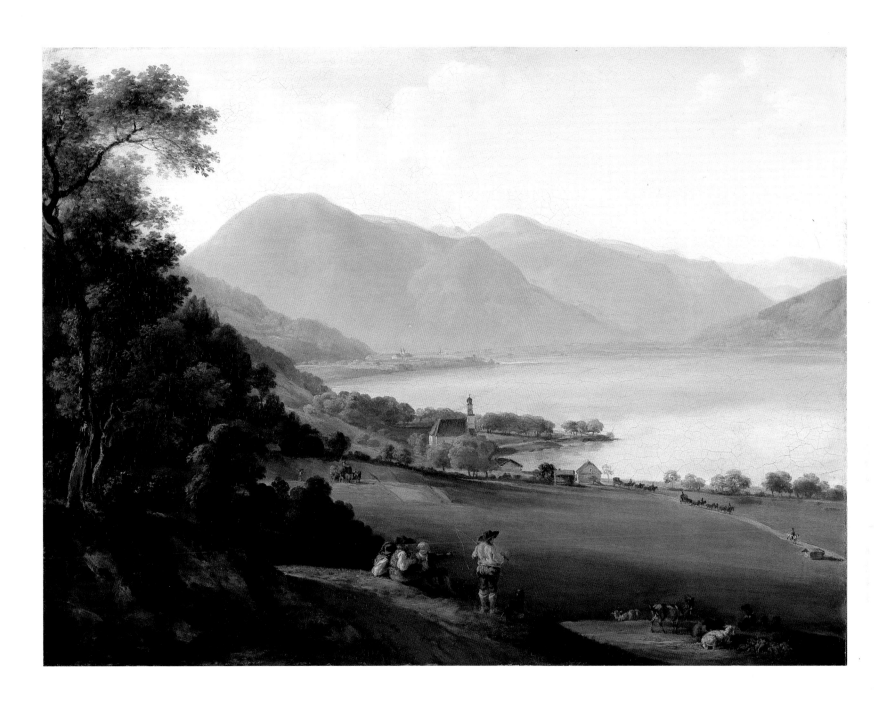

Wilhelm Alexander Wolfgang von Kobell

1766–1855

The Siege of Kosel, 1808

Landscape with the River Isar near Munich, 1819

View over the Tegernsee, 1833

KOBELL was the son of a landscape painter. His father Ferdinand modelled his style on the Dutch school and encouraged his son to do the same. Wilhelm received his technical training at the Mannheim Academy but his artistic vision was formed by steeping himself in the landscape art of the Dutch seventeenth-century masters.

Gradually he began to incorporate his own direct observations of nature into canvases which still echoed the Dutch school and it was not until he was about forty that the combination crystallized into an individual style.

The course of his development was characteristic of the Munich school, where, in the early years of the nineteenth century, Realist landscape painting grew out of imitation of the Dutch.

Kobell moved from Mannheim to Munich in 1793 to become the court painter of the Elector Karl Theodor who had himself made the same move when the old Wittelsbach line died out in 1778. In 1814 he was appointed professor of landscape painting at the Munich Academy but teaching was not his métier and his influence was slight. In 1826 the chair of landscape painting was suppressed by Cornelius, the new director, who considered history painting to be the only worthwhile endeavour.

Kobell's later paintings breathe the spirit of Biedermeier. Nature has been tamed and tidied. The figures are neatly decked out in their Sunday best. The clear sunlight denies the possibility of a storm. The charming little views were enormously popular with the new middle-class patrons of the arts who found in them a reflection of their own well-regulated lives.

The Dutch influence, particularly that of Wouwermans, is still very obvious in *The Siege of Kosel* of 1808. The Bavarian soldiers cast long shadows in the slanting light of dawn which bathes their hilltop vantage point in a rosy glow. The fortified town of Kosel is seen in the blue distance and, according to an inscription on the back of the painting, the officers are anxiously watching a sortie mounted by the besieged Prussian forces on 15 March 1806. The skeletal trees etched against the morning sky confirm the time of year.

The series of twelve large-format battle scenes commissioned from Kobell by the young Crown Prince Ludwig of Bavaria are the most important paintings inspired by the Napoleonic Wars in Germany. This is the first of the series which took the artist from 1808 to 1815 to complete. Kobell's careful study of light is already apparent in this picture. His perception of the way sunlight defines the modelling of figures allows him to render the soldiers and their horses with direct realism.

He made painstaking preparations for his battle pictures: portrait studies, studies of uniforms, and studies of individual figures and their poses. The landscapes were based on sketches by other artists of the locations of famous battles, though he visited several of them himself. The dominance of landscape in a broad overview of the scene is characteristic of his battle series.

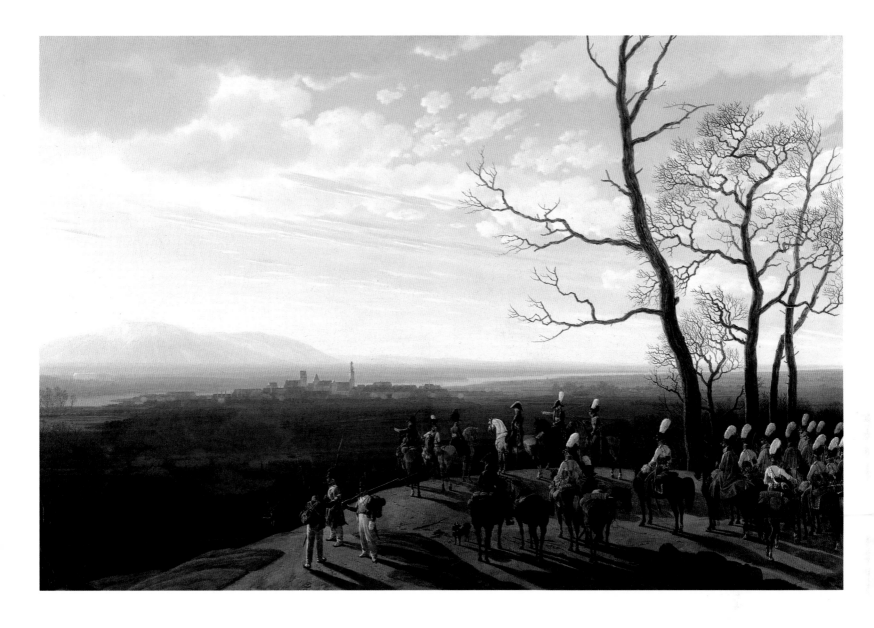

overleaf

Landscape with the River Isar near Munich is a painting of Kobell's maturity. There is perhaps still an echo of Cuyp in the golden sunlight that plays on the back of the white horse in the foreground but by the time he painted this picture he had developed his own, highly individual landscape style, which he was to repeat with innumerable variants in the decades ahead. A boy is playing the flute astride one of the three horses he has brought down to the river to drink. They stare placidly out over the river while the little dog in the foreground laps the water. To the left of the picture, two children attempt to shift a recalcitrant goat and where the well-watered verdure of the plain meets the sky the distant towers and rooftops of Munich can just be discerned.

WILHELM KOBELL. *Landscape with the River Isar near Munich*

Opposite. WILHELM KOBELL. *View over the Tegernsee*

View over the Tegernsee is painted in the same manner though fourteen years divide the two pictures. Kobell painted the Tegernsee repeatedly, together with other landscape vistas round Munich. His individual approach makes the paintings instantly recognizable.

A small group of figures, peasants in traditional dress and their animals, are regularly placed in a sunlit landscape with a low horizon and a lot of sky. The paintings are of small format and the clear colours are applied with a detailed precision that gives an almost enamel-like finish.

In this painting, a shepherdess in traditional Bavarian costume guards her small flock of sheep on a hill overlooking the Tegernsee. Two young friends, one carrying a lamb, climb the hill to join her. On the shore of the lake in the middle distance can be seen the old Benedictine monastery which the king bought in 1817 and converted into a summer palace.

Domenico Quaglio
1787–1837

North-East Side of the King's Palace with the Court Pharmacy in the Year 1828, 1828

USING THE SHARP CONTRAST between sunlight and shadow to clarify the outline of this complicated jumble of buildings, Quaglio achieves an effect reminiscent of Canaletto and the Venetian view painters of the eighteenth century who were an important influence on his work.

He shares their delight in textures, enjoying the plaster peeling from walls, and, like them, brings the architecture to life by the addition of small colourful figures. The figures in contemporary dress establish a sense of period. Elegant aristocrats, some on horseback, mingle with servants and workers.

The painting was commissioned by King Ludwig I of Bavaria and records how the north-east side of the Munich Residenz, or royal palace, looked before the architect Leo von Klenze built on a ballroom.

The low-roofed buildings to the left are the remains of the Neuveste wing which was burned down in 1750. The court pharmacy was accommodated here. A tall, narrow building, known as the 'Hirschgang' or 'deer walk', had previously connected the Neuveste to the guest's wing which stands at right angles to it. Behind can be seen the Hofgarten arcade and its entrance arch.

Domenico Quaglio was Munich's most distinguished practitioner of architectural painting – an important and popular field of art in the Biedermeier period. He belonged to a family of artists who wandered north from Italy in the eighteenth century, working mainly as theatrical scene painters. He himself worked at the court theatre in Munich from 1804 and was the official scene painter from 1808 to 1814. From 1819 onwards he devoted himself to oil painting. He helped found the Munich Kunstverein, became court painter, and was given responsibility for overseeing the restoration of Hohenschwangau by Crown Prince Maximilian in 1832.

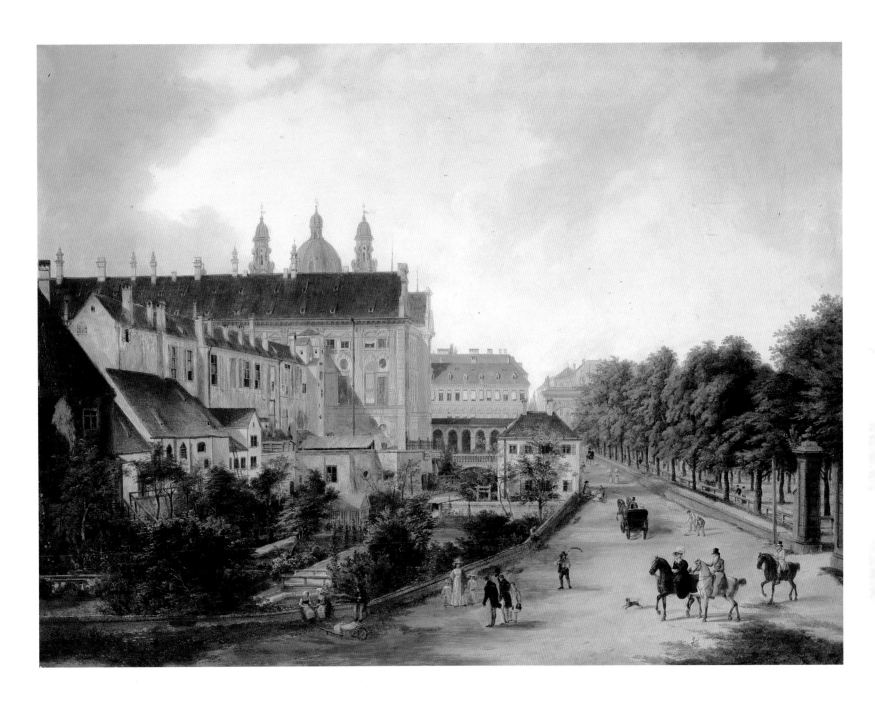

Lorenzo Quaglio
1793–1869
By the Starnbergersee, 1832

THE LADIES have put on aprons to protect their brightly coloured dresses while they tend the flowerbeds outside their charming two-storey home. A sportsman with a gun slung over his shoulder is talking to the older lady on the bench. The sunshine playing on the pretty, well-kept garden and the cheerful, industrious family creates a scene which epitomizes all that the Biedermeier middle classes held most dear: family, home, garden, and domestic virtue.

Beyond the garden on the right hand of the picture is the white bulk of Starnberg Castle and behind it the elegant little Josefskirche with its onion tower. It is a topographically correct rendering of the well-known village south of Munich and its lake, and is therefore probably a family portrait rather than an imaginary scene, but the identity of the family has been forgotten.

Informal group portraits in interiors are a characteristic development of the Biedermeier period, with the furnishing of the interior reflecting the personality of the sitters; this is an extension of the same approach: the family is grouped in the garden whose well ordered prettiness mirrors their character.

Lorenzo was the younger brother of Domenico Quaglio, the most famous member of this large artistic family. Like Domenico, he was taught by his father, Joseph, and worked as a scene painter at the court theatre in Munich. He became one of Munich's leading genre painters, on a par with Heinrich Bürkel and Peter von Hess, painting outdoor scenes of the lives of both peasants and the bourgeosie.

Carl Rottmann
1797–1850
The Kochelsee, 1823

THE SLANTING, early morning light still has a hint of pink in it as it catches the middle distance, half the lake and a rocky peak beyond it, leaving the foreground in shade. The hazy blue of the distance reflects the recent passing of a storm.

During the nineteenth century Rottmann was the most highly acclaimed of all German landscape painters. He paints the poetry of nature, an epic of majestic mountains, ancient ruins, blue seas. He is said to have been influenced by the work of Turner, and he shares with the English painter this poetic approach.

His foregrounds are generally loosely sketched inventions. His interest lies in the overall structure of the view: he has an almost architectural approach to the way in which it is built up. Sunlight is used to bring out the modelling of this structure and to heighten its poetic impact.

His classical landscapes – views of Italy, Sicily and Greece – are his most famous works, but this early view of a lake in the Bavarian mountains already reveals his individual style. Having studied with his father in Heidelberg, he arrived in Munich in 1822; Koch was the first important influence on him – he carefully copied one of Koch's mountain landscapes. Koch's feel for the majestic architecture of mountains is brilliantly assimilated in this view of the Kochelsee.

Although the romantic mood of the view has been consciously heightened, the landscape is realistically painted. Rottmann went on a sketching expedition in the Bavarian mountains in the summer of 1823. On 7 July he wrote from Murnau to his fiancée in Munich to tell her that he could not finish his painting of the Staffelsee because the light had gone, and that he was moving on to the Kochelsee. (See also *Palermo*, p. 183.)

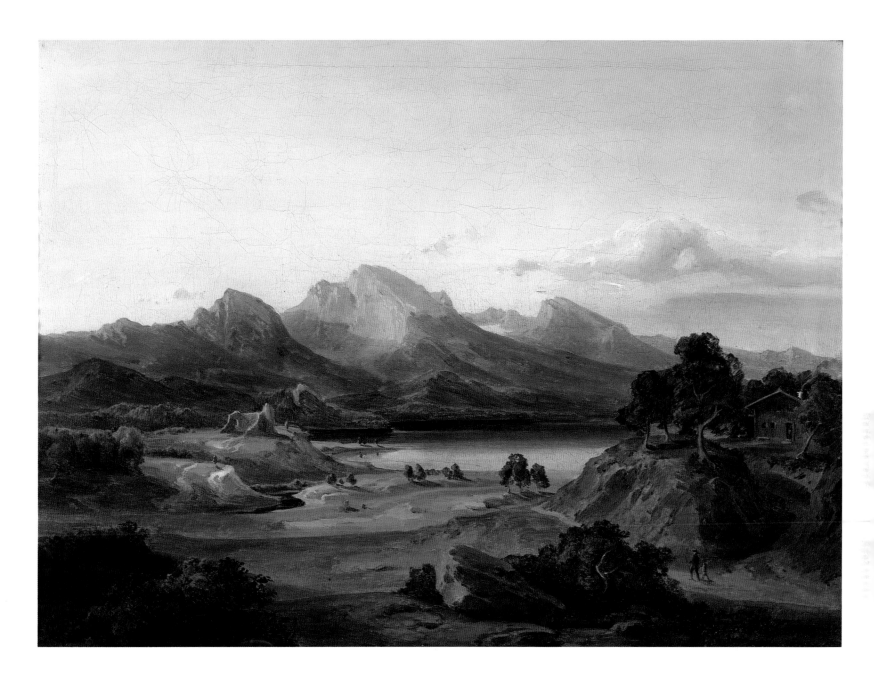

Moritz von Schwind
1804–71
The Visit, c.1855

THE SCENE IS SET in Frau Schwind's sitting room. A friend has come to visit her and they have been reading a letter together. The artist's wife still holds the letter in her hand while the friend points out on the wall map some place mentioned in it.

Schwind has enjoyed painting his wife's room, paying special attention to the textiles, the striped tablecloth, the pink sofa, the embroidered cushion and the embroidery with velvet edging with which the chair in the foreground is upholstered.

The painting belongs to a series of some forty small oils known as 'Reisebilder' which Schwind painted between 1848 and 1864, mainly for his own pleasure. Their subject matter ranges over fairy story, legend and contemporary genre. (See p. 16 for Schwind's *Erl-King*.) They combine strong, confident brushwork with a highly individual poetic note and are considered among his best paintings.

Schwind studied at the Vienna Academy from 1821 to 1825 while earning his living by painting vignettes, fashion plates, New Year cards and similar saleable graphics. Much of his working life was devoted to illustration; his woodcut illustrations to fairy stories helped create a new style of art. He also designed fresco cycles to decorate numerous public buildings and private castles, taking his subjects mainly from German legends. Important fresco commissions from King Ludwig I of Bavaria meant that he spent much of his life in Munich.

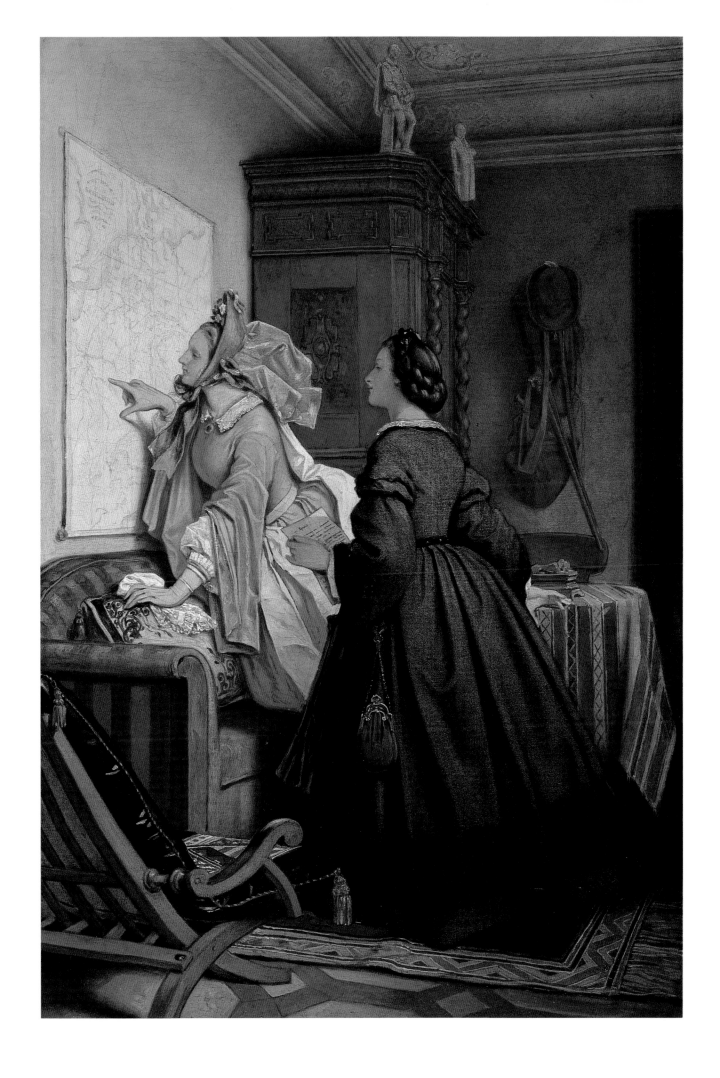

Erwin Speckter
1806–35
The Artist's Four Sisters, 1825

HERMINE, the eldest sister, holds the youngest, Adelheid, in her arms. Malwine is shown in profile on the left, holding a flower to amuse the baby. Adelheid already has a floral trophy in one hand but is keenly interested in the second spray. To the right Ida stares straight out of the picture with folded arms.

The simple, hard-edged grouping springs from a conscious endeavour to imitate early Italian painting. The sisters are enclosed in a round medallion and the four corners are painted gold to imitate the effect of a gold ground panel.

Speckter had been profoundly affected by Overbeck's *Entry into Jerusalem* which he saw in Lübeck in 1823. Overbeck was one of the leading German Nazarenes. In this painting the spiritual simplicity of the Nazarene style has been applied to a characteristically Biedermeier subject, a bourgeois family group, to create a striking and ornamental picture.

The painting demonstrates how different artistic currents can combine. The format is Nazarene and the subject Biedermeier while the portraits are painted with a direct Realism characteristic of the Hamburg school.

Speckter studied in Hamburg, a pioneering centre of Realist painting, and enjoyed the early patronage of Baron Rumohr, an art historian specializing in early Italian painting. He then went on to work in Munich with Peter Cornelius, another Nazarene painter, and spent 1830 to 1834 in Rome.

Carl Spitzweg
1808–85
The Poor Poet, 1839

✿

IN STRIPED DRESSING GOWN and nightcap, his quill pen secured in his mouth, the poor poet is rereading his verses. The finger and thumb of his right hand are pressed together in a gesture of exquisite appreciation. Lost in his art, he is oblivious to his surroundings.

The leaking roof is controlled by a tattered umbrella, his books with broken bindings are piled beside him on the floor while his green tiled stove is about to consume some of his earlier work. The pages that have been half pushed into it are entitled 'Operum meor(um) fasc(iculum) III' or 'My work, part III'.

The painting is highly finished and the textures of still-life features, such as the transparent bottle and broken box, are captured with extreme finesse. The art historian Hermann Uhde-Bernays described these very detailed early paintings of Spitzweg's as 'painted drawings'.

Spitzweg was the quintessential delineator of Biedermeier Germany. His humorous little paintings are devoted to the lifestyle of the petit bourgeoisie, most often single figures set in a landscape or townscape. Spitzweg himself came from this milieu. He trained as a pharmacist and it was a chance meeting with a group of artists at Bad Sulz, where he was recovering from an illness in 1833, that turned him to painting.

Considering himself to be too old to attend the academy, Spitzweg taught himself to paint by copying the work of seventeenth-century Dutch masters in the Pinakothek. He became a successful humorous illustrator, working for the *Fliegende Blätter* in Munich and other publications. A visit to Paris in 1851 brought him into contact with Delacroix and Diaz, whose fluent, approximative brushwork he emulated in his later work with great success.

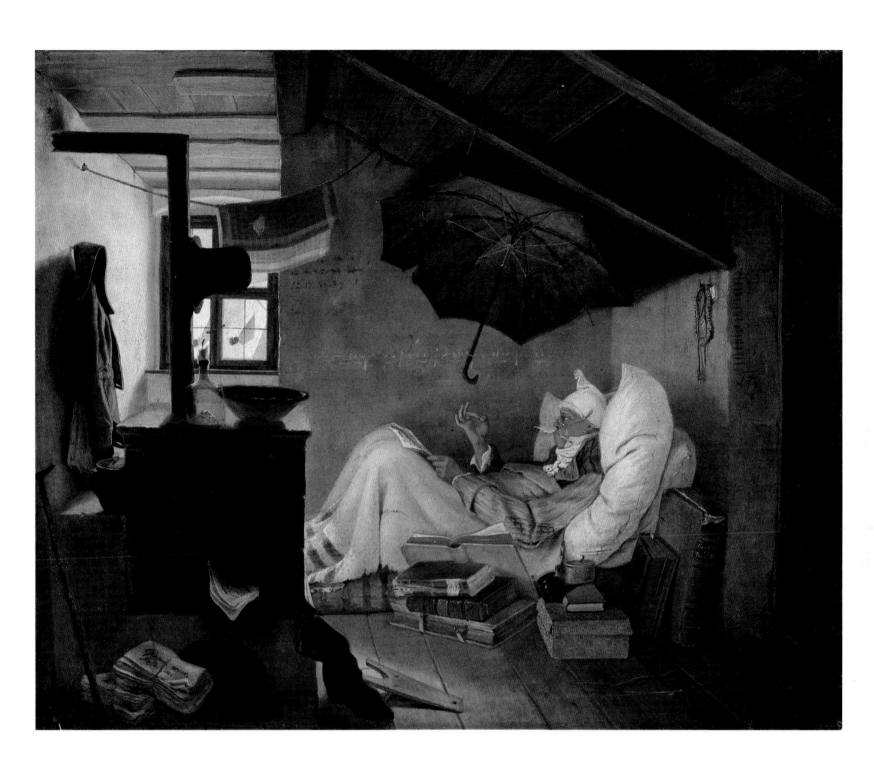

Joseph Karl Stieler
1781–1858
Amalie von Schintling, 1831

WITH JEWELS IN HER HAIR, pendant pearls in her ears and a rope of pearls around her neck, Amalie von Schintling is a sophisticated beauty. Her curls have been arranged by an expert and a red cashmere shawl, very fashionable at the time, is cast carelessly over her shoulder.

Ludwig I of Bavaria commissioned Stieler to paint the portraits of all the most beautiful women of his realm. The famous Schönheitengalerie, now housed in the Nymphenburg Palace outside Munich, contained beauties of every social class from peasant to aristocrat, all of them dressed for a gala occasion. Amalie's long nose, full lips and dark eyes have a hint of *hauteur* which marks her out as the aristocrat.

Stieler studied in Paris with Gérard, the favourite portraitist of the Napoleonic era, and it was there that he learned his smooth modelling and high finish. Although his portraits are always carefully posed and ornamental, he is not much interested in the character of his sitters. His works are rather cold and glassy.

He started his career as a miniature painter working in various German cities, but in 1800 left for Vienna to study with Füger, whose freely painted portraits were inspired by the English school. Here Stieler began to paint portraits in oils. He went on to spend 1807 to 1808 in Paris and 1811–12 in Rome.

He worked extensively for Maximilian I of Bavaria and was named court painter by his successor, Ludwig I. In 1824 he was one of the moving spirits behind the foundation of the Munich Kunstverein.

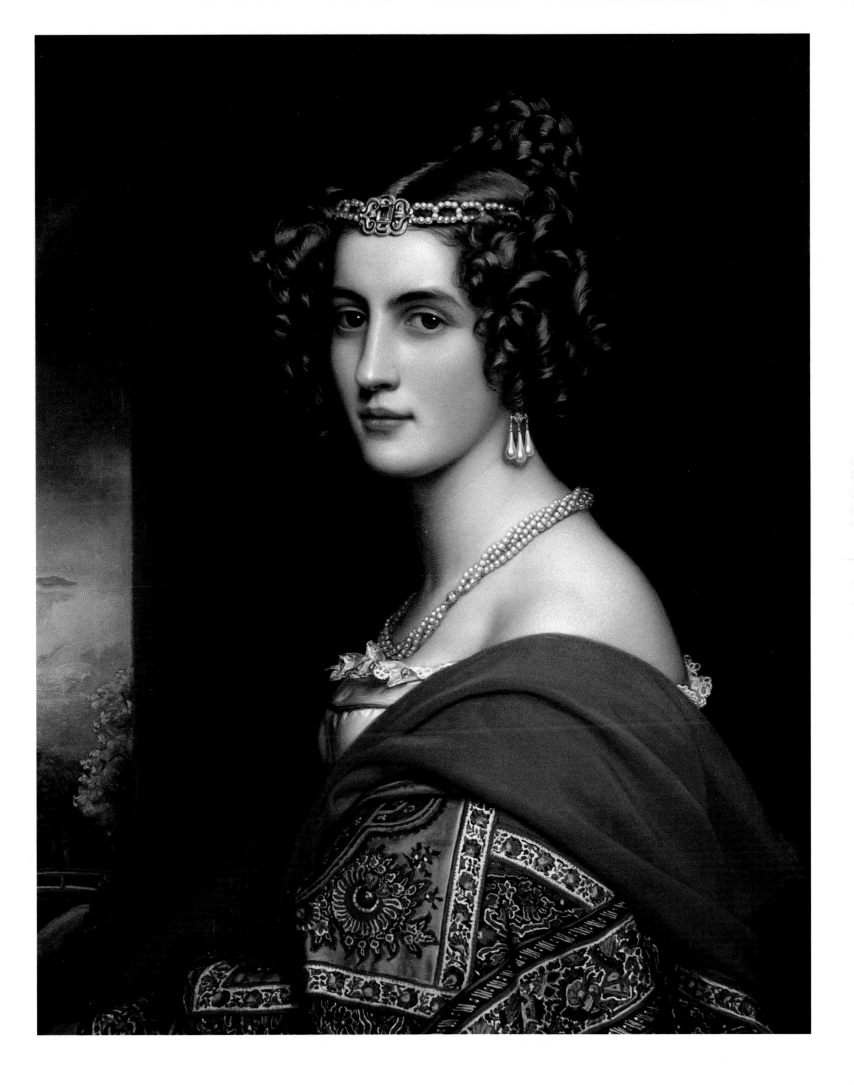

DÜSSELDORF

DÜSSELDORF was the historical seat of the Dukes of Berg. The dukedom had passed by marriage to the Electors Palatine in the eighteenth century and then, together with the Palatinate, to Bavaria. For this reason Düsseldorf's great art collection was removed to Munich in 1806. The territory was occupied by Napoleon and the Congress of Vienna gave it to Prussia. During the Biedermeier period, Düsseldorf was thus the principal city of Prussia's Rhineland province.

The Düsseldorf Academy had begun life in 1769, growing out of a drawing school run by the curator of the ducal art collection. When the collection was moved to Munich, the director of the academy went also, and it seemed unlikely that the institution would survive. The Prussians, however, decided to reopen it, hoping both to enhance the city's importance and to please its inhabitants.

After casting around for a sufficiently distinguished artist to appoint as its director, they selected Peter Cornelius, the Nazarene who was already in Munich working on frescoes for Prince Ludwig's Glyptothek. Cornelius was director from 1821 to 1824, during which time the academy was almost exclusively devoted to the preparation of fresco cartoons.

In 1824 Cornelius was replaced by Wilhelm Schadow, another Nazarene, but one with a gift for teaching and administration which made the Düsseldorf Academy one of the most highly regarded art schools in Germany. Schadow was followed from Berlin by a group of his students, including Karl Friedrich Lessing, Carl Ferdinand Sohn, Ferdinand Hildebrandt and Eduard Bendemann. Their melancholy, rather theatrical, history paintings were admired throughout Germany and gave the school its initial high reputation.

Lessing became the pioneer of Realism within the Düsseldorf school. In 1832 he discovered in the Eifel district a wild landscape that exactly suited his taste; thereafter his views are careful studies of nature for which he even researched geological formation. Johann Wilhelm Schirmer accompanied Lessing on numerous sketching trips and his early work includes some remarkable landscape studies. A visit to Italy in 1839–40 gave him a taste for classical landscape which greatly enhanced his contemporary reputation though today it is looked on as a fall from grace. In his pupil Andreas Achenbach, however, Düsseldorf nurtured a Realist landscape painter of international fame. Enormously prolific, he was at his best in his pre-1848 pictures, rather lapsing into formula in later works.

Political feeling against the authoritarian rule of Prussia ran particularly high in its distant Rhineland province and Düsseldorf artists became actively politicized in the years leading up to 1848. They rallied around Lessing in the name of Realism, becoming sharply critical of Schadow and the academy's traditionalist attachment to history painting. Several of them, including Achenbach, Johann Hasenclever and Carl Hübner, joined the citizens' army and fought on the barricades in 1848.

Lessing himself veiled his political criticism by painting historical rebellions with obvious contemporary parallels. He lost his teaching post at the academy as a result of his paintings of the Hussite rebellion. His younger colleagues used contemporary genre painting to convey a political message.

Hasenclever gave substance to the young artists' rebellion against the academy in his charming *Studio Scene*, which pokes fun at the theatrical props used by history painters. He also painted some memorable images of the 1848 uprising. Hübner's genre scenes, notably *The Silesian Weavers* of 1844, depict the sufferings of the poor with theatrical gusto.

Andreas Achenbach
1815–1910
Landscape, c. 1833–39

WANDERING ON FOOT through wild country, particularly mountains and forests, was the delight of artists and students of this period. Love of nature was a characteristic feature of Biedermeier Romanticism. It was inspired, as elsewhere in Europe, by Jean-Jacques Rousseau, and found outlets in poetry and song.

Achenbach has caught two student wanderers resting by the roadside. They are characteristically dressed and equipped: a leather pack covered in green oilcloth, a light coat, a peaked hat and a strong wooden staff.

The scene has not been dramatized, but it is imbued with the artist's own delight in nature: the play of light and shade on the rocks and mountainous scrub and the noble pines outlined against the sky. The hunched shepherd in a blue coat following his flock down the mountain track embodies the intimacy of peasant life with nature which the Romantics so admired.

Achenbach was one of the pioneers of Realist painting in Germany, a leading figure in the influential Düsseldorf school. He sought to portray the poetry of everyday nature, developing free, approximative brushwork which can be compared to Constable in England and Théodore Rousseau in France.

This is a comparatively early work. He was a child prodigy, entering the Düsseldorf Academy at the age of twelve and exhibiting at the Kunstverein at fourteen. A visit to Holland in 1832–33 established his interest in naturalistic landscape painting but it was his sketching trips in Italy and Norway – on which, no doubt, he was dressed much as the young men in this picture – that inspired his main *oeuvre*. The oil paintings were worked up from sketches in the studio and this sometimes led to over-elaborated compositions. Achenbach was an enormously prolific artist.

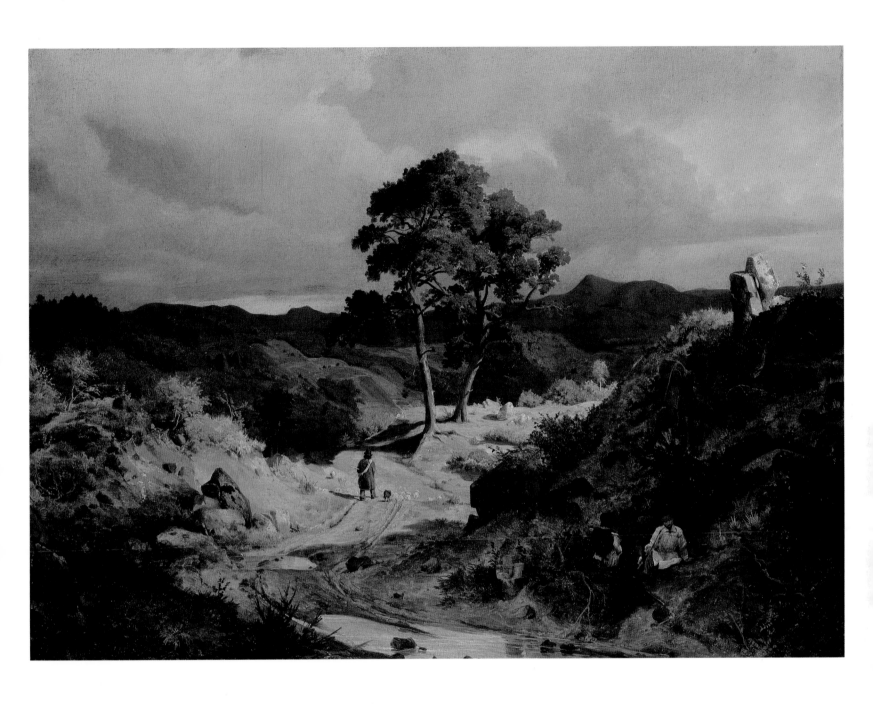

Johann Peter Hasenclever
1810–53
Studio Scene, 1836

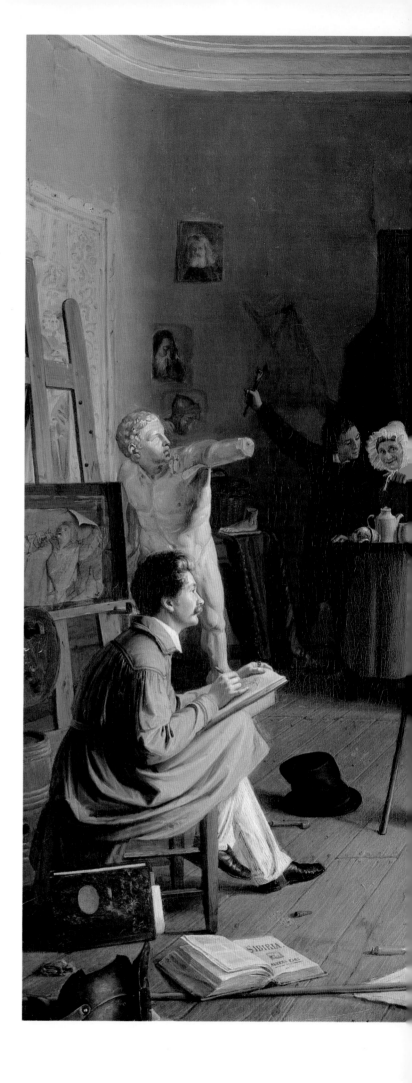

IN A STUDIO of the Düsseldorf Academy six young artists boisterously exhibit their disdain for academic teaching. A direct act of rebellion, the painting is signed by all six of the artists depicted, though Hasenclever's hand is the principal one.

At the centre of the picture two artists parody the pose of the Borghese *Gladiator*, a famous classical sculpture; a plaster cast of it has been pushed to the side of the room. Drawing from casts was a central component of academic instruction, a lesson not only in human anatomy but also in how to improve on it to conform to the classical ideal.

Major history paintings, then considered the highest form of art, were generally painted on large canvases. The back of such a canvas is depicted here used as a partition. A painter's smock hangs over the top. A lay figure, or life-size doll, used as a compositional aid, is slung carelessly over Hasenclever's shoulder as he walks across the background of his painting. Among the debris in the foreground lie the rejected props from the medieval romances much favoured by older Düsseldorf artists – a sword, helmet, lantern and skull.

Hasenclever was a leading Düsseldorf Realist and this painting is in effect the group's manifesto. He specialized in humorous scenes from the life of the proletariat and the petit bourgeoisie. British artists, such as Hogarth, Rowlandson and Wilkie were an important influence on his work.

He was a founder member of the Düsseldorf Malkasten, a self-help society formed by artists who found themselves at odds with both the 'official' art of the academy and the Kunstverein, the local exhibition society. The same spirit of rebellion is reflected in his paintings of the 1848 uprising. He was one of a group of artists who joined the Bürgerwehr, or citizens' army, which manned the barricades in 1848.

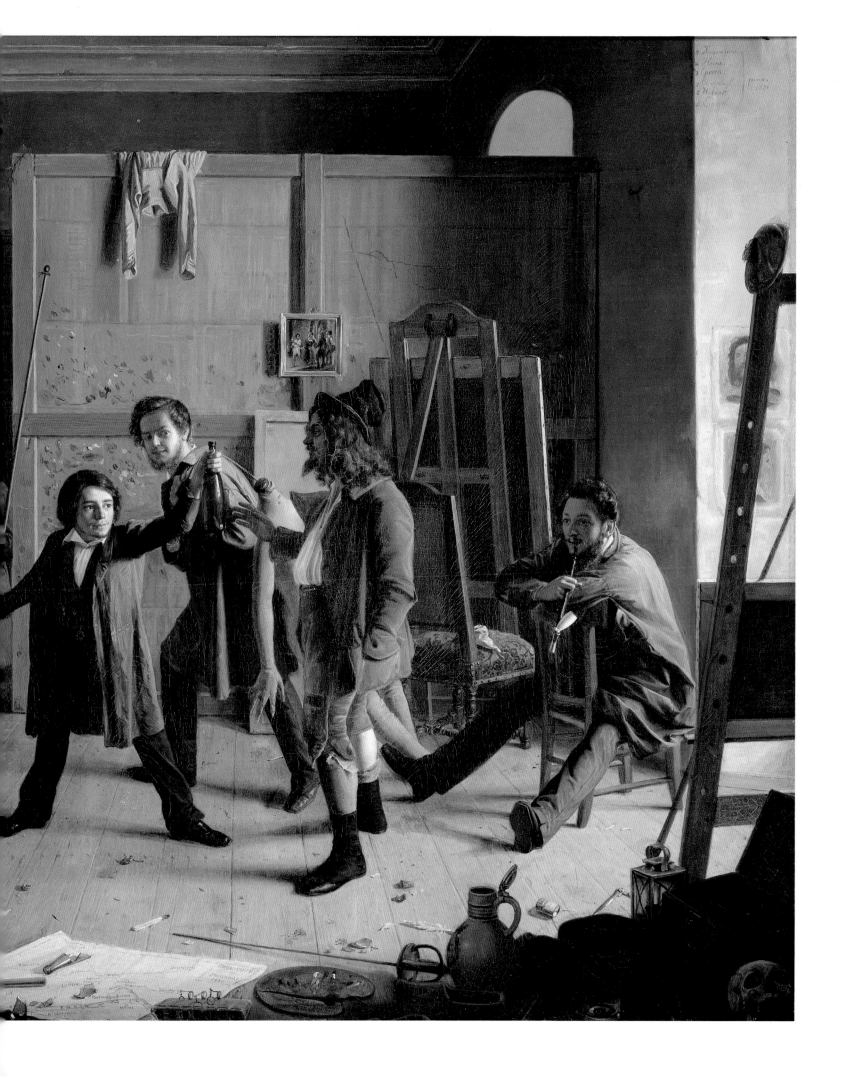

Wilhelm Joseph Heine
1813–39
A Service in the Prison Chapel, 1837

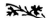

MOONLIGHT pours through the window to illumine the varied response of the congregation to a service conducted out of the picture to the right. Heine's keen observation of character and psychology place him among the leading Realists of the Düsseldorf school and with this picture he pioneered a new genre of political critique.

The prisoners include student revolutionaries and political agitators as well as weavers who had risen in protest against their conditions shortly before. Heine reinforces his identification with the downtrodden by painting his own portrait as a young weaver in a smock; he is caught by a shaft of moonlight in the left foreground as he turns to stare at the armed Prussian guard.

The old man leaning against the central pillar is thought to represent Friedrich Ludwig Weidig, the priest and political agitator who had committed suicide in prison shortly before. In more cheerful vein, a young student is seated on top of the pew at the back reading a book and paying no attention to the service.

Heine studied at the Düsseldorf Academy from 1829 to 1838. His death the following year cut short a promising career. He left a handful of paintings demonstrating a powerful grasp of composition and colour.

He painted portraits and genre scenes with pronounced political overtones. His early works romanticized the lives of outlaws, such as smugglers and poachers, in the story-telling mode favoured by Lessing and the older generation of Düsseldorf artists. His later works belong to the Realist generation.

Carl Wilhelm Hübner
1814–79
The Silesian Weavers, 1844

❦

THE RICH MANUFACTURER rejects the cloth that a poor weaver has brought him and she sinks to the ground in despair, casting her eyes to heaven. The Silesian weavers worked in their own homes and depended for their living on the manufacturer who controlled the trade. Here they are shown bringing in their cloth for checking and the emotions depicted range from hope to misery.

In the years running up to the 1848 revolution, the cause of the downtrodden masses was espoused by a breakaway group of Düsseldorf artists, whose politically inspired paintings received a rapturous reception. Hübner was a leading exponent of the genre and *The Silesian Weavers* was mobbed when it was exhibited in Berlin in 1844. In the same year it was shown in Cologne, Düsseldorf, Halberstadt, Frankfurt and several other cities.

Engels commented that the picture 'made an enthusiasm for socialist ideas acceptable'. Its impact relies on careful realistic detail, on one hand, and a theatrical presentation of emotion on the other. The uneven flagstones and the poor weavers dressed in their Sunday best on the right of the composition are contrasted with the richly garbed merchant on the left, standing on a carpet with a hound at his feet. A luxuriously appointed office, bathed in warm lamplight, is glimpsed behind him.

Hübner entered the Düsseldorf Academy in 1838 and set up his own studio in 1841. He was a strong supporter of the Realist, anti-academic faction in the Düsseldorf art community and was one of a group of artists who joined the Bürgerwehr, or citizens' army, in 1848. His later work, lacking political edge, lapsed into sentimentality.

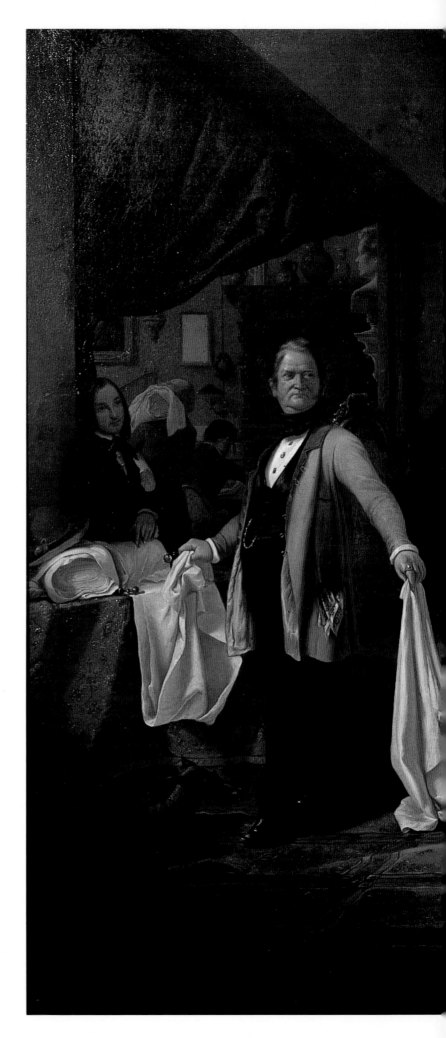

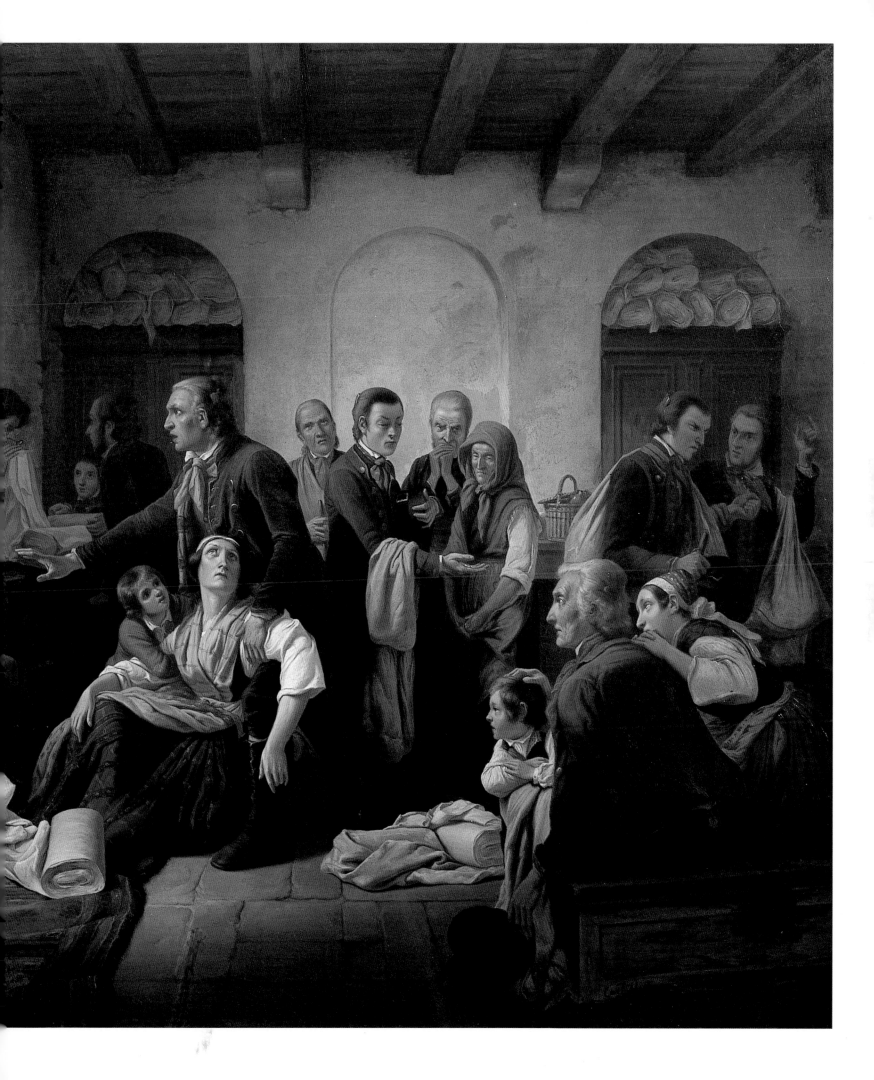

Alfred Rethel
1816–59
The Harkort Factory at Burg Wetter, c.1834

WITH A CLEAR BLUE SKY above, the sunlight plays on the contrasting textures of brick factory buildings, the elegant white plaster of an eighteenth-century residence, and the remains – tower and ramparts – of the medieval fortress which had originally crowned the hilltop.

Rethel has approached the industrial view much in the spirit of Canaletto and the Venetian view painters. He models the architectural complex with sunlight and shadow. The buildings are given a human dimension by the inclusion of small figures walking to work or idling. And he takes special pleasure in rendering the textures of crumbling old brick and plaster.

The exact date of the painting is not known but it is considered one of the first important paintings of the industrialization of Germany; a similar painting by Blechen dates from 1834.

The machine building workshop at Burg Wetter was opened in 1819 and the first blast-furnace in 1826. In 1829 Rethel's father was hired as a bookkeeper and worked there until 1837.

Rethel began his artistic schooling at the Düsseldorf Academy in 1829 at the age of only thirteen. This work was painted when he was about eighteen. Though highly accomplished, it is most uncharacteristic. Rethel made his name as a history painter and his talent in this field was recognized early in his career at the academy. His style was strongly influenced by the Nazarenes.

His later work contained an element of weird fantasy. His Dürer-esque woodcuts, *Another Dance of Death, in the Year 1848*, with their political overtones, are now more famous than his paintings and are often compared to the work of Daumier in France. He went mad in 1853.

Friedrich Wilhelm von Schadow
1788–1862
Portrait of a Young Woman, 1832

THE YOUNG GIRL has an enigmatic half-smile reminiscent of Leonardo's *Mona Lisa*. Her aubergine gown hovers in style between the Renaissance and the nineteenth century, while the landscape background – a series of rolling blue hills – is also an echo of Italian Renaissance painting. The twisting vine leaves that frame her head play a decorative role and are a romantic evocation of the South.

Schadow belonged to the group of German painters known as the Nazarenes who sought to breathe new life into German painting by imitating the religious purity of early Renaissance art. He became a member of their Brotherhood of St Luke in 1813 and converted to Catholicism a year later. The influence of his years in Rome (1811–19) dominated his work for the rest of his life, in religious pictures and portraits.

The clear outline and highly finished modelling of this painting owe a clear debt to Raphael. They are characteristic of Schadow's work and that of the other Nazarenes. The same stylistic influence can be traced in many German figure painters of the Biedermeier period.

Schadow himself was an influential teacher. The son of a distinguished Berlin sculptor, Gottfried Schadow, he became a professor of painting at the Berlin Academy in 1819. In 1826 he was appointed director of the Düsseldorf Academy and such was his popularity as a teacher that many of his pupils followed him to Düsseldorf. Under his direction the Düsseldorf Academy became one of the most highly regarded art schools in Germany and attracted many students from abroad.

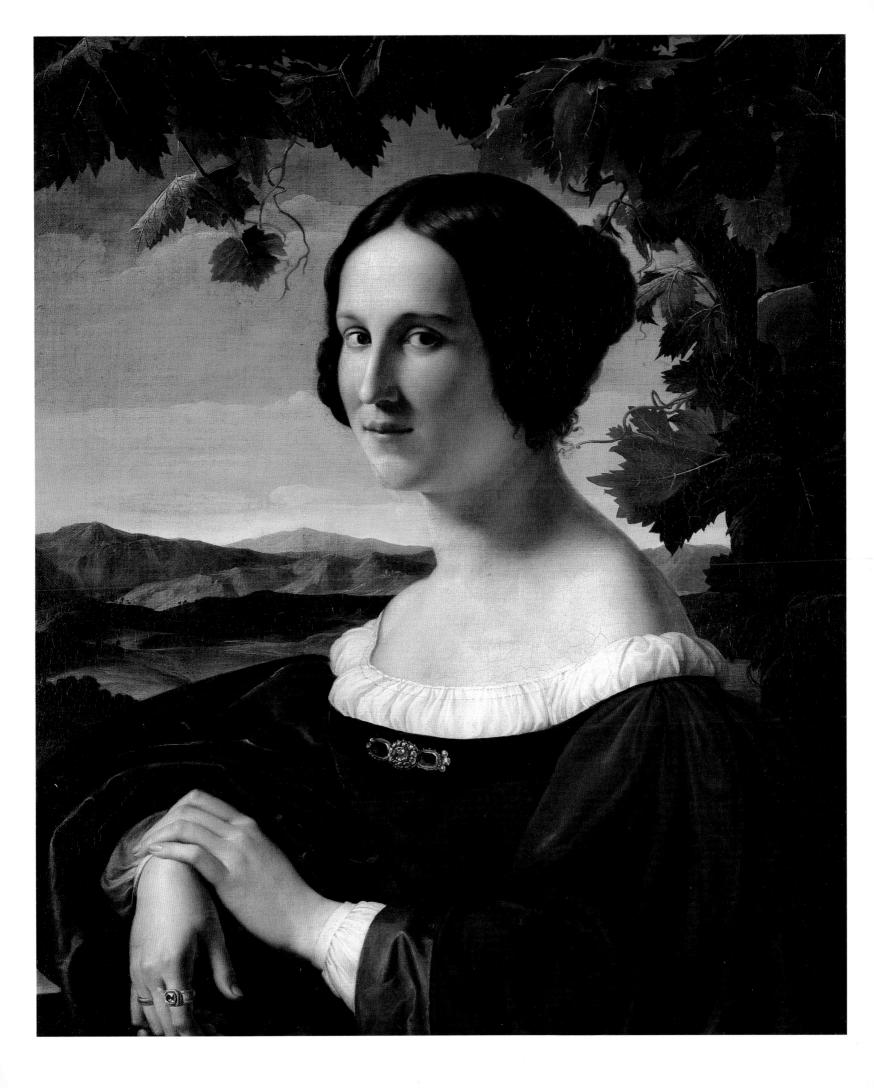

Johann Wilhelm Schirmer
1807–63
Romantic Landscape, c. 1828

A SHEPHERD BOY, caught in a shaft of sunlight, stands in the river valley looking up at the ancient castle that crowns the opposite hill. It is a lonely dwelling surrounded by wild, craggy mountains.

The picture is built up from different views in the Eifel district where Schirmer and his brother had been on a sketching holiday. The rocky hillside on the left is near Altenahr while the river valley is south-west of Altenahr, near Kreuzberg. 'We were passionate about seeking out and sketching the remains of fortresses and castles,' Schirmer wrote in his memoirs. The fortress of Altenahr is shown in this picture.

Schirmer, the son of a bookbinder, began his studies at the Düsseldorf Academy in 1825. He and Lessing together developed a style of Romantic landscape painting, of which this is a notable example, which evoked medieval legend – the world of robber barons in lonely castles. In a period of burgeoning nationalism, the Middle Ages were seen to symbolize the greatness of the German spirit and landscapes such as these were much admired, adding to the fame of the Düsseldorf school.

The shepherd boy in the foreground would have been interpreted by contemporaries as a reference to Uhland's poem, 'The Chapel'; a shepherd boy gazes up at a chapel, little thinking that he will soon be carried up there to his grave.

Although the composition is outspokenly Romantic, the execution is Realistic, reflecting Schirmer's careful studies of nature.

Peter Schwingen
1813–63
The Distraint, 1846(?)

A YOUNG WORKMAN has fallen into debt and his creditor, a man so rich that his yellow waistcoat will hardly stretch over his paunch, has arrived with a clerk to remove the family's meagre possessions. Schwingen highlights the contrast between the poverty of the interior and the obvious wealth of the creditor, with his grey top hat, twinkling gold watchchain and ringed fingers.

The wife kneels pleading while her husband hangs his head in shame. The crucifix and the engraving of 'Christ carrying the Cross' on the wall behind him imply that this is the cross the young man has to bear. A pathetic pile of shopping basket, saucepan and coffee-grinder lies on the floor in front of him, while to the right two men dismantle a stove and carry it off.

It is a masterly piece of painting with the fashionable high finish. Schwingen had attended the Düsseldorf Academy from 1832 to 1845, studying with Hildebrandt and Sohn, both famous for their melancholy scenes from history. Schwingen has adopted the same story-telling approach but applied it to a contemporary scene.

The picture was painted a few years before the 1848 revolution and is a clear political comment. Many Düsseldorf artists became highly politicized at this time. Their pictures, representing the sufferings of the poor, proved very popular.

Schwingen's contemporary fame was based on genre paintings, such as this one, which tended to be theatrical in their presentation, as was the fashion of the Düsseldorf school. He also painted portraits and portrait interiors with more objective realism.

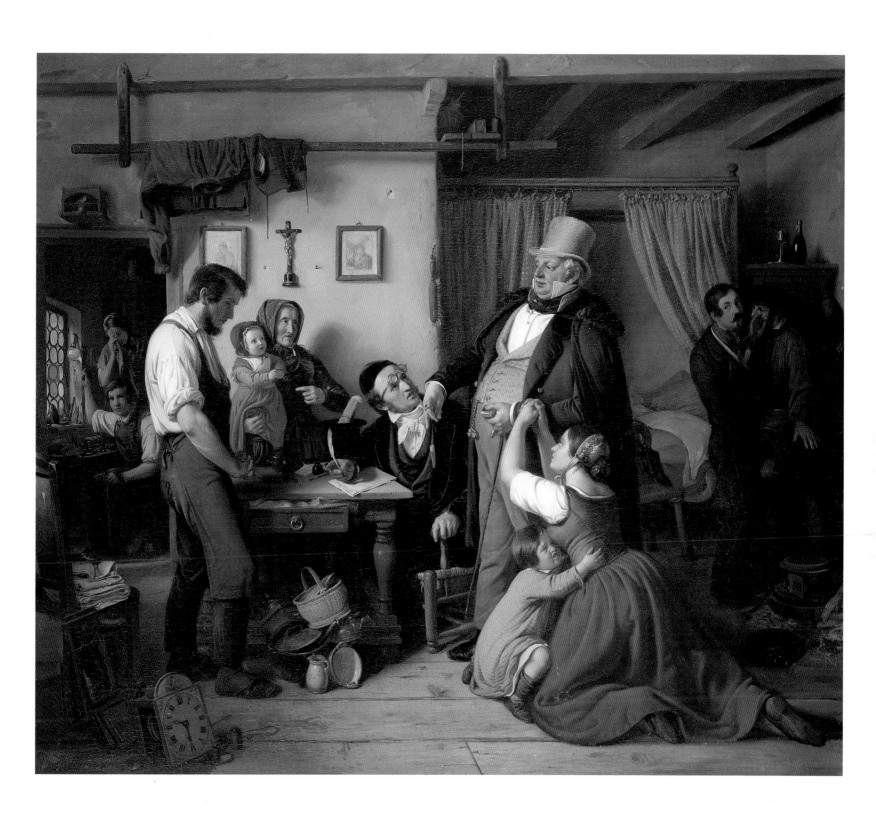

DRESDEN

Saxony, like Bavaria, was made into a kingdom by Napoleon in 1806 but, having sided with the French, saw half its territory handed over to Prussia by the Congress of Vienna. Industry began to flourish there under the first king, Friedrich August I (1806–27), while the second, Anton I (1827–36), reformed the legislation of the country, instituting a liberal constitution.

In the troubled years between 1800 and 1815 Dresden was the leading centre of Romantic painting in Germany. Caspar David Friedrich settled there in 1798 after his student years at the Copenhagen Academy while Philipp Otto Runge worked there on his mystical allegories of the *Times of Day*. The city attracted less acclaim from contemporaries during the Biedermeier epoch but nevertheless made an outstanding contribution to Realist painting in Germany.

Friedrich's famous Romantic landscapes in which Gothic ruins, gnarled trees, lonely figures and moonlight are used to convey a very personal religious symbolism date from the early years of the century. From 1820, when he began to share a house with Johan Christian Dahl, he also shared the latter's fascination with naturalistic landscape painting.

Dahl and Carl Gustav Carus, another outstanding landscape painter, tend to be treated as followers of Friedrich but both in fact arrived in Dresden as fully fledged artists and both influenced Friedrich's work. Friedrich never visited Switzerland and his views of snow-capped mountains and glaciers are based on Carus's sketches which Carus himself also worked up into striking oil paintings.

Carus was a remarkable polymath. He was the court physician in Dresden, where he settled in 1814, and doctoring was his principal

career. He was nevertheless an artist of professional standard and also a writer. He approached landscape rather as he approached anatomical drawing, faithfully reproducing what he saw. His was, however, a poetic vision and he gloried in the drama of colour and line that he found in nature.

Dahl was a Norwegian who had been sent to the Copenhagen Academy in 1811 as a child prodigy. In Copenhagen he rapidly turned into a master of architectural and landscape painting. It was after he arrived in Dresden in 1818, however, that he made his unique contribution to the Realist generation. Like Constable in England, he concentrated on capturing fleeting effects of weather and atmosphere, making many cloud studies. His rapid oil sketches of the countryside around Dresden are among the great achievements of northern landscape painting. He became a professor at the Dresden Academy in 1824 and influenced many younger artists.

The nearby Meissen porcelain factory provided employment for two other major figures of Biedermeier painting in Dresden. Georg Friedrich Kersting moved from the Copenhagen to the Dresden Academy in 1808 and became a close friend of Friedrich. From 1818 he was head of the painting section at the Meissen factory. His interiors, usually with a single figure, lie on the borderline between portrait and genre but surpass the achievements of other Biedermeier Realists in this field. Effects of light in an enclosed space are his chief preoccupation and give an extra poetic dimension to his careful realism. His work has often been compared to that of Vermeer.

Ludwig Richter taught drawing at the Meissen factory from 1828 until 1835, when he became a professor at the Dresden Academy. His woodcut illustrations to children's books – sugary images of pastoral or fairy romance – are an embodiment of the Biedermeier spirit and the foundation of his lasting fame, but he was also a notable landscape painter. In his early years he was influenced by Koch and the Salzburg landscape painters but after he settled in Dresden he developed a cosy style of little landscapes peopled by peasants. Set more or less interchangeably in Italian or German scenery, they owe an obvious debt to Dutch peasant scenes of the seventeenth century.

Carl Gustav Carus

1789–1869

The Mer de Glace near Chamonix, 1825–27

THE ALPS appealed strongly to citizens of the Biedermeier age, whose romantic yearnings were encouraged, rather than stifled, by the limitations of small town life. The scenery spoke to them of the majesty of untamed nature, while the historical independence of the Swiss cantons spoke of political freedom. Carus's painting embodies this romantic idealism.

It was elaborated in his Dresden studio from sketches he had made in Switzerland and the French alps in September 1821. He retained the powerful emotional impact the view had made on him and translated it into paint with extraordinary success. His diary records it: 'Beyond anything, this view over the sea of ice, with its blue-green, eternally motionless waves, half descending from Mont Dru and half from Mont Blanc but rapidly joining to form a single field of ice. And how beautiful are the alpine peaks with their eternal snows! The Grand Jorasse, the Géant . . . the Mont Dru, their needles of mica-schist soaring into the blue heavens remind one of Gothic cathedrals, neatly dusted with snow. And all with such superhuman proportions that one must first find some comparison before one can grasp their true size. Then how seductive is the colour play of these gigantic masses, how delicate and pure the gradations of tone, the reds, ochres and distant violet, despite their gigantic proportions.'

Carus was court physician to the Saxon royal family in Dresden from 1827. Although he was an artist of great technical skill and originality, he painted only part-time. He was a close friend of Caspar David Friedrich and he echoes in his own work not only Friedrich's spiritual vision of nature but also his delight in surprising geometrical effects. Friedrich, who never travelled to Switzerland, used Carus's 1821 sketches for several of his mountain landscapes.

In this picture, the two cloaked figures of pilgrims are dwarfed by the glacier, allowing Carus to emphasize its 'superhuman proportions'. Solitary figures in silent contemplation of nature were frequently used by Friedrich in his landscape paintings and Carus has used the same device. The spectator instinctively identifies with the human figures, thus catching the mood of contemplation.

Johan Christian Clausen Dahl
1788–1857

Frederiksholm Canal in Copenhagen with Christian IV's Brewery, 1817

Storm Clouds near Dresden, 1830

Morning after a Stormy Night, 1819

DAHL was the most distinguished landscape painter of the Biedermeier period. His Realism, the faithful and unromanticized delineation of the world before his eyes, was his major contribution to German art.

He was the son of a Norwegian fisherman. Local admirers of his youthful talent sent him in 1811 to the Copenhagen Academy; Norway was at that time still under Danish rule. His skill as a painter developed rapidly and before he was twenty he was recognized as one of the great new talents of Copenhagen, earning patronage from the royal family.

Eckersberg, the founder of Denmark's Realist school, returned to Copenhagen in 1816 and his influence helped reinforce Dahl's Realist leanings. In 1818 Dahl left Copenhagen for Dresden which remained his home for the rest of his life. He formed a close friendship with Caspar David Friedrich, the mystical landscape painter who had lived in Dresden since 1798. They shared a house from 1820 onwards. A group of artist friends gathered around them, including Oehme, Carus and Kersting.

It was during a visit to Italy in 1820–21 that Dahl became absorbed by the problem of naturalistic rendering of light. He also made frequent painting trips to Norway, the land of his birth. His Norwegian views follow in the footsteps of Jacob van Ruisdael and Allart van Everdingen but are painted with sensitive Realism.

JOHAN CHRISTIAN DAHL. *Storm Clouds near Dresden*

He became a professor at the Dresden Academy in 1824 and exerted a powerful influence on several artists, notably Blechen in Berlin and Morgenstern in Munich. He was Norway's first important painter and a lasting influence on their landscape school.

Frederiksholm Canal in Copenhagen with Christian IV's Brewery is a product of his student years in Copenhagen and underlines the outstanding technical skill that he had already achieved.

Moonlit landscapes were much favoured by German artists of the Romantic era and Dahl was the chief exponent of the genre. He is best known for his moonlit views of Dresden but in this early work he has already mastered the pale silver light and the pictorial possibilities it offers.

Roofs, spires and rigging stand out against the sky where the silver light is caught and diffused by the clouds. The moon is reflected in the water and palely illumines the street, boat and buildings in the foreground. A single figure in a fur hat and pink coat is seen from behind staring out over the water.

The viewer, identifying with this human presence, catches his mood of contemplation. Similar figures were often used by Friedrich to emphasize the spiritual content of his landscapes and it is interesting to note that Dahl was already using the device before he arrived in Dresden. His purpose differs from Friedrich's in that his lonely figure is used to heighten the viewer's perception of reality.

It was only after his move to Dresden that Dahl discovered the Realist possibilities of looser brushwork. In *Storm Clouds near Dresden*, it enabled him to render effects of weather and atmosphere. The edge of the dark storm clouds is tinged with pink as the evening sun breaks through. A shaft of sunlight has caught some small white houses with red roofs, making a bright contrast to the shadowed landscape, the dark trees and the distant line of blue hills.

Although this is a view of Dresden, Dahl's interest is concentrated on rendering light. No feature of the landscape predominates; it is the overall effect of the storm that matters.

Like Constable in England, Dahl painted cloud studies and used a sketch finish as the best means to capture fleeting effects of light. Despite the similarity of approach, there was no contact between the two contemporaries. Realism posed them the same problems and they happened to come up with the same solutions.

The atmospheric drama that he has rendered in *Morning after a Stormy Night* was already a conscious exercise in Realism, though the early work treats a classic theme beloved of European painters from the seventeenth century onwards. The Romantic generation, in particular, liked to paint their seascapes in stormy weather.

The artist took only eight days to complete the picture in March 1819 and considered it the best of all his paintings. For a seascape, it is relatively large, reflecting the importance Dahl attached to the subject. He did not see himself as painting a storm, but the human anguish of a tragic event.

The lonely figures of a sailor and a dog serve to focus the viewer's response not on the romantic scenery with wild waves crashing against rocks but on the human tragedy of the wreck. As in the Copenhagen painting, the solitary human figure heightens the sense of reality.

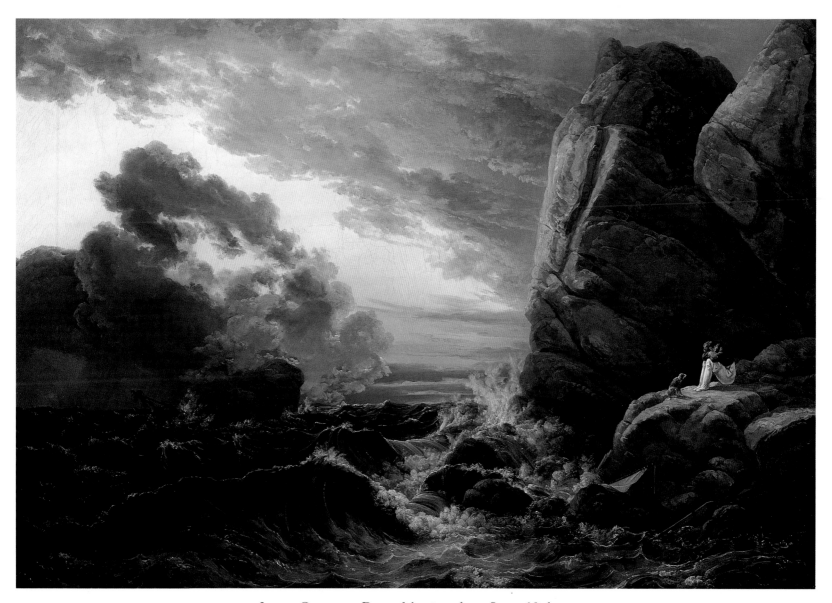

JOHAN CHRISTIAN DAHL. *Morning after a Stormy Night*

Caspar David Friedrich
1774–1840

Painting in Memory of Johann Emanuel Bremer, 1817

Flat Countryside, 1823

Moving Clouds, c.1821

IN THE TWENTIETH CENTURY Friedrich has come to be looked on as the greatest German landscape painter of the Romantic era. His paintings are a visionary interpretation of nature in terms of a very personal religious symbolism. The most famous of them select and exaggerate natural phenomena – gnarled trees, ivy-covered ruins, mountains or icebergs – to create arresting, highly emotive, images.

The power of these images derives from Friedrich's love and understanding of nature. His sketching trips, particularly those in the Harz mountains around 1810 to 1813, gave him a mastery of Realist landscape painting that enabled him to portray nature in all weathers and moods. In addition to his romantically imagined landscapes, he painted real views with a fidelity that places him beside Dahl, his close friend, as a master of Biedermeier Realism.

Religious persecution drove Friedrich's family from Silesia to Greifswald on the Baltic coast and the protestant religion remained at the centre of his life. He studied at the Copenhagen Academy from 1794 to 1798, then settled in Dresden, where he moved in the circle of the Romantic poets and philosophers which included Tieck and Novalis. He achieved fame and created controversy with his landscape altarpiece, *The Cross in the Mountains*, of 1808.

From 1820 he shared a house in Dresden with Dahl but his period of popularity was over by then and his work was rapidly forgotten. It was to be rediscovered at the Berlin Centennial Exhibition of 1906.

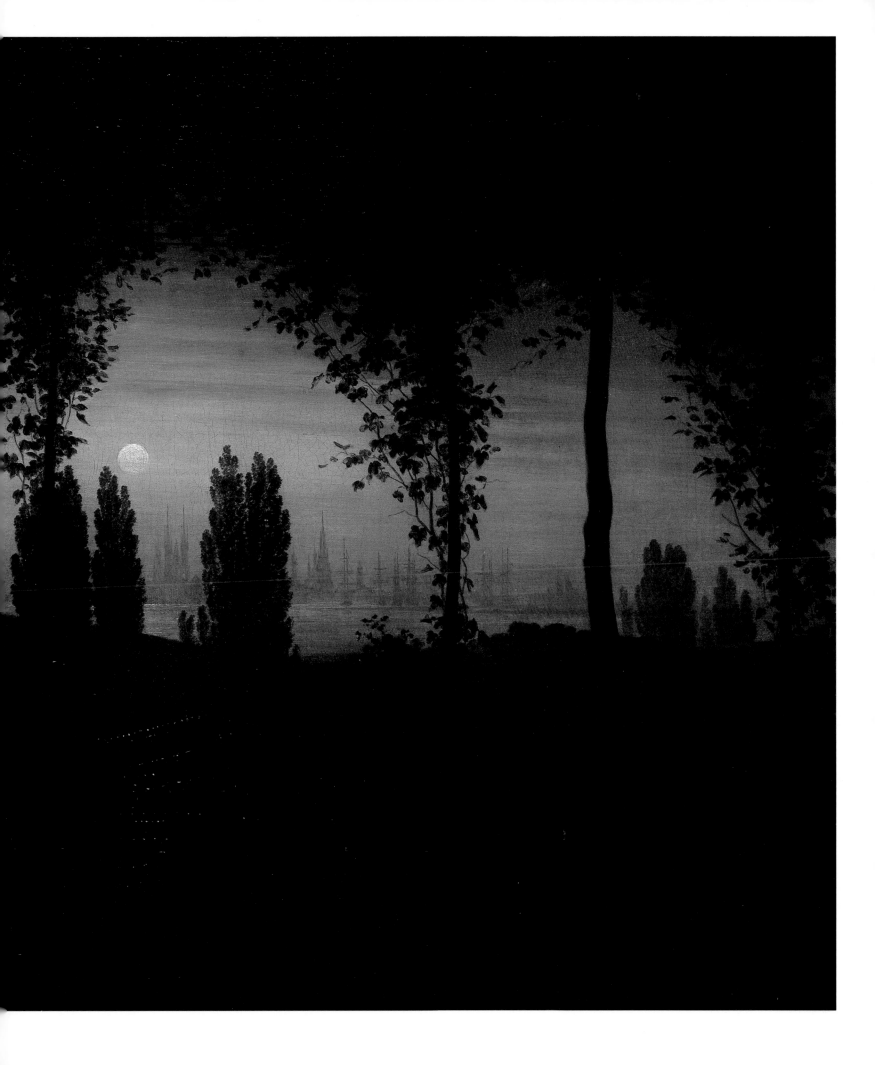

His power to render an imaginary scene with sensitive realism is revealed by the *Painting in Memory of Johann Emanuel Bremer*. The landscape has almost lost its colour in the moonlight, leaving only dark shapes and luminous reflections. From the pergola of vines in the foreground, poplars can be seen standing dark against the moonlit river and sky while across the river, in the misty distance, rise the Gothic spires of a town.

It is naturalistically painted and can be appreciated either as a moonlit landscape or as a memorial, full of religious symbolism.

It was painted in memory of a Berlin doctor who died in 1816. Bremer was a pioneer of smallpox vaccination and was famous for his work among the poor. Friedrich has expressed his admiration for the man with complex symbolism.

The foreground enclosure denotes earthly life which is redeemed through the eucharist, symbolized by the vine. The gate of death divides earthly existence from the afterlife, symbolized by the

river and distant town. The moonlight is an emanation of Christ; the rays which play through the bars of the gate onto the path in the foreground represent Bremer's piety in life.

Even a simple landscape sketched from nature, such as *Flat Countryside*, contains hidden symbols. Friedrich has adopted a viewpoint which places man and his activities along the horizon, the symbolic meeting point of this world and the next.

The bright green field in the foreground leads the eye naturally to two small figures working in the middle distance, a cluster of cottages with thatched roofs, apple trees, village rooftops and a windmill. Human activity and its products – buildings and carefully tended fruit trees – lie in an almost straight line across the canvas, where earth meets sky along a flat horizon.

It is a view of the landscape in which Friedrich grew up, near Greifswald on the Baltic – possibly on the little island of Rügen just off the coast. The picture dates from the period when Friedrich and

CASPAR DAVID FRIEDRICH. *Flat Countryside*

CASPAR DAVID FRIEDRICH. *Moving Clouds*

Dahl began to share a house in Dresden and it has a close affinity with the naturalistic landscapes that Dahl was painting around that time.

Friedrich and Dahl had met when the latter arrived from Copenhagen in 1818. One of Dahl's great interests was the study of weather and, in particular, cloud formations. In *Moving Clouds* Friedrich shows that he too can give a masterly rendering of atmospheric effects.

The clouds scud along the mountainside, alternately obscuring and revealing the landscape below and allowing only occasional patches of sunlight to break through. The view is from the Brocken in the Harz, the highest mountain in northern Germany, famous for its magnificent views in all directions and for its mists. A place of heathen worship, myths gathered round it which inspired the Romantic generation; a scene in Goethe's *Faust* is set on the Brocken. Friedrich had sketched the view in 1811 and seems to have developed this painting from that sketch.

It belongs to the series of naturalistic landscapes that he painted in the 1820s in which a spiritual message is hinted at rather than spelt out, as was the case in his more Romantic works.

The symbolic interpretation of this painting sees the pool in the foreground which reflects the sky as the spiritual element contained within a mountainside of temporal creation, littered with rocks of faith. The landscape glimpsed through the clouds is Paradise, which is placed beyond the valley of death.

Georg Friedrich Kersting
1785–1847
In front of the Mirror, 1827

DELICATE COLOUR HARMONIES give a magic to the quiet room where a girl concentrates on the task of plaiting her long hair. The glimpse of landscape through the open window heightens the sense of enclosure in a solitary world dominated by a single preoccupation – the act of getting dressed.

She is wearing a white petticoat, while her violet walking dress and white shawl lie waiting on the table beside the Baroque glory of her yellow bonnet. The play of light on the green wall allows the artist to run through a subtle range of tones, achieving masterly modulations.

Although the simplicity and domestic nature of the scene are characteristic of the Biedermeier ethos, Kersting builds out of it a sense of human life as solitary endeavour. The same stillness and solitude are to be found in the landscapes of Caspar David Friedrich, Kersting's close friend, and they constitute a unique achievement of German Romanticism. The small painting has a larger significance.

His single figures in interiors, where the character of the interior reflects that of the figure and where a concentrated play of light helps to heighten both, are the works which have made Kersting famous.

He studied in Copenhagen from 1805 to 1809. The academy's stress on fine classical draughtsmanship and careful observation was a powerful influence on Realist painting in Germany. Kersting, Friedrich and Dahl carried the influence of their Copenhagen training to Dresden. Kersting settled there in 1809. In 1818 he became director of painting at the Meissen porcelain factory, a job which left him little time for easel painting. His works are therefore rare. Their significance was first brought to public attention by the Berlin Centennial Exhibition.

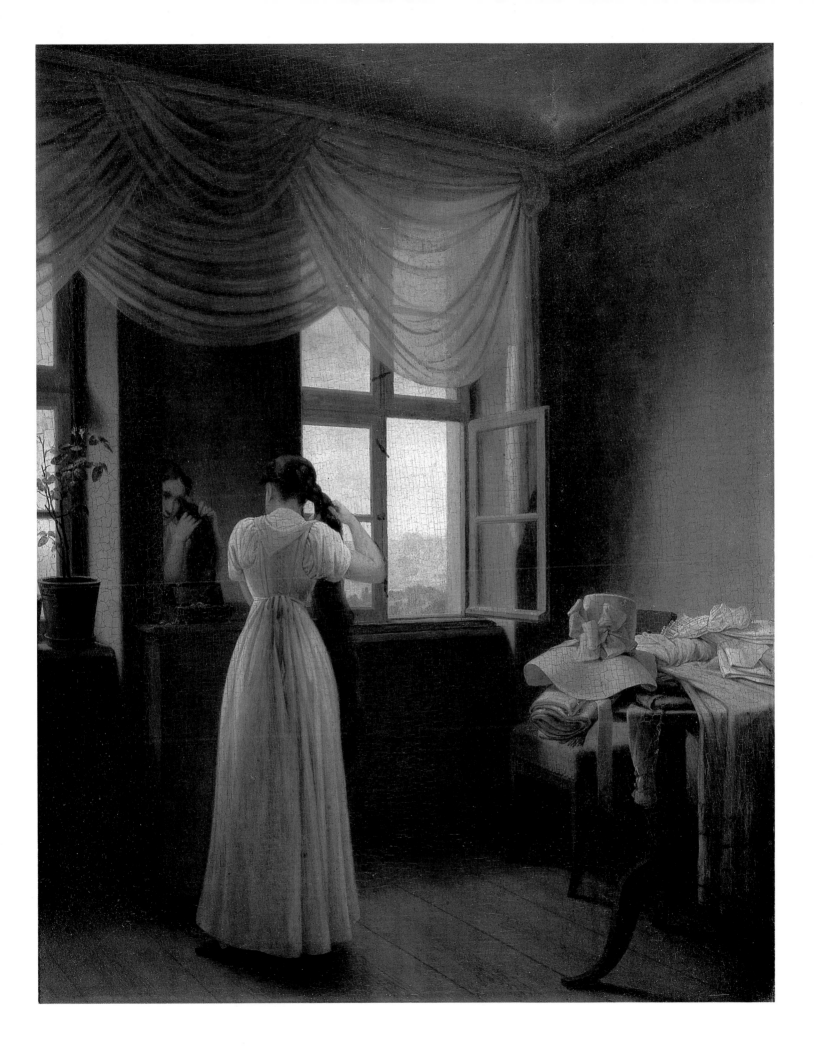

Ferdinand von Rayski

1806–90

Portrait of Carl Ludwig von Schönberg, Inspector of the Saxon Forests, 1850

THE BEARDED, aristocratic figure is painted wearing a simple green coat and old trousers, deep in the forests it was his duty to protect. His gun on his arm, he stands quietly by a tree, watching but not disturbing the deer.

A single shaft of sunlight has penetrated the forest to light the figure and the tree trunk behind him, leaving the rest of the undergrowth in shadow. The effect is similar to that of a theatre spotlight but the intention is practical, to place the figure in the context of the forest, without allowing the latter to interfere with the impact of the portrait.

It is an outstanding piece of Realist painting, going beyond the conventions of Biedermeier Realism – painstaking attention to detail and a high gloss finish. Rayski combines free and fluent brushwork, strong composition and modelling, and psychological insight. The picture reflects the influence of the French painterly tradition on his work. His visit in 1834–35 to Paris, where he met Delacroix, Delaroche, Horace Vernet and above all Géricault, was a turning point in his career. The technique of applying paint to canvas was far more sophisticated in the French studios than in provincial German art schools.

Rayski's career was based in Dresden. He started to attend the academy there in 1823 while he was still in the army. Although he tried his hand at landscape, history and animal painting, he worked mainly as a portraitist. The German aristocracy patronized him and his commissions carried him from Berlin in the north to Switzerland in the south.

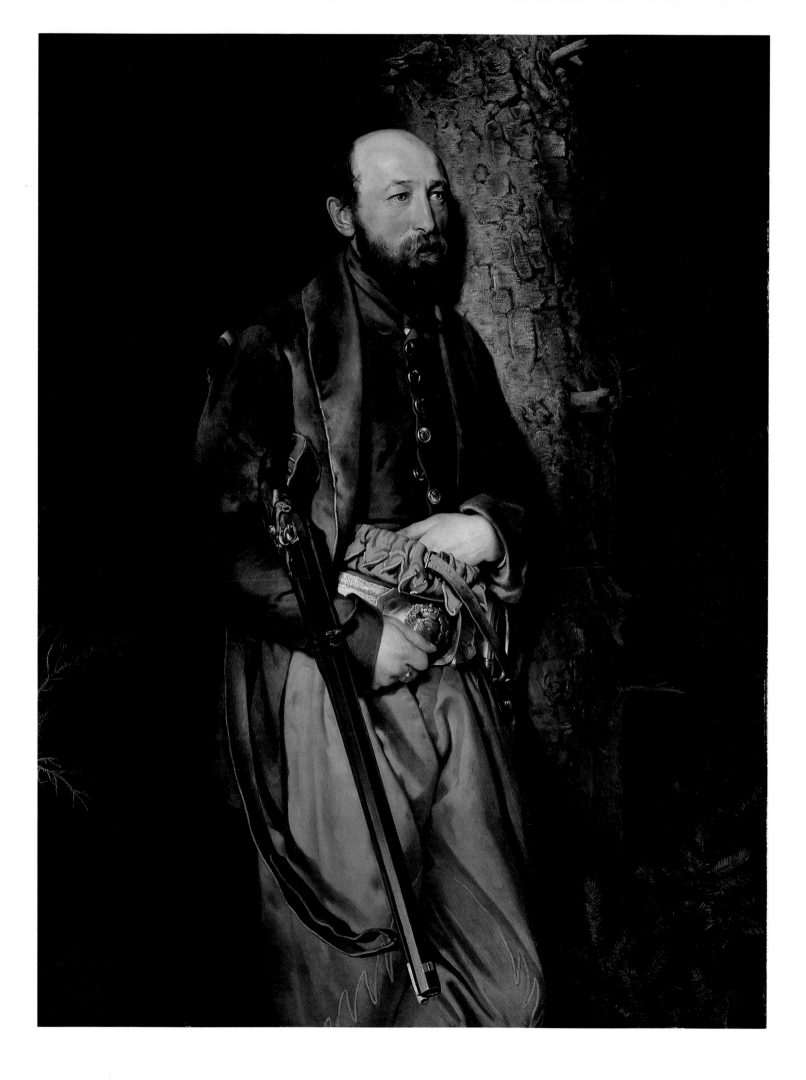

Ludwig Adrian Richter

1803–84

The Watzmann, 1824

Taking a Rest in the Mountains, 1833

RICHTER'S FAME is primarily based on engravings and woodcut illustrations for books. He specialized in children's books, depicting peasant life and fairytale landscapes. He portrays a cosy, domesticated idyll which epitomizes the spirit of Biedermeier.

Richter learned drawing and engraving from his father, who was a professor at the Dresden Academy. The success of his early topographical engravings led the Dresden publisher Christoph Arnold to underwrite a three-year visit to Italy beginning in 1823. He travelled south via Salzburg where he met the important group of landscape artists whose new Realist approach was inspired by a mystical reverence for God's creation.

Several of the artists who adopted Salzburg as a base for sketching trips also visited Rome, where they gravitated to the circle around Koch, the most distinguished of the older generation of

German landscapists. Richter did the same, and these influences formed his landscape style. On his return to Dresden he took to sketching in the Elbe valley and this northern landscape becomes mingled with Italy in the paintings he worked up in the studio. Their subjects owe a debt to the Dutch school – peasants returning home in the evening light, harvesting, a huntsman beside a stream, travellers resting in the mountains. . . .

The Watzmann was painted in Koch's studio in Rome and as a celebration of alpine scenery it closely resembles Koch's own *Schmadribach Waterfall*, painted in 1821–22 (see p. 173), though Richter's mountain is friendly and bathed in golden sunlight. Domestic life is indicated by the smoke from the chalet's chimney and a little chapel is visible among the trees on the other side of the ravine. Richter's instinctive response to landscape was to see a pastoral idyll.

Richter had sketched the Watzmann, a mountain near Salzburg, on his journey south and worked up the picture in Rome. He describes the view in his journal: 'Built like a Gothic cathedral, it rises from the flowering meadows in the foreground, to the waterfall frothing over a rocky precipice and sparkling green forests, to the high mountains and silver snow peaks above the clouds, which reach up to the azure heaven.' It heads the list he gives of his oil paintings and was his first significant canvas.

By the time he painted *Taking a Rest in the Mountains*, Richter had abandoned the landscape epic in favour of pastoral charm. A family of Italian peasants with their grapes and melons, donkey and little dog have stopped to take a rest beside the road. This belongs to a series of small paintings that he made in Dresden. Realistic details taken from sketches made outdoors are combined into idyllic little pastoral hymns.

LUDWIG RICHTER. *Taking a Rest in the Mountains*

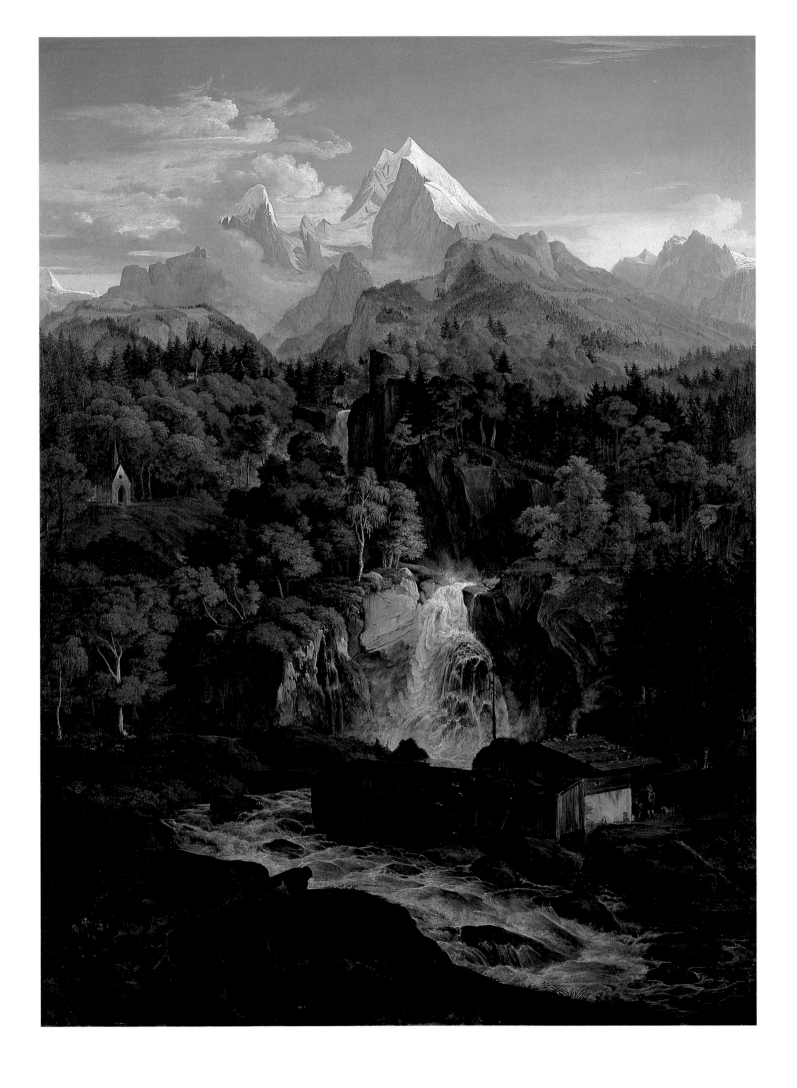

THE
ITALIAN EXPERIENCE

ARTISTS HAVE TRAVELLED TO ITALY to study its art and its landscape since the Renaissance; Dürer was an early visitor. The French were the first formally to acknowledge the educative role of the Southern experience with the establishment of the French Academy in Rome by Louix XIV in 1666. In the same period, two great Frenchmen, Claude and Poussin, both resident in Rome, painted wide vistas of the *campagna* in a manner that was to be imitated by artists from all over Europe for two centuries. They were still the prime models for the more conservative landscape artists of the Biedermeier period.

German artists began to establish themselves in Rome in considerable numbers in the eighteenth century. It was in Rome that Johann Joachim Winkelmann, the German art theorist, developed the tenets of Neo-classicism which found their first major exponent in Anton Raffael Mengs. Jacob Philipp Hackert painted landscapes in the classical tradition of Claude and Poussin.

In the early years of the nineteenth century Rome ranked with the major cities of the north as a centre of activity for German painters. A period of residence in Rome was considered an important part of an artist's education and some artists chose to remain there.

Joseph Anton Koch, who lived in Rome from 1795 until his death in 1839, apart from a three-year stay in Vienna, was the most influential landscapist of the Biedermeier period. His paintings were in the classical tradition of Claude and Poussin but he sketched assiduously from nature and this is reflected in the Realistic detail of his landscapes.

Koch welcomed visiting German landscapists and went with them on sketching trips around Olevano, their favourite centre. Franz Horny, who died young, was one of them. A letter to his mother of 1823 helps to explain the presence of so many Germans in Rome: 'Many travellers discuss why it is that so many German artists, and some of the most distinguished, live in Rome and not in the land of their birth. The devil of it is that they cannot work as independent artists at home; without noble patronage they would find themselves as superfluous as the fifth wheel on a carriage. Let me take the case of landscape artists in Rome as an example. Travellers pour into Rome from all over Europe, especially in winter; on average there are some 15,000 foreigners in Rome; everyone who travels has money; each of them, in his own manner, wishes to take some memento home with him, especially landscapes.'

Just as travellers poured into Rome from all over Europe, so did artists. German, French, English and Italian painters met from time to time and exchanged ideas. Many Danish artists also came to Rome, notably Eckersberg, the most influential teacher of the Biedermeier period in Denmark. He had studied with David in Paris but it was in Rome that he met Ingres, whose example reinforced the influence of French classicism on his work.

There were so many Germans in Rome that they even founded an Art Union, or exhibiting society, on the same lines as the German Kunstverein. It was called the the Società Amatori e Cultori delle Belle Arti.

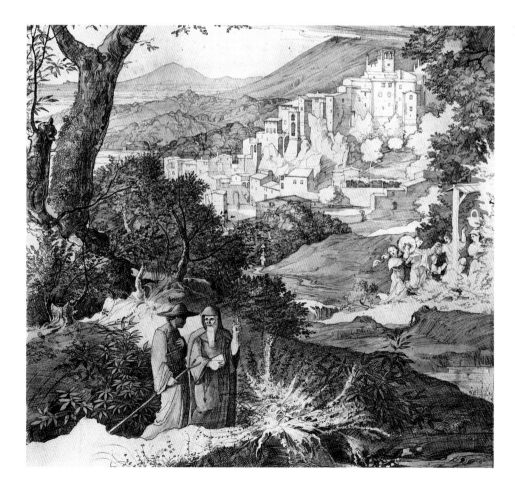

FRANZ HORNY. *View of Olevano* (detail)

Carl Beckmann

1799–1859

The Roof of Milan Cathedral, c.1830

THE LACE-LIKE GOTHIC TRACERY of Milan cathedral etched against a rich blue sky gives this little picture a jewel-like effect. The vision is characteristic of Berlin Biedermeier but is given a new slant by its application to a southern scene under a southern light.

Eduard Gärtner's panorama of Berlin, painted in six panels, looking out over the roof of the Friedrichwerder Church, is the most famous example of a rooftop view. Beckmann echoes his approach but is more interested in the elaborate Gothic carving of the cathedral itself than in the surrounding town. However, he gives this fairy-tale architecture an air of Biedermeier sobriety by introducing the small figures that peer over the edge. Tourism, or 'seeing the sights', was a pastime keenly enjoyed by the cultured bourgeoisie of the period.

Beckmann studied in Berlin, paid the statutory student visit to Paris in 1824 and was in Italy from 1828 to 1832. He later taught architecture and perspective at the Berlin Academy of Art.

Franz Ludwig Catel

1778–1856

Crown Prince Ludwig in the Spanish Tavern in Rome, 1824

CROWN PRINCE LUDWIG OF BAVARIA, later King Ludwig I, was a passionate patron of the arts. It was on his youthful visits to Rome that he found the inspiration that was to transform Munich into the artistic capital of Germany. This painting depicts a lunch party given by the prince at the Spanish tavern on the banks of the Tiber, a favourite haunt of German artists in Rome. He is surrounded by his artist friends.

According to Catel, the occasion for the party was the imminent departure of Leo von Klenze on a journey. Ludwig, seated at the end of the simple wooden bench, is gesturing to Don Raffaele, who ran the establishment, to bring more wine. On his left is Klenze, the architect he was to employ for his major public buildings in Munich, and who was to transform the old town with majestic Neo-classical façades. On the prince's right is Thorwaldsen, the Danish sculptor whose cool Neo-classical marbles brought him a European fame rivalled at the time only by that of Canova.

Catel had been invited by the prince to paint a record of the lunch and he sits at the foot of the table with his sketchbook. On his left is Julius Schnorr von Carolsfeld, whose fresco cycles depicting Teutonic legends decorate the interiors of Ludwig's palaces and castles.

In a letter to an art critic friend, Catel described this painting as a 'small Bambocciata', an Italian term for a seventeenth-century low-life scene. That Ludwig should desire to be painted in such a style underlines the high status then accorded to artists and *la vie bohème*.

Catel began his career in Berlin. The crisp realism of his figures and the architectural vista across the river to the Aventine still echo the Berlin school. Having settled in Rome in 1811, he specialized in the landscapes and Italian peasant scenes that were so popular with northern visitors.

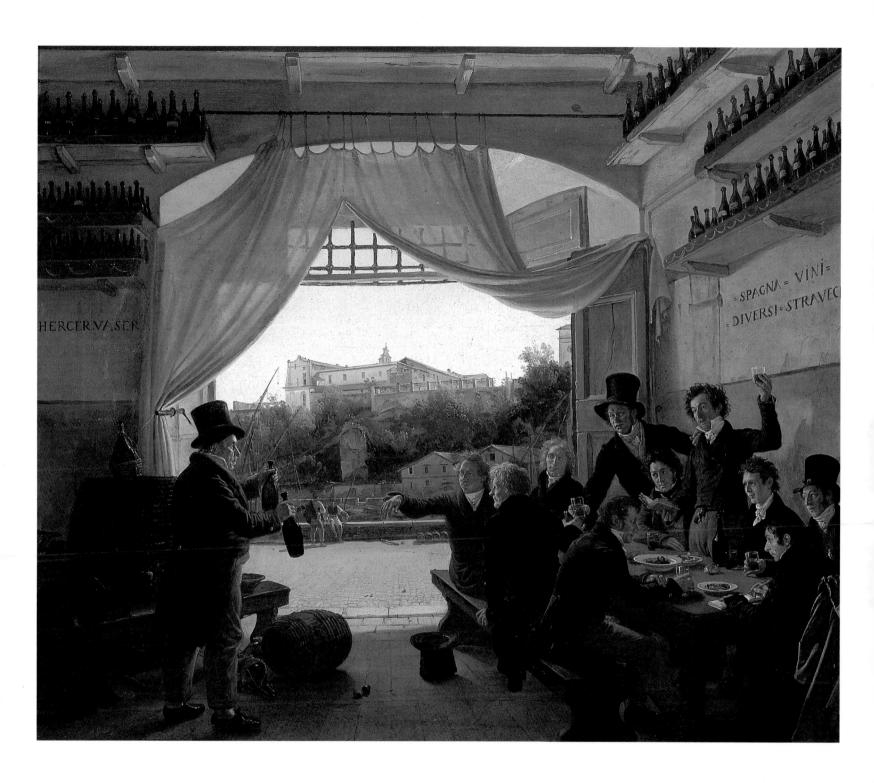

Constantin Hansen
1804–80
A Group of Danish Artists in Rome, 1837

THE ARCHITECT GOTTLIEB BINDESBØLL, wearing a bright red fez, reclines in cushioned ease on a Turkish rug while he regales his friends with travellers' tales from the East. A group of the most distinguished Danish artists of the day are gathered in Hansen's studio in Rome drinking Turkish coffee and puffing at long Turkish pipes while they listen to Bindesbøll's account of the trip to Greece and Turkey that he and the painter Martinus Rørbye had just made.

The frustration of having to sit in silence while your companion tells the story is conveyed by the way Rørbye, sitting in the doorway, is fiddling with his coffee cup. Jørgen Sonne perches on the table listening while Albert Küchler and Ditlev Blunck stand on the balcony with Wilhelm Marstrand, the landscape artist, who stares out at the view. Hansen himself is seated on the far left; he asked Küchler to paint him in his chosen attitude and copied the brilliant portrait provided by his friend into his own picture.

It has been suggested that Hansen is paraphrasing Raphael's *School of Athens* in this brilliant essay in Realist genre. Where the philosopher instructs his listeners against a back-lit opening which symbolizes cognition in Raphael's masterpiece, the contemporary artists attend to a high-flown tale against a window opening on reality.

Hansen was one of Eckersberg's most gifted pupils at the Copenhagen Academy, inheriting the master's pleasure in unconsidered detail and careful finish.

Hansen spent nine years in Italy from 1835 to 1844 concentrating on architectural views and contemporary figure subjects. A charming view of the Temple of Vesta, now in the Hirschsprung Collection in Copenhagen, hangs on the wall to the right of this picture, which was commissioned by Copenhagen's Kunstforening, the society through which Danish patrons and connoisseurs supported local artists. (See also p. 90 for Hansen's *Sportsman Showing a Little Girl his Bag.*)

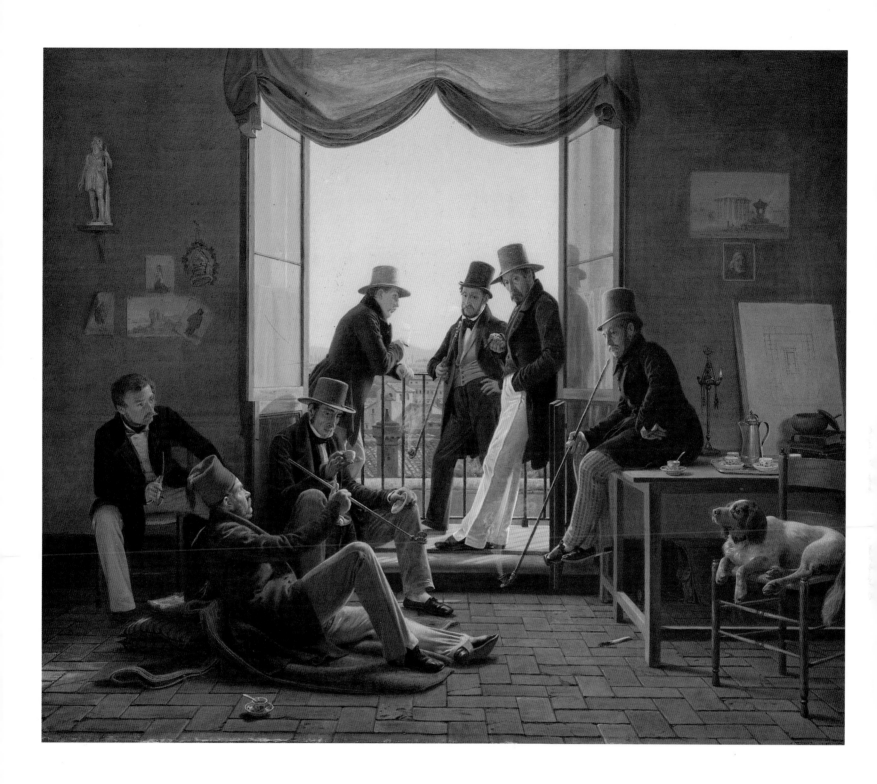

Joseph Anton Koch

1768–1839

The Schmadribach Waterfall, 1821–22

Imaginary Italian Landscape, c.1834

❧

KOCH was a powerful influence on German landscape painting in the nineteenth century. Although he set great store by sketching from nature to ensure a high degree of realism, he believed that a landscape painting should be freely and poetically composed from these observations to embody a theme.

Koch was born at Obergibeln in the Tyrol, the son of a peasant. His talent was discovered by the Bishop of Augsberg, who paid for his artistic education. Koch, however, did not like the discipline of the art school in Stuttgart where he was sent and in 1791 he ran away, first to Strasbourg and then to wander sketching in the Swiss Alps. In 1795 he travelled on to Rome, where he was to spend the rest of his life, apart from a short stay in Vienna.

From his arrival in Rome, Koch devoted himself to sketching in the *campagna*, usually composing from his sketches landscapes with biblical or mythological themes, which echo the work of Claude and Poussin. Earlier northern artists, such as Hackert and Rohden, had turned to the same source of inspiration and were a direct influence on Koch whose own work can be seen as carrying the impact of the Neo-classical school into the Romantic generation.

Young German artists visiting Rome – among them Carl Fohr, Richter, Ernst Preller and Rottmann – prized his acquaintance and treated him as their master. A period spent in Rome studying its artistic tradition and sketching in the *campagna* was considered to be a crucial part of a young artist's education at this time. Koch was friendly with the Nazarenes and collaborated with them on a fresco cycle for the Casino Massimo.

Koch painted his famous picture of *The Schmadribach Waterfall* in 1821–22. 'Mighty glaciers hurl streams down over tall cliffs into the pine forests below where the waters roar with rage over the wild rocks.' Thus Koch described its subject in a letter to a friend dated April 1822. It is a view in the Bernese Alps in Switzerland, with the peak of the Breithorn veiled in cloud to the right and the Grosshorn to the left. But Koch has translated the view into a poetic celebration of the might of nature, introducing a peasant with his goats into the foreground of the picture only to demonstrate how they are dwarfed by the mountain torrent.

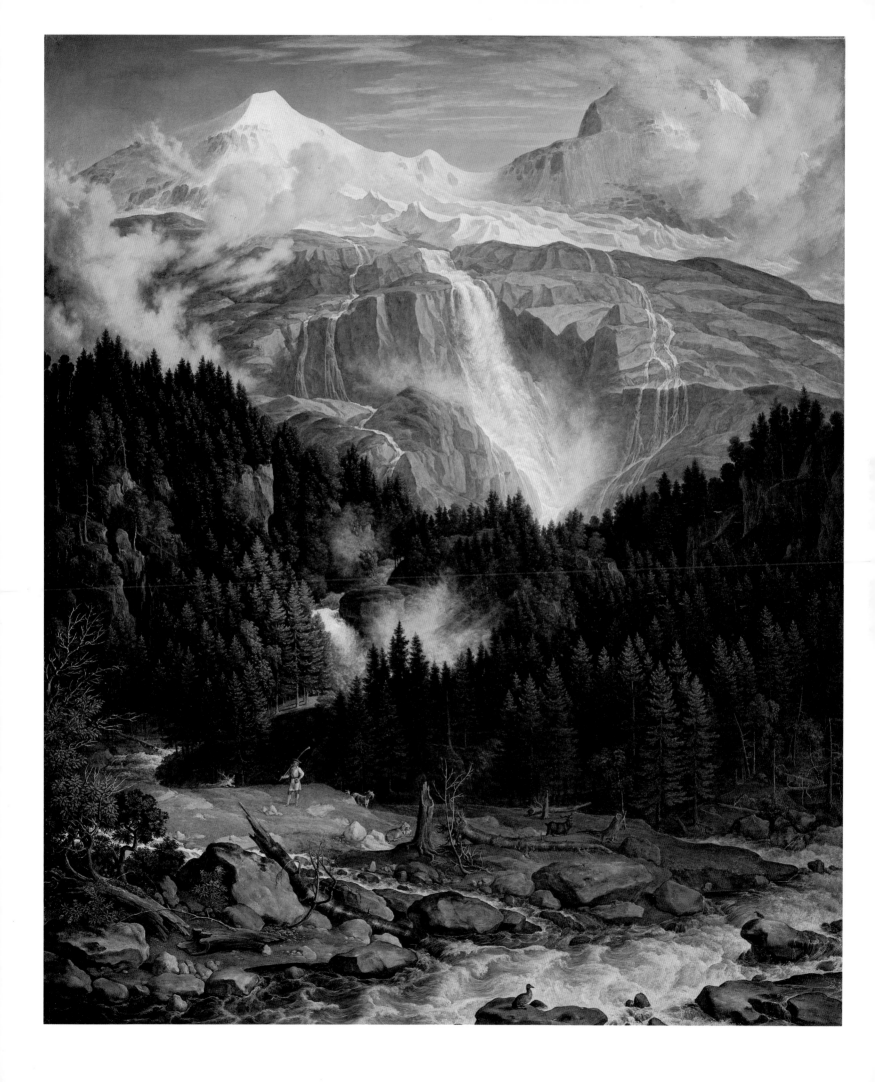

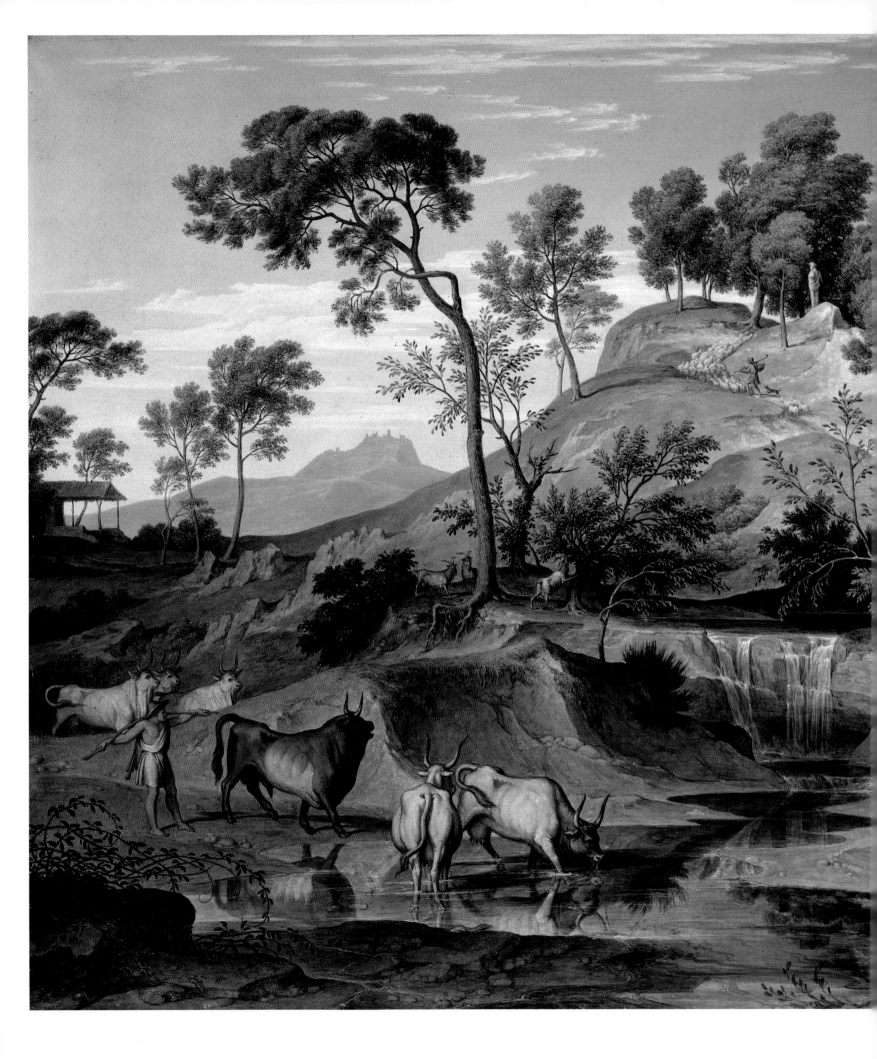

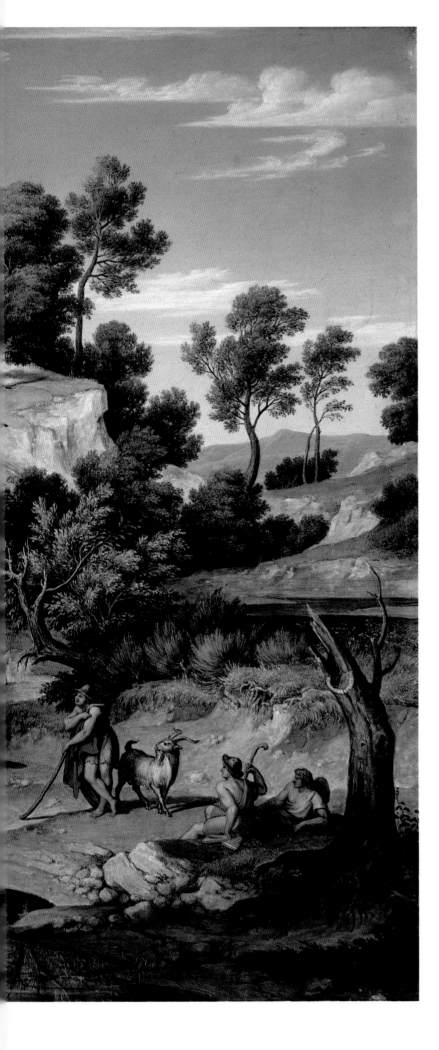

The poetry of Koch's landscapes is usually on an epic scale. The foreground or middleground often contain figures from biblical stories or classical myth; the small figures play an apparently insignificant part in the landscape painting, but its character is intended to reflect the nature of their history.

The figures in his *Imaginary Italian Landscape* are meant to embody the timeless nature of the pastoral idyll. White oxen and a proud brown bull are led by a peasant to the shallow waters of a stream whose glassy surface magically reflects animals, plants and its own banks. Behind, a shepherd and his flock are climbing a wooded knoll where an antique sculpture stands among the oak trees.

Koch married a peasant's daughter from Olevano in 1806 and this imagined view is characteristic of the neighbouring landscape. The artists sketched there constantly, filling one sketch book after another with highly finished drawings of plants, trees, animals and landscape vistas.

In this painting every detail is rendered with scrupulous realism, repeated, no doubt, from his Olevano sketch books, but in its sunny peace and beauty the landscape is intended to evoke Paradise. The poetry of observed nature is consciously idealized.

JOSEPH ANTON KOCH. *Imaginary Italian Landscape*

Friedrich Nerly

1807–78

Old Elm Trees, c.1834

TWO OLD, GNARLED TREE TRUNKS with twisting roots are entwined by climbing tendrils of vine. Nerly has made a loving study of the contrasting textures of bark and foliage, choosing to concentrate his attention only on the lower section of the trees to escape the distraction of their overall shape in space.

The dark trunks and green leaves stand out in relief against the pinkish toned hillside up which a path climbs behind them. The restriction of the picture space to the format of a 'close-up' and a concentration on the Realist rendering of foreground texture is repeated in several of Nerly's oil on paper studies during his first years in Italy. The bright southern sunlight and blue skies give great clarity of definition to these paintings.

The early death of his father meant that Nerly grew up with relations in Hamburg and received his first artistic instruction there. The city was much under the influence of Copenhagen and was one of the first German centres to develop a Realist approach to landscape painting.

Nerly's artistic talent came early to the attention of Baron Karl Friedrich von Rumohr, who combined patronage of contemporary artists with pioneering work as an art historian. He taught Nerly painting and in 1828 took him to Italy. Nerly was in Rome from 1828 to 1835, spending most of his time working from nature in the Sabine and Alban hills. This painting dates from his Roman years which saw him actively involved with other German artists in founding the Roman Kunstverein (Società Amatori e Cultori delle Belle Arti) and organizing joint exhibitions.

In 1835 he moved permanently to Venice and became a specialist in Venetian views.

Heinrich Reinhold

1788–1825

Rocky Gorge with a Bridge, near Sorrento, 1823

THE WILD GORGE has been domesticated and tamed by the local inhabitants. A steep path leads from a gateway on the left while a bridge connects the two precipices. Reinhold has highlighted the contrast between wilderness and domestication with the play of sun and shade. The irregular cliff faces, with bushes clinging to the rocks, are cast in shadow, while the man-made staircase leading into the gorge is caught in bright sunlight which also smiles on a little town glimpsed under the bridge in the distance.

The small sketch (29 × 22 cm) was among a group of twelve bought from Reinhold in 1824 by the famous Berlin architect and landscape painter Karl Friedrich Schinkel. Schinkel noted in his diary that most artists would not sell their sketches as they constituted an important record of views to which the artist might not return. Reinhold agreed to the sale on condition that he kept the sketches long enough to copy them.

Schinkel carried the sketches back to Berlin where they were enormously admired. At this period landscape paintings were generally worked up in the studio from sketches made outdoors. It was unusual for an artist's sketches to be seen or to exert any influence beyond the direct circle of his friends. Reinhold is the exception. Not only did Schinkel carry his sketches north, but after Reinhold's early death in 1825 a large number of his landscape sketches were auctioned in Rome and his influence was therefore extended. His crisply finished detail and poetic contrast of sunlight and shade are echoed by many Biedermeier landscape painters, notably Waldmüller.

The son of a portrait painter, Reinhold studied at the Dresden and Vienna academies. He worked as an engraver in Paris for Baron Vivant Denon, director of the Musée Napoléon, from 1809 to 1814, and took up landscape painting in 1816 under the influence of the Olivier brothers and their circle. In 1820 he moved to Italy where he died five years later.

Sorrent. d 3 Juni 23.

Johann Martin von Rohden
1778–1868
The Falls at Tivoli, 1819

LOOKING FROM SHADOW INTO SUNLIGHT – a poetic device beloved of German landscapists – Rohden has painted a wide view of the river valley below Tivoli. The town perches on the hilltop to the left and the famous falls cascade down the hillside below, throwing up clouds of spray.

The foreground is painted with almost surreal precision: rocks, olive trees, scrub and yuccas with their stems of pendulous flowers are caught in bright sunlight. As the landscape recedes into the distance, trees and buildings are modelled with the same precise linear clarity. Rohden pulls this accumulation of detail together through the architectural structure of the composition, using a restricted range of colour harmonies in which yellow and green predominate.

Rohden's Italian landscapes owe a debt to Koch and Hackert, notably in the choice of big panoramas, but he developed an individual approach. Where his contemporaries poeticized their landscapes with pastoral or historical figures, Rohden avoided figures altogether. His Realist approach led him to painstaking detail which gives his pictures an almost naive air.

He grew up in Kassel but settled in Rome in 1795 and married a girl from Tivoli in 1815. In 1831 the Elector Wilhelm II of Hesse named him as his court painter; Rohden was required to supply his patron with one landscape every two years, in return for which he received a steady income and extra payments if the work particularly pleased his master. The arrangement reflects the fact that Rohden worked very slowly. Views of Tivoli predominate in his oeuvre.

Carl Rottmann
1797–1850
Palermo, 1832

THE SHADOWED FOREGROUND ensures that the eye focuses on Palermo, sparkling in the sunlight on the plain, with Monte Pellegrino rising behind it. Rottmann liked to use effects of light and colour to bring out the mood of his landscapes. The fierce blue of sky and water and a warm pink tone to the earth are used repeatedly to express his perception of the timeless grandeur of southern landscape and its classical ruins.

Ludwig I of Bavaria financed Rottmann's first visit to Italy from April 1826 to July 1827. The two paintings of Rome and Palermo which he exhibited on his return in 1828 were greatly admired by the king who then conceived the idea of decorating the arcades of the palace garden (Hofgarten) with landscape frescoes. These frescoes, of which the king himself wrote a description, kept Rottmann at work from 1829 to 1833. There were twenty-eight views of Italy and

Sicily in all, following the sequence of a visitor's journey. Their fame spread throughout Germany.

Rottmann spent the winter of 1829 to 1830 in the south and began work on the frescoes in April 1830. He made careful preparatory studies for each view and this little painting on wood is the preparatory modello from which he painted the view of Palermo under the arcades.

So delighted was the king with the first fresco cycle that he commissioned a second series of Greece. Rottmann visited Greece in 1834–35 and painted the series of twenty-three views in encaustic on large slabs of slate as decorations for the recently built Neue Pinakothek. The theme of the Italian cycle is the fusion of past and present in the timeless context of landscape, while the accent in the Greek series is on civilizations overpowered by the forces of nature. (See also p. 118 for Rottmann's *Kochelsee*.)

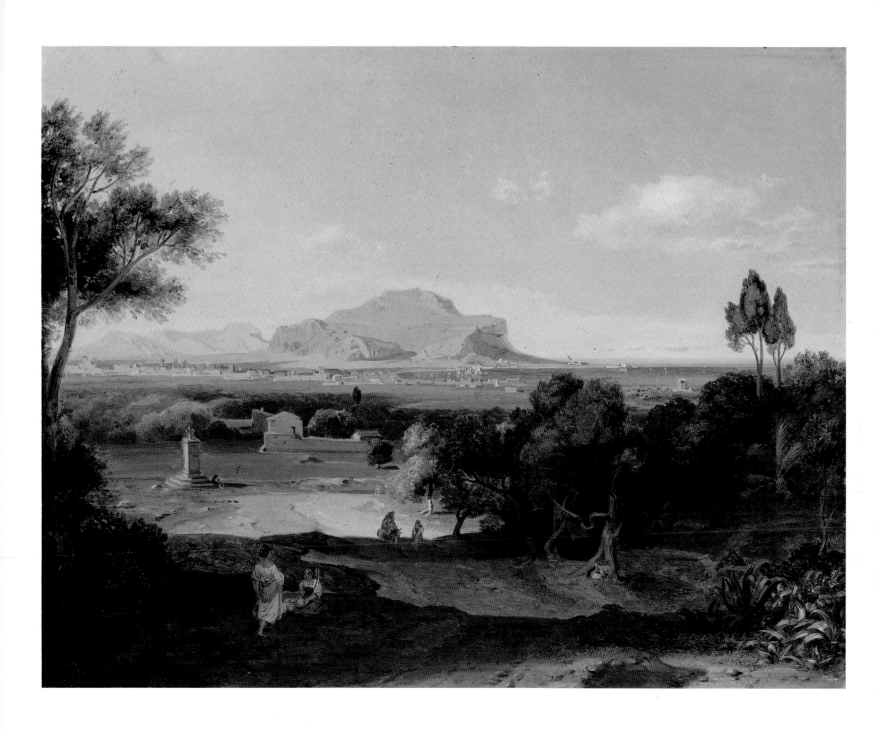

Bibliography

General

Boehn, Max von. *Biedermeier, Deutschland von 1815–1847*, Berlin n.d.
Böhmer, Günter. *Die Welt des Biedermeier*, Munich 1968
Gentsch, D. *Biedermeier*, Leipzig 1976
Heilborn, Ernst. *Zwischen Zwei Revolutionen: Der Geist der Schinkelzeit*, Berlin 1927
Hermann Georg. *Das Biedermeier im Spiegel Seiner Zeit*, Berlin 1913
Houben, H. H. *Der Gefesselte Biedermeier: Literatur, Kultur, Zensur in der Guten Alten Zeit*, Leipzig 1924
Kalkschmidt, Eugen. *Biedermeiers Glück und Ende*, Munich 1957
Krüger, Renate. *Biedermeier: Eine Lebenshaltung zwischen 1815 und 1848*, Leipzig 1979
Leitich, Ann Tizia. *Wiener Biedermeier*, Bielefeld and Leipzig 1941
Pauls, Eilhard Erich. *Der Politische Biedermeier*, Lübeck 1925
———. *Der Beginn der bürgerlichen Zeit Biedermeierschicksale*, Lübeck 1927
Ramm, Agatha. *Germany 1789–1919: A Political History*, London 1967
Sagarra, Eda. *An Introduction to Nineteenth-Century Germany*, London 1980
Schrott, Ludwig. *Biedermeier in München: Dokumente einer Schöpferischen Zeit*, Munich 1963
Waissenberger, Robert. *Vienna 1815–1848: L'Epoque du Biedermeier*, Fribourg 1985
Weiglin, Paul. *Berliner Biedermeier*, Bielefeld and Leipzig 1942
Wirth, Irmgard. *Berliner Biedermeier*, Berlin 1972

Art History

Becker, Wolfgang. *Paris und Die Deutsche Malerei 1750–1840*, Munich 1971
Been, C. A. (ed.) *Danmarks Malerkunst: Billeder og Biografer*, 2 vols, Copenhagen 1902/3
Beenken, H. *Das Neunzehnte Jahrhundert in der Deutschen Kunst*, Munich 1944
Bernhard, Marianne (ed.) *Deutsche Romantik: Handzeichnungen*, 2 vols, Munich 1974
Boetticher, Friedrich von. *Malerwerke des 19. Jahrhunderts*, 4 vols, Dresden 1891
Börsch-Supan, H. *Deutsche Romantiker: Deutsche Maler zwischen 1800 und 1850*, Munich 1972
Bramsen, H. *Landskabsmaleriet i Danmark 1750–1875: Stilhistriske Hovedtraek*, Copenhagen 1935

Brion, Marcel. *Die Kunst der Romantik*, Munich and Zurich 1960
Buchsbaum, M. *Deutsche Malerei im 19. Jahrhundert: Realismus und Naturalismus*, Vienna and Munich 1967
Bünemann, H. *Deutsche Malerei des 19. Jahrhunderts: Deutschland, Österreich, Schweiz*, Königstein im Taunus 1961
Champa, K and K. *German Painting of the Nineteenth Century*, New Haven, Conn. 1970
Christoffel, U. *Deutsche Malerei des 19. Jahrhunderts*, Leipzig 1966
de Keyzer, E. *Das Abendland der Romantik, 1789–1850*, Geneva 1965
Ebertshäuser, Heidi C. *Malerei im 19. Jahrhundert: Münchner Schule*, Munich 1979
Einem, Herbert von. *Deutsche Malerei des Klassizismus und der Romantik, 1760–1840*, Munich 1978
Feuchtmuller, R. and Mrazek, W. *Biedermeier in Österreich*, Vienna, Hanover and Berlin 1963
Finke, U. *German Painting from Romanticism to Expressionism*, London 1974
Fuchs, H. *Die Österreichischen Maler des 19. Jahrhunderts*, Vienna 1972
Geismeier, W. *Deutsche Malerei des 19. Jahrhunderts*, Leipzig 1966
———. *Biedermeier: Kunst und Kultur*, Leipzig 1979
Geller, H. *Deutsche Künstler in Rom: Von Raphael Mengs bis Hans von Marees (1741–1887): Werke und Erinnerungsstätten*, Rome 1961
Grimschitz, B. *Die Altwiener Maler*, Vienna 1961
———. *Österreichische Maler von Biedermeier zur Moderne*, Vienna 1963
Gurlitt, C. *Die Deutsche Kunst Seit 1800*, 4th ed., Berlin 1924
Hamann, R. *Die Deutsche Malerei im 19. Jahrhundert*, Leipzig and Berlin 1925
Hevesi, L. *Österreichische Kunst im 19. Jahrhundert*, 2 vols, Leipzig 1903
Hintze, C. *Kopenhagen und die Deutsche Malerei um 1800*, Würzburg 1937
Hütt, Wolfgang. *Die Düsseldorfer Malerschule*, Leipzig 1964
Immel, Ute. *Die Deutsche Genremalerei im 19. Jahrhundert*, Dissertation, Heidelberg 1967
Jensen, J. C. *Malerei der Romantik in Deutschland*, Cologne 1985
Kaiser, K. *Deutsche Malerei um 1800*, Leipzig 1959
Karlinger, H. *München und die Deutsche Kunst des 19. Jahrhunderts*, Munich 1933
Keller, H. *Deutsche Maler des 19. Jahrhunderts*, Munich 1979
Königswinter, Wolfgang Müller von. *Düsseldorfer Künstler aus den Letzen*

Fünfundzwanzig Jahren, Leipzig 1854
Lankheit, Klaus. *Das Freundschaftsbild der Romantik*, Heidelberg 1952
———. *Revolution und Restauration*, Baden-Baden 1965
Lieb, N. *München: Die Geschichte Seiner Kunst*, Munich 1971
Ludwig, H. *Münchner Malerei im 19. Jahrhundert*, Munich 1978
———. (ed.) *Münchner Maler im 19. Jahrhundert: Erster Band: Adam – Gaupp*, Munich 1981
Martins, Lilli and Klose, Olaf. *Skandinavische Landschaftsbilder: Deutsche Kunstlerreisen von 1780 bis 1864*, Neumünster 1975
Neidhardt, Hans Joachim. *Die Malerei der Romantik in Dresden*, Leipzig 1976
Noack, F. *Das Deutschtum in Rom*, 2 vols, Stuttgart 1927
Norman, Geraldine. *Nineteenth-Century Painters and Painting: A Dictionary*, London 1977
Oldenbourg, R. and Uhde-Bernays, H. *Die Münchner Malerei im 19. Jahrhundert*, 2 vols, Munich 1922
Raczynski, Graf Athanasius. *Geschichte der Neueren Deutschen Kunst*, 3 vols, Berlin 1836 and following years
Rave, P. O. *Deutsche Malerei des 19. Jahrhunderts*, Berlin n.d.
Robels, Hella. *Sehnsucht nach Italien: Bilder Deutscher Romantiker*, Munich 1974
Rosenberg, Adolf. *Geschichte der Modernen Kunst*, 2 vols, Leipzig 1884–1889
Roth, E. *Damals in Oberbayern*, Munich 1970
Schaarschmidt, Friedrich. *Zur Geschichte der Düsseldorfer Kunst: insbesondere im 19. Jahrhundert*, Düsseldorf 1902
Scheyer, Ernst. *Biedermeier in der Literatur und Kunstgeschichte*, Würzburg 1960
———. *Schlesische Malerei der Biedermeierzeit*, Frankfurt am Main 1965
Schindler, H. *Grosse Bayer: Kunstgeschichte*, 2 vols, Munich 1976
Schmidt, Paul Ferdinand. *Biedermeiermalerei*, Munich 1921
———. *Die Deutsche Landschaftsmalerei von 1750–1830*, Munich 1922
———. *Deutsche Malerei um 1800*, Vol I: *Die Landschaft*, Vol II: *Bildnis und Komposition*, Munich 1922, 1928
Schrade, Hubert. *Deutsche Maler der Romantik*, Munich 1969
Schümann, C. W. *Deutsche Malerei des 19. Jahrhunderts*, Cologne 1971
Schwarz, H. *Salzburg und das Salzkammergut: Die Kunstlerische*

Entdeckung der Stadt und der Landschaft im 19. Jahrhundert, 3rd ed., Vienna 1958

Skasa-Weiss, E. *Bergromantik in der Malerei des 19. Jahrhunderts*, Munich 1977

Tietze, H. *Das Vormärzliche Wien in Wort und Bild*, Vienna 1925

Uhde-Bernays, H. *Münchener Landschafter im 19. Jahrhundert*, Munich 1921

Vaughan, W. *German Romantic Painting*, New Haven, Conn. 1980

Vechtritz, Friedrich von. *Blicke in das Düsseldorfer Kunst und Kunstlerleben*, 2 vols, Düsseldorf 1839, 1840

Waldmann, Emil. *Das Bildnis im 19. Jahrhundert*, Berlin 1921

Wichmann, S. *Realismus und Impressionismus in Deutschland*, Stuttgart 1964

Wiegmann, Rudolf. *Die Königliche Kunst-Academie zu Düsseldorf: Ihre Geschichte, Einrichtung und Wirksamkeit*, Düsseldorf 1856

Wolf, G. J. *Die Entdeckung der Münchener Landschaft*, Munich 1921

Zimmermann, E. H. *Das Alt-Wiener Sittenbild*, Vienna 1923

Exhibition Catalogues

Ausstellung Deutscher Kunst aus der Zeit von 1775–1875 in der Königlichen Nationalgalerie, Berlin 1906. Introduction by Hugo von Tschudi, 2 vols, Munich 1906

Bildnis und Komposition, 1750–1850: Zeichnungen und Aquarelle aus der Sammlung Heumann, Chemnitz, Museum der bildenen Künste, Leipzig, 1934

100 Jahre Düsseldorfer Malerei, Kunstsammlungen der Stadt Düsseldorf 1948

Deutsche Malerwerke der Frühzeit des 19. Jahrhunderts, Museum Folkwang, Essen, 1949

Blick aus dem Fenster: Gemälde und Zeichnungen der Romantik und des Biedermeier, Schloss Cappenberg, Dortmund, 1956

Romantik in Österreich: Malerei und Graphik, Residenz-Galerie, Salzburg, 1959

Um 1800: Deutsche Kunst von Schadow bis Schwind, Kunsthalle, Bremen 1959

Romantik und Biedermeier: Gemälde, Zeichnungen, Lithografen und Möbel aus Privatbesitz, Kunstamt Reinickendorf, West Berlin, 1960–61

Biedermeierausstellung, Friedrich Gauermann und seine Zeit, Servitenkloster, Gutenstein-Mariahilfberg; Gauermannhof and Postl-Mühle, Miesenbach 1962

Blumenbilder des Biedermeier aus den Sammlungen des Niederösterreichischen Landesmuseums, Schloss Hunyady, Maria Enzersdorf, near Mödling, 1966

Deutsche Zeichnungen des 19. Jahrhunderts, Staatlichen Kunsthalle, Karlsruhe, 1966

Klassizismus und Romantik in Deutschland: Gemälde und Zeichnungen aus der Sammlung Georg Schäfer, Schweinfurt, Germanisches Nationalmuseum, Nuremberg, 1966

Berliner Biedermeier von Blechen bis Menzel: Gemälde, Handzeichnungen, Aquarelle, Druckgraphik, Bremen 1967

Der frühe Realismus in Deutschland 1800–1850: Gemälde und Zeichnungen aus der Sammlung Georg Schäfer, Schweinfurt, Germanisches National-Museum, Nuremberg, 1967

Romantik und Realismus in Österreich: Gemälde und Zeichnungen aus der Sammlung Georg Schäfer, Schweinfurt, Castle Laxenburg, near Vienna, 1968

Barock und Biedermeier im Niederösterreichischen Donauland, Schloss Charlottenburg, Berlin, 1969

German Painting of the 19th Century, Yale University Art Gallery, New Haven, Conn., 1970

Österreichische Malerei des 19. Jahrhunderts aus Privatbesitz, Innsbruck 1970

Kunst der Bürgerlichen Revolution von 1830 bis 1848/49, Neue Gesellschaft für bildende Kunst, Berlin, 1972

Österreichische Künstler und Rom, vom Barock zur Secession, Akademie der Bildenden Künste, Vienna, 1972

The Düsseldorf Academy and the Americans: An Exhibition of Drawings and Watercolours, The High Museum, Atlanta, Ga., 1973

Düsseldorf und der Norden, Kunstmuseum, Düsseldorf, 1976

The Hudson and the Rhine: Die Amerikanische Malerkolonie in Düsseldorf im 19. Jahrhundert, Kunstmuseum, Düsseldorf, 1976

La Peinture allemande à l'époque du Romantisme, Orangerie des Tuileries, Paris, 1976

Die Düsseldorfer Malerschule, Kunstmuseum, Düsseldorf, 1979

Münchner Landschaftsmalerei 1800–1850, Städtische Galerie im Lenbachhaus, Munich, 1979

Romantiken i Dresden: Caspar David Friedrich och hans Santida 1800–1850, Nationalmuseet, Stockholm, 1980–81

C. W. Eckersberg og hans Elever, Statens Museum for Kunst, Copenhagen, 1983

Danish Painting, the Golden Age, National Gallery, London, 1984

200 Jahre Brüder Grimm, 4 vols, Museum Fridericianum, Kassel, 1985

List of Illustrations

Numbers refer to pages

Dimensions are given first in centimetres, then in inches, with height before length

Index